HOW
ART
MADE THE
WORLD

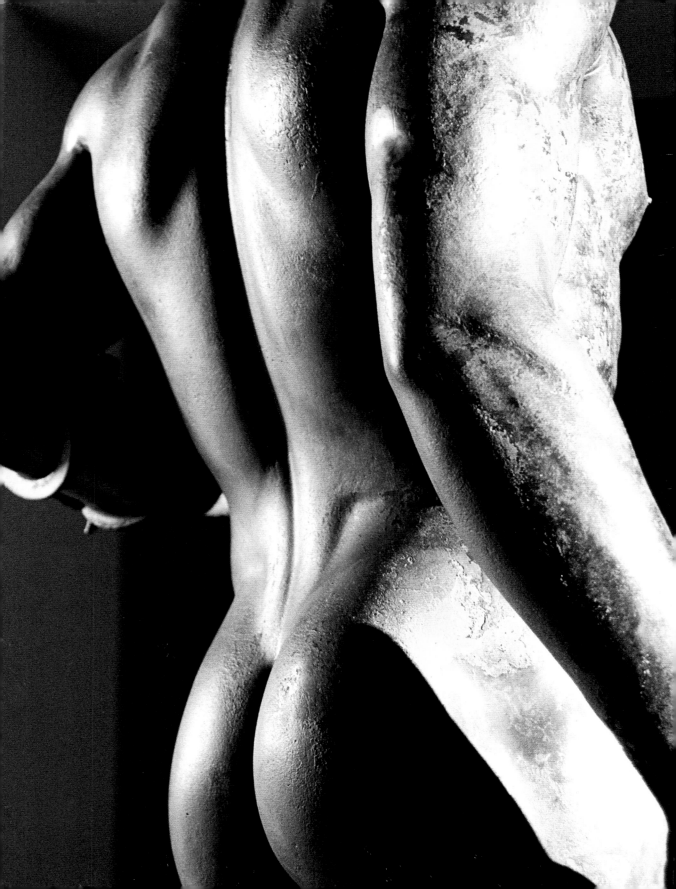

HOW
ART
MADE THE
WORLD

NIGEL SPIVEY

BOOKS

To Anna-Louise
sine qua non

This book is published to accompany the television series entitled *How Art Made the World*,
which was first broadcast on BBC1 in 2005.
Executive producer: Kim Thomas
Series producer: Mark Hedgecoe

Published by BBC Books, BBC Worldwide Limited, Woodlands, 80 Wood Lane,
London W12 0TT.

First published 2005
Text © Nigel Spivey 2005
The moral right of the author has been asserted.

ISBN 0 563 52205 4

Commissioning Editor: Sally Potter
Project Editor: Sarah Reece
Copy Editor: Trish Burgess
Designers: Linda Blakemore and Kathryn Gammon
Picture Researcher: Vanessa Fletcher
Production Controller: Alix McCulloch

Set in Gill Sans and Plantin
Colour origination and printing by Butler & Tanner Ltd, Frome, England

For more information about this and other BBC books, please visit our website on
www.bbcshop.com or telephone 08700 777 001.

I (previous page) Detail of one of the Riace bronzes (Statue A), created c.450 BC and found
off the coast of southern Italy in 1972 (see pages 75–81).

CONTENTS

THE
HUMAN
ARTIST

ONCE THERE WAS AN ARTIST who was also a teacher of art. He held classes at an art school, and many students signed up to follow them. So many students applied to take this artist's lessons that the directors of the art school became alarmed. There was not enough space, they said, to accommodate such a crowd of apprentices. They summoned the artist and ordered him to cut down the number of people taking his lessons. 'You mean I must reject some people who apply?' he asked. 'Of course!' replied his superiors. 'Not possible,' said the artist. 'Why not?' they asked. 'Because everyone is an artist,' declared the artist. He refused to alter that faith: in the classroom he would chalk up the message, EVERYONE IS AN ARTIST. Eventually the directors of the art school had him dismissed.

We see a hand: it seems to wave or reach to us across centuries and across continents (*Fig. 2*). It is represented without great dexterity or skilful manipulation, yet it is, at the same time, a significant imprint of the potential for just that – great dexterity, skilful manipulation. For the structure of bone, tendon and muscle within the human hand is one of the key anatomical features by which humans are defined. Compared to the

primates - gorillas, chimpanzees and other ape-like relatives of the human species –
humans have hands that are distinctive. Chimpanzees can peel bananas and can also
(if required) lift china teacups; but their grasp is essentially one of power rather than
precision. Unlike humans, they cannot cup their palms. And the digits of a human hand
are not only straighter and more extensive than those of the primates. In particular,
human fingers have a third joint or phalange, which enables a large range of precise and
delicate movements; and each hand has an elongated thumb, set at a wide angle to the
palm and providing further possibilities of flexion and grip. Without this 'opposing
thumb' we should hardly be able to write a word, sketch a line – or fire a gun.

The first detailed anatomical drawings of the hand were made by European artists
in the early sixteenth century. And in their isolated studies of the hand, artists around
this time surely worked with a sense of conscious dependence (*Fig. 3*). Hands cannot be
represented without hands. Nor, for that matter, can hands be dissected without hands.
So the painting of an anatomy lesson in seventeenth-century Holland chooses precisely
that moment where a surgeon demonstrates how the thumb and index finger of the
hand are operated by the flexor tendons of the arm (*Fig. 4*). The surgeon himself uses
the thumb and index finger of his right hand to hold his forceps, while emphasizing the
opposing thumb gesture with his left. The painter recording this scene knows well
enough what the message was at the time: that this prehensile capacity came as a divine
gift – a gift distinctively raising humankind above all other creatures.

In the annals of human evolution the fossilized relics of these hands, with triple-
phalanged fingers and wide-set thumb, are directly related to another peculiarity of the
species – the big toe at the end of our feet. The proto-human creatures (known scientifically
as Australopithecines) roaming about on the Earth some 4 million years ago can be set apart
from apes by this big toe feature. Its anatomical importance is that it facilitates the gait and
balance of walking upright on two feet: the bipedal capacity that, as evolution-theorists
believe, critically determined how systems of blood circulation flowed into place within
the human frame – and subsequently conditioned a gradual increase in size of the brain.

The primary effect of bipedalism? That of freeing up the hands for activities other
than getting around. Those activities include the making and carrying of tools and
weapons. They also include the creation of art.

When I was a boy the leading attraction of London Zoo was a daily event, billed as
'The Chimps' Tea Party'. A group of chimpanzees was placed around a table and served

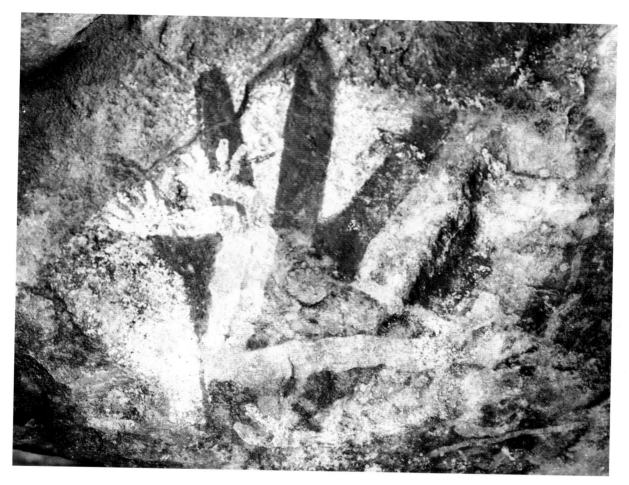

2 A hand image on a rock surface in Arnhem Land, Australia. Date unknown.

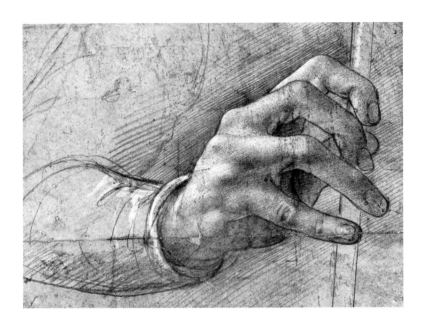

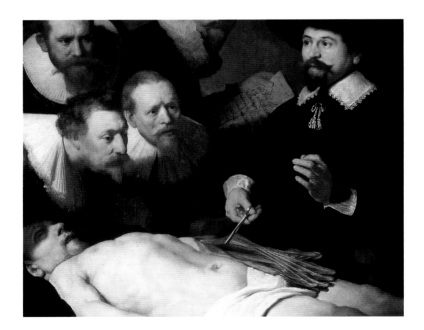

3 (top) *Study of a Hand* by an anonymous Milanese artist, c. 1500.

4 (above) *Anatomical Lecture of Dr. Nicolaes Tulp* (detail) by Rembrandt van Rijn, 1632.

with food and drink. Whether they were dressed for the occasion, I can't now recall; nor quite how far the animals were trusted with crockery or knives. But part of the spectacle must have consisted in witnessing some kind of mess or bun-fight, because grown-ups would describe a scene of domestic chaos by saying that it looked 'like a chimps' tea party', and the balance of entertainment always seemed poised between admiring the apparent etiquette of the animals and waiting for an episode of slapstick clumsiness.

The memory dates me. Great apes are no longer deployed for general amusement in zoos or circuses; and one long-running and successful series of television commercials was cut because its trick of putting chimpanzees into costume and making them appear as droll aficionados of a certain brand of tea became morally outmoded. Yet the sentiment persists, among certain zoological enthusiasts, that the affinity between apes and humans is really very close.

Probably the most influential discovery of modern science is the microscopic analysis of nuclear DNA, the genetic molecule in living things that combines the coiled strands or chromosomes present in each cell of tissue. Each given species usually has paired chromosomes of a definite number. In humans the normal number is 46; in types of African ape the average is 48 – in other words, very close in terms of genetic constitution (compared, for example, with the chromosome total of six for a mosquito, or 78 for a chicken).

The DNA proximity of apes and humans, combined with a general sense of evolutionary kinship, has encouraged some researchers to see if there is any shared inclination to behave artistically. Just as chimpanzees can be trained to drink cups of tea, so a number of tamed apes have been taught how to hold pencils and paintbrushes. A chimp named Congo, domiciled at London Zoo in the late 1950s, had an exhibition of his work. Given encouragement, he showed some capacity for what we might call 'rhythmic patterns'. He seemed to be able to confine his actions to a sheet of paper and make groups or intersections of the lines produced by his movements with the brush. Congo also apparently understood how to daub his paws with paint and make fan-shaped designs by pressing five digits on to a surface.

Congo's exhibition sold out. But since then, further experiments have failed to prove much more than a certain gift for mimicry among chimps when supplied with art materials and steered by humans to create certain scribbles. 'Abstract expressionism' is the most charitable description of what these domesticated animals have displayed.

Neither Congo nor any other ape has so far indicated any disposition to *represent* anything. To claim that primates can produce art is therefore not very meaningful; rather like claiming that parrots can talk.

Is that it – the end to the question of whether any species apart from humans is capable of art? Not quite. None of us will dispute the claim that birds can sing. Some birds, including the so-called birds of paradise and the blue-footed booby of the Galapagos Islands, are known also to dance. And the bower bird of New Guinea and northern Australia is even more exceptional, exhibiting qualities in its pyramidal bower constructions that we associate with art: design, form, tone and colour.

Australian Aborigines have long known about the gazebo-like structures of the bower bird. European explorers, coming across them for the first time, assumed them to be the relics of human creativity. Rising up to 3 metres (10 feet) in height, the twig and branch scaffolds evidently do not serve as nests or shelters. Embellished on the outside with flowers, berries, bright lichens and mosses, and smeared on the interior with colours and glistening resins, the typical bower seems like some improvised jungle folly. When in northern Queensland, my family and I once unknowingly pitched a tent very close to one of these constructions; at dawn we were made fully aware of where we were. Petulant screams filled the air. A male bower bird, feathers fully fluffed, strutted round his edifice, as if enraged. Clearly this bird was a connoisseur of red and pink plastic: select old bottle tops and pegs were spread in a halo about his bower, amid a scatter of other precious collectibles – shells, glass, shards of porcelain. Peeping from behind canvas, we thought he must be trying to evict us from the vicinity. Then we realized that this was a display directed not at intrusive campers, but to impress a dun-coloured female bower bird perched – with her head cocked coyly to one side – in nearby foliage. It was a bravura performance, athletic and spry – jumping, posturing, hissing and thrashing about. I later learnt that if all went well, the bower would serve as a backdrop for one ultimate flurry: copulation.

The male bower bird goes to these industrious and dynamic lengths only during breeding time. The making of the bower seems to be a part of the courtship ritual that happens in its shadow. Unlike the peacock, the male bower bird has no fan of gorgeous feathers to flourish in front of his desired female. He must attract a mate by the vigour of his self-display, and through the extravagance and ingenuity of his bower – which, in turn, he must defend from being vandalized by rivals. Naturalists say that sexual signals

in the male bower bird have been transferred away from his appearance towards his faculty for presenting an object of his own artifice.

If this is the correct behavioural explanation for the bowers of the bower bird, then it is hard to resist attributing to both male and female bower birds a sort of decorative or even aesthetic sensibility. The bower bird not only has a scavenger's eye for glittery and interesting objects, but an exhibitionist's flair for laying out such finds. And the bird even appears to do a form of painting. It will masticate grass, ash or berries to generate a coloured slime, which is then spread by beak over the entwined bower walls.

The bower bird in action is a marvel to behold. But is it a marvel of *art* or sheer reproductive energy?

'Anything can be art,' declared the avant-garde French artist Marcel Duchamp (1887–1968), who made his name exhibiting ordinary objects, such as a bicycle wheel, a bottle rack and a ceramic urinal, as art. He also depicted the *Mona Lisa* with a dainty moustache and beard. The mischief of modern artists, oppressed by the public expectation that they should be original, is repeatedly typified by following Duchamp's subversive precedent. A pile of tyres, an unmade bed: who says these are not art?

Predictably, the public reacts with scorn, outrage and bewilderment. Our reaction stems not only from a sense of indignation – the bourgeois horror of being defrauded. It goes deeper than that. Because instinctively we *know* what art is – because we are all artists. We are the symbolic species: the species that knows how to *represent* a bicycle wheel or an unmade bed by using its uniquely nimble hands to make an image that symbolizes such an object.

It took another avant-garde artist of modern times, the German Joseph Beuys (1921–86), to voice as a human birthright the slogan that 'Everyone is an artist' and to provoke the administrators of an art school by refusing to limit the numbers of students enrolling on the courses he taught. This refusal, dating from 1972, is the source of the parable with which we began; and it was staged as a plea for creativity in all fields of human endeavour, not as a mission to prove each citizen of Düsseldorf a maestro at the easel. Yet the basic truth resides in that sentence, 'Everyone is an artist'; and renders the heading of this introductory chapter a blatant tautology – or at least a statement of the obvious.

'The human artist': what other kind of artist can there be? Not chimpanzees, nor birds, as we have argued. Only we humans have the imaginative power to make symbols,

to represent not only the world around us, but also what goes on within our heads. This book explores the history of how we developed and exercised that power: to tell stories, to create social hierarchies, to connect with the environment, to express the supernatural, to make images of ourselves – and to mitigate the hard fact of our mortality. The book's title, though tendentious, is not meaningless. After all, the human species, or something like it, existed long before humans became artists. More or less upright hominids – of the type whose relics were found at Olduvai Gorge in Tanzania – appeared about 2 million years ago. A fully upright human species (*Homo erectus*) duly followed, using hands to fashion stone tools and make fires. Then, about 200,000 years ago, came *Homo sapiens*, the 'knowing human', in turn yielding to *Homo sapiens sapiens*, the 'extra-knowing human', perhaps 100,000 years ago. This was the species that eventually colonized and 'made' the world.

Specialists debate when and how another unique human capacity, that of language, developed. How *Homo sapiens* displaced another large-brained species, the Neanderthals, is also a matter of academic conjecture. So too, of course, is the arrival of art. Certain sporadic archaeological finds suggest that natural objects bearing a chance resemblance to a human face or figure were picked up and kept as such. Periodically, evidence arises to indicate that human agency in making marks or patterns is older than we think – such as the engraved stone recovered from Blombos Cave on the coast of southern Africa, dated to about 77,000 years ago. But readers will already have realized that this book imposes a specific understanding of what art is. It is not craft – the ability to shape wonderfully balanced tools, as possessed by *Homo habilis* over a million years ago. It is not embellishment – the sense of beauty in colour and form shown by the bower bird. The human production of art may be full of craft and decorative intent, but above all, and definitively, the art of humans consists in our singular capacity to use our imaginations. Like the habit of walking on two legs, this capacity for visual symbolizing arrived at a certain stage of our prehistoric evolution. So a journey to the origins of art must start with that quest into the past. When was it that we combined the dexterity of our hands with the power of our brains and learnt the knack of representation?

'CHILD ART'

FROM THE 50 or so historical instances where children happen to have been raised 'in the wild' by animals, it is clear that art, like language, depends upon human society. A child brought up by wolves or bears neither speaks nor paints pictures. Children create art because they are taught to do so; because they are born into a world where art exists. In many parts of the world children are encouraged to make images as soon as they can manage to hold a pencil. The results of such early attempts are universally similar, fitting patterns of juvenile development established by the influential Swiss psychologist Jean Piaget (1896–1980). A group of four-year-olds, if asked to draw people or objects familiar to them, will invariably produce images that show the following characteristics (*Fig. 5*):

1 Drawn from memory, not direct observation.

2 Emphasizing certain salient (i.e. memorable) features, while omitting others. The phenomenon of the 'tadpole figure', or *homme tétard* (all-head man) with no apparent torso, is the most common manifestation of this tendency.

3 Conversely, adding other features known to be part of the scene, even if not visible – such as people inside a house.

4 Little regard for scale or proportion; no sense of perspective, foreshortening or other 'illusionistic' devices.

These are the hallmarks of 'conceptual' art: art that derives primarily from a mental image, not from the effort to match a visual symbol or representation to the object it symbolizes or represents. At a subsequent stage, as Piaget and others showed, children will 'correct' their image-making in order to gain the illusion of reality.

Some experts believe that a certain part of the brain favours the ability in some individuals to excel at this representational skill, often identified as a signal of artistic genius: legendarily the Italian painter Giotto (*c.*1270–1337) was 'discovered' as a shepherd-boy, idly scratching pictures of his sheep upon a rock; while the twentieth-century maestro Pablo Picasso liked to boast, 'I never made children's drawings, not even when I was a child.' Aside from this, however, is the stark evidence – illustrated throughout the following pages – that the earliest art of humankind is rarely, if ever, childlike.

5 Drawings by four-year-old children, 2004.

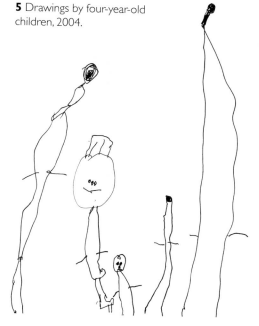

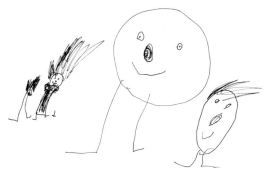

2

THE
BIRTH
OF THE
IMAGINATION

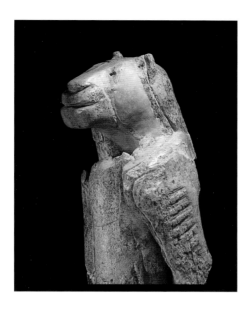

ONE DAY IN THE AUTUMN OF 1879 a Spanish nobleman and his daughter set out on a little adventure. They were going to explore a cave not far from the family estate at Puente San Miguel, in the Cantabria region of northern Spain. The nobleman's name was Marcelino Sanz de Sautuola, and his daughter – not yet in her teens – was called Maria. Together they made for the hillside of Altamira, which had lately been reported as a site of prehistoric occupation. To use the language of the time, Altamira was the sort of place where troglodytes or 'people before Adam' were thought to have sheltered.

As a keen amateur archaeologist, de Sautuola had high hopes of what he might find at Altamira. The bones of strange animals might be scattered around; perhaps traces of fires kindled long ago. With any luck, and close investigation of the cave floor, some rudimentary tools or implements might also be retrieved.

De Sautuola was not merely hunting for curiosities. When it came to publishing his discoveries at Altamira, he gravely noted that his ultimate motive for making the expedition with Maria was to 'tear away the thick veil that separates us from the origins and customs of the ancient inhabitants of these mountains'. Once he and Maria were inside the cave, he crouched down and began to examine the ground by lantern light. It was cool and damp in the cave, but spacious too. While her father was poking and

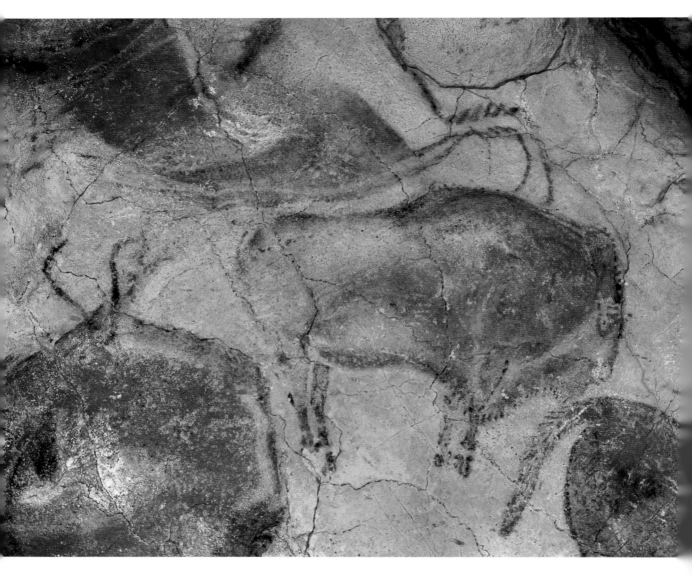

6 A detail of the cave paintings at Altamira, Spain, c. 11,000 BC, which Maria and Marcelino de Sautuola discovered by chance.

scraping at the floor, Maria wandered off to do some exploring of her own. It was not long before the darkness of Altamira echoed with a child's wondrous cry.

'Look, Papa – paintings of oxen!'

So a young girl was the first modern human to set eyes upon the 'gallery' of prehistoric paintings for which Altamira would become renowned (*Fig. 6*).

Being small, Maria had a better view of the cave's low ceiling than her father. However, her recognition of the animals whose images were ranged over Altamira's natural vault was not quite accurate. These were aurochs – a type of bison that had been extinct for thousands of years. Herds of them were depicted – standing, grazing, running, sleeping. And around these aurochs there were other four-legged beasts: horses, ibexes, boar. Gazing up at what his daughter had found, de Sautuola was almost speechless with excitement. He knew instinctively that this art was very old indeed; but it was more than instinct that told him so. The cave was littered with debris belonging to what would become known as the Stone Age – or, in archaeological parlance, the Upper Palaeolithic period (35,000–10,000 years ago). Moreover, de Sautuola could see similarities between the bison depicted here at Altamira and some bone carvings of animals lately discovered in caves in France.

The gentleman-scholar lost no time in communicating the news. It created a sensation, understandable even to this day, although, for reasons of preservation, visitors are now admitted only to a replica of the cave. Gazing over Altamira's rocky surfaces, the viewer soon appreciates that the word 'painting' is inadequate here. The uneven contours of the rock have been ingeniously incorporated to give the animals a bulky, almost three-dimensional presence. Big bovine shoulders loom up in the half-light: and, while the exact species of bison depicted is no longer to be seen, we cannot fail to be struck by the quality of close observation on display. How the animals stood while at pasture, how they collapsed when recumbent or wounded – the Altamira depictions are, as we should say, convincing. The colours, too, are memorable: predominantly red and black, but with shadings of form also picked out in brown, purple, yellow, pink and white. These strong organic pigments, derived from various oxides and carbons, play their part in giving the work a powerfully earthy depth and substance. All in all, it might be concluded that the paintings here are too good to be true.

Sadly for de Sautuola, many of his contemporaries thought just that. After an initial accolade from the press, royal visits to the cave and so on, doubts regarding the

authenticity of the art at Altamira began to be voiced. Nothing comparable to their scale and pictorial delicacy had been found at prehistoric sites then known to archaeological connoisseurs. One premature explanation of Altamira suggested that the paintings had been done during the Roman occupation of the Iberian peninsula. Within a year of de Sautuola's announcement of the find, however, more poisonous rumours were circulating. An artist was seen going into the cave (de Sautuola had commissioned him to make copies of the ceiling): word went round that he was the one who had painted it in the first place. At home and abroad, de Sautuola found himself mocked as a dupe, or suspected of perpetrating a hoax. He died in 1888, a deeply disappointed and widely disbelieved man. His friends said he was brokenhearted by the whole affair.

Young Maria would live to see her father's honour thoroughly redeemed. But before we lament the scepticism that brought misery to a pioneer explorer of prehistoric art, let us admit our own primary reaction to what we see at Altamira, and at other great underground sites subsequently revealed in Spain and southern France – most notably the caves of Lascaux and Chauvet. 'Amazing'; 'incredible'; 'astonishing': we reach for the clichéd language of admiration, and for once it denotes a genuine mystery. No sample of early human handiwork is more perplexing than the large-scale cave paintings of Palaeolithic Europe. What follows here is an attempt to make sense of what the images might mean, and why they were painted on subterranean walls. A particular theory is pursued, and other theories rejected – but they are theories all the same. In the end, amazement may remain the proper response. What we can establish for certain, however, is that these paintings are not localized miracles. Altamira belongs to a wider process of human development, and it is all the more exciting for that.

THE CREATIVE EXPLOSION

Radiocarbon dating of the pigments used in the Altamira paintings has established that the cave investigated by Maria and Marcelino de Sautuola was decorated between 13,300 and 14,900 years ago. This more or less confirms the notional antiquity assigned to the images by de Sautuola back in 1879. But beyond the element of forgivable surprise, why *were* the learned contemporaries of de Sautuola so reluctant to believe him?

The answer is that Altamira simply did not fit with prevailing scientific and popular views about the origin and development of the human species. Charles Darwin may have

caused theological controversy in Victorian Britain with his theory of evolution by natural selection – a process often summarized as 'the survival of the fittest', though Darwin himself did not coin that phrase – but so far as it confirmed stereotypical Western attitudes to the prehistoric past, Darwin's model was widely accepted. If evolution favoured the survival of the fittest, and humankind was set on an upward curve of progress in adapting to understand and control the world, then those humans left behind – especially those left behind many thousands of years ago – must be congenitally backward, ignorant and clumsy.

Already in 1651, the English philosopher Thomas Hobbes had fastidiously described the 'ill condition' of humans living in a pre-civilized 'state of nature'. It was a situation, he declared, of 'continual fear, and danger of violent death; and the life of man solitary, poor, nasty, brutish and short'. At the time when the paintings at Altamira were found, most people would have imagined the typical 'caveman' as some shaggy, low-browed creature, his ground-scraping knuckles clamped to a knotty club. This savage might have chased bison to fill his belly, but to represent the animal in delicate profile, with careful, sensitive hues – such fine aesthetic capacity was surely beyond belief?

So went the logic of orthodox opinion. However, even the most tenacious upholders of this view were forced to reconsider as further painted caves came to light, especially in France. In 1901, for example, two major sites near Les Eyzies in the Périgord region – Les Combarelles and Font-de-Gaume – were confirmed as bona fide. The following year, a major shift in attitudes was signalled when Emile Cartailhac, one of the French experts who had dismissed Altamira as a prank, published a penitential essay, accepting that his doubts had been in error: the paintings at Altamira, and others like them, really did belong to 'the dawn of time'. In the summer of 1902, Cartailhac joined other delegates from a scientific conference at Montauban in making a tour to inspect the several painted caves in the area. A consensus was declared: art indeed existed in prehistory, and the science of understanding it had only just begun.

Discoveries of further caves proliferated throughout the twentieth century. France yielded not only examples of painted surfaces, but also relief figures, such as the 'frieze' of animals brought to light in 1909 at Cap Blanc, again near Les Eyzies, and the two bison moulded in clay at the end of the deep cave at Tuc d'Audoubert in the Pyrenees.

Most stories of modern discovery contain a ration of drama. Appropriately, perhaps, it was while searching for a lost dog that several schoolboys came across the

splendid menagerie painted within the cave at Lascaux, near Montignac, in 1940 (*Fig. 7*). And while the finding (in 1994) of even more remarkable animal scenes in France's Ardèche Gorge came about from deliberate underground exploration, the subsequent dispute over ownership of this site – named Chauvet Cave after the potholing enthusiast who first flashed a torch beam over it – is something of a legal soap opera.

A pair of rhinoceroses lock horns for a fight; a natural event recorded with swift, confident brushstrokes. A set of feline profiles overlap, as if casually anticipating the draughtsman's rules of depth and perspective by many millennia (*Fig. 8*). Astonishing? Indeed. But not absolutely incredible – because the paintings of Chauvet Cave, firmly dated to over 30,000 years ago, provide merely the most spectacular indicators to date of what some archaeologists refer to as a general 'Creative Explosion' occurring in the Upper Palaeolithic period (*c.* 40,000–10,000 years ago). The phenomenon is not confined either to France or to continental Europe. Essentially, it marks the ascendancy of a particular biological species, *Homo sapiens,* the 'knowing human' type that has come to dominate the Earth's surface.

A summary of the background to this arrival of anatomically modern humans may be found in a separate section of this book (see page 14). Here, it is enough to observe that paintings on cave walls belong to a catalogue of telltale relics left by the ingenious and creative *Homo sapiens c.* 40,000–30,000 years ago. Among these relics are the following:

1 Flint tools, produced in such a way as to be exquisitely symmetrical. Such symmetry may have assisted their function (if, for example, axes were thrown as missiles); otherwise it exists to invest a functional object with aesthetic value.

2 Perforated teeth and shells, collected for the sake of bodily ornament. Items of jewellery, such as the necklace of shells found at Mandu Mandu in Western Australia, are sure signs of personal embellishment; possibly also indicators of social status.

3 Depositions of food and gifts along with burial of the dead. Excavated burials at the Cro-Magnon shelter near Les Eyzies and at the site of Dolni-Vestonice in the Czech Republic may not qualify structurally as tombs, but the presence of grave goods is suggestive of ritual, and some concept of an afterlife.

4 Scratchings on bone and antler that seem intentional and ordered. Several examples of such markings from the site of Zhoukoudian, near Beijing in China,

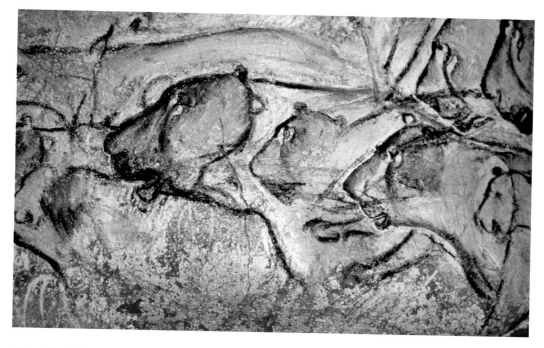

7 (top) Detail of the 'Salon of the Bulls' at Lascaux, near Montignac, France, c.18,000 BC.

8 (above) The masterfully depicted feline faces in the 'Lion Panel' of Chauvet Cave, France, c. 32–30,000 BC.

remain open to interpretation, while an ingenious case has been made for reading notches on the handle of a tool found at Ishango, in central equatorial Africa, as a notational system of tallies that marked time according to phases of the moon.

Certain aspects of this cultural 'take-off', such as vocal communication (singing included), dance, and painting done directly on to bodies, can never be known. Much small-scale or portable art may have vanished. And in many parts of the world there are markings on rocks that simply cannot be securely dated by archaeologists. These are reasons why, in any investigation of the origins of art, attention focuses upon the cave-paintings of Palaeolithic Europe. Accepting that they are the best-preserved and most visible signs of the global creative explosion, how do we start to explain their appearance?

ART FOR ART'S SAKE?

Pablo Picasso, arguably the most illustrious artist of the twentieth century, seems to have paid a visit to the newly discovered Lascaux cave in 1941. 'We have learnt nothing!' is reported as his awed, almost indignant comment, implying that the anonymous Stone Age draughtsmen of Lascaux had miraculously anticipated the representational aims and achievements of art within modern, 'civilized' society. Uncannily (as it must have seemed to him), the prominent animals at Lascaux were bulls – favoured subjects of Picasso, and indeed, featuring in one of his earliest paintings as a boy. Also, some of the animals depicted at Lascaux have their form emphasized in thick black outline. This is also uncannily similar to a pictorial device favoured at one time by Picasso and his post-Impressionist contemporaries, some of whom would be nicknamed in 1905 as *les fauves* (the wild ones). It must have unnerved the Spanish painter, to see a stylistic invention pre-empted by many thousands of years: 'the shock of the old', we might say. Later, at a Parisian exhibition in 1953, Picasso re-created for his own work the flickering, torchlit experience of viewing a prehistoric cave – such was his empathy for ancestral comrades.

Picasso's reaction is one that many of us would share. Identifying the precise species of bison, ibex or mammoth might be beyond us. But, like young Maria at Altamira, we have little essential difficulty in seeing what these ancient artists were trying to represent.

Instinctively, then, we may want to 'update' the earliest human artists by assuming that they painted for the sheer joy of painting.

The philosophers of Classical Greece recognized it as a defining trait of humans to 'delight in works of imitation' – to enjoy the very act and triumph of representation. If we were close to a real lion or snake, we should feel frightened. But a well-executed *picture* of a lion or snake will give us pleasure. Why suppose that our Palaeolithic ancestors were any different?

This simple acceptance of cave-paintings as art for art's sake has a certain appeal. To think of Lascaux as a gallery or *salon* allows it to be a sort of special viewing place where the handiwork of accomplished *artistes* might be displayed. And at Lascaux, the evident care with which individual animals have been abstracted from any natural background or landscape makes it tempting to suppose that the painters sought to create, as it were, 'life studies' of their subjects. Plausibly, daily existence in parts of Palaeolithic Europe may not have been so hard, with an abundance of ready food, and therefore the leisure time for art.

The problems with this explanation, however, are various. In the first place, the proliferation of archaeological discoveries – and this includes some of the world's innumerable rock art sites that cannot be dated – has served to emphasize a remarkably limited repertoire of subjects. The images that recur are those of animals; and, commonly, similar types of animal. Human figures are unusual; and when they do make an appearance, they are rarely done with the same attention to form accorded to the animals. If Palaeolithic artists were simply seeking to represent the beauty of the world around them, would they not have left a far greater range of pictures – of trees and flowers, of the sun and the stars?

A further question to the theory of art for art's sake is posed by the high incidence of Palaeolithic images that appear not be imitative of any reality whatsoever. These are geometrical shapes or patterns consisting of dots or lines. Such marks may be found isolated or repeated over a particular surface, but also scattered across more recognizable forms. A good example of this may be seen in the geologically spectacular grotto of Pech Merle, in the Lot region of France (*Fig. 9*). Here we encounter some favourite animals from the Palaeolithic repertoire – a pair of stout-bellied horses. But over and around the horses' outlines are multiple dark spots, daubed in disregard for the otherwise naturalistic representation of the animals. What does such patterning imitate?

There is also the factor of location. The caverns of Altamira and Lascaux might conceivably qualify as underground galleries, but many other paintings have been found

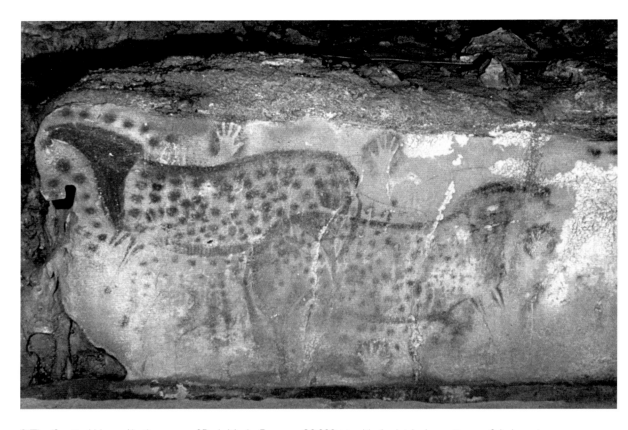

9 The 'Spotted Horses' in the caves of Pech Merle, France, c. 20,000 BC, with the intriguing patterns of dark spots around the horses' outlines. The hand stencils may be later touches.

in recesses totally unsuitable for any kind of viewing – tight nooks and crannies that must have been awkward even for the artists to penetrate, let alone for anyone else wanting to see the art. For example, a painted cave adjoining Pech Merle, called Le Combel, can only be reached by squeezing through a narrow cleft in the rock and crawling along on one's stomach; there was never any room to admire the handiwork in comfort.

Finally, we may doubt the notion that the Upper Palaeolithic was a Garden of Eden in which food came readily, leaving humans ample time to amuse themselves with art. For Europe it was still the Ice Age. An estimate of the basic level of sustenance then necessary for individual human survival has been judged at 2200 calories per day. This consideration, combined with the stark iconographic emphasis upon animals in the cave art, has persuaded some archaeologists that the primary motive behind Palaeolithic images must lie with the primary activity of Palaeolithic people – hunting.

ART AND HUNTING

Hunting is a skill. Tracking, stalking, chasing and killing the prey are difficult, sometimes dangerous activities. What if the process could be made easier – by art?

In the early decades of the twentieth century, an influential French archaeologist, Abbé Henri Breuil (1877–1961), made this suggestion the basis for his theory that the cave-paintings were all about 'sympathetic magic'. The reason why Palaeolithic artists so often depicted animals was that the business of hunting animals preoccupied them and their contemporaries. And the artists strived diligently to make their animal images evocative and realistic because they were attempting to 'capture the spirit' of their prey. As Breuil stressed, these debutant human artists clearly did not draw like children. What could have prompted their studious attention to making such naturalistic, recognizable images? For Breuil, it had to come from some extraordinary belief about the power of images. If a hunter were able to make a true likeness of some animal, then that animal was virtually trapped. Images, therefore, had the magical capacity to confer success or luck in the hunt.

As with the interpretation of cave-paintings as art for art's sake, there is a general element to the theory of hunting magic that is immediately attractive. After all, anyone who has ever kissed a photograph knows that images can serve the purpose of wishful thinking. Many instances are known of societies in which images are honoured as

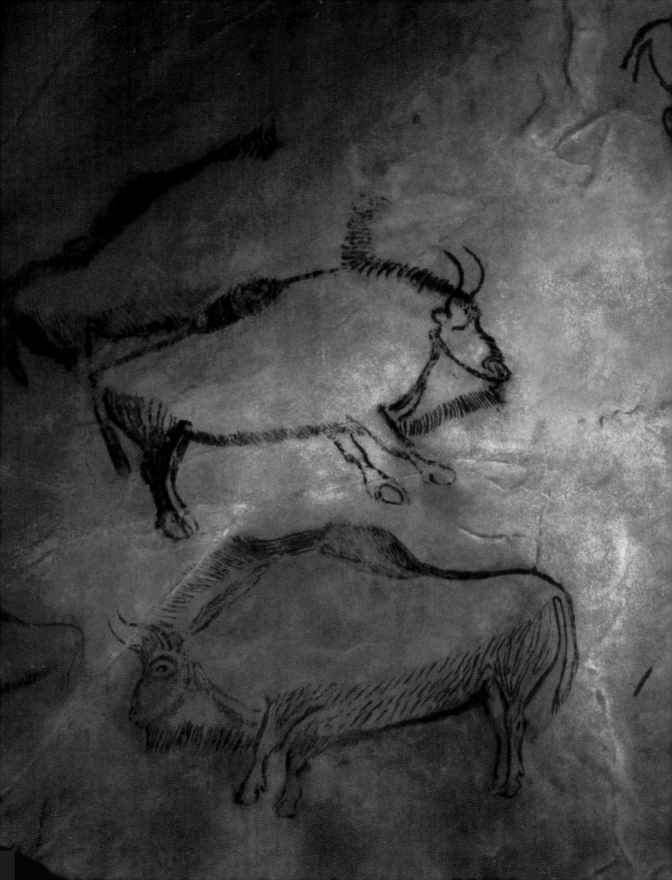

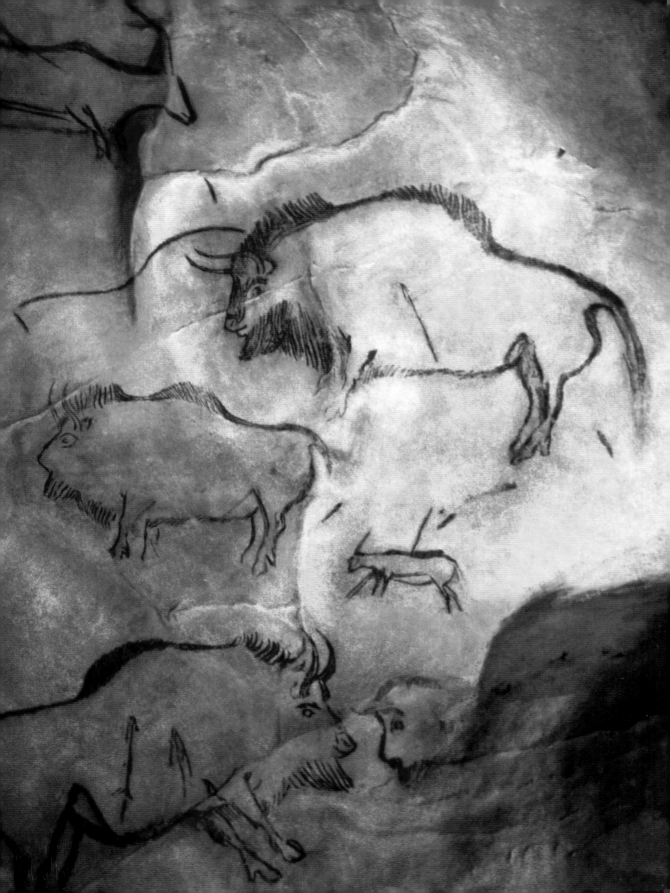

potential surrogates of reality. Voodoo-type superstitions, for instance, rely on the belief that sticking pins in a wax effigy of someone will make that person feel pain. Art thereby becomes a medium for magic. And while we might accept that the image of a lion or a snake does not terrify us like the real thing, it is also well documented that we are quite capable of responding to an image as if it *were* real. Being a Catholic priest, Breuil knew well enough that many people of his time could stand before a picture or statue of the Virgin Mary with all the respect due to an animate presence.

Breuil could point to further specific features of the cave-paintings that favoured his approach. In numerous images, an animal was shown apparently struck by arrows or spears, or else marked as if wounded or snared (*Fig. 10*). As for the many animals not shown as direct victims of the hunt, they could belong to art's magical purpose nonetheless. Large herds, with well-fed or pregnant beasts signified yet more wishful thinking on the part of hunters hoping for the bountiful increase of their prey. And, of course, it was the mysterious or occult function of the paintings that, for Breuil, explained why they were located deep under ground. Magic had to be performed in dark places, out of sight; it was a secret operation.

Breuil's theory appealed to those who envisaged the Ice Age in Europe as a period of hard survival, when mammoths roamed the land, and fierce bears competed with humans for rocky shelters. And the element of superstitious or irrational belief suited anyone whose view of the past was shaped by the sort of desk-bound anthropology so eloquently presented by J.G. Frazer in his multi-volume compendium, *The Golden Bough* (1907–15). Subtitled 'A Study in Magic and Religion', Frazer's work seemed, from the poet T.S. Eliot's admiring point of view, to create 'an abysm of time'. Yet the Frazerian pursuit of data from 'primitive' societies relied upon an ideal of progress characteristic of Victorian Britain. Frazer himself styled it as 'the long march, the slow and toilsome ascent, of humanity from savagery to civilisation'. Trust in magicians was, for Frazer, a key defining feature of 'savage' societies.

Anthropology has moved on from such complacency. But the main objection to Breuil's theory arises not from ideological disdain; rather from more attentive archaeological examination of the ancient debris within the caves – in particular, analysis

10 (previous page) Wounded bison from Niaux caves, near Ariège, France, c.14,000 BC.

of food remains left around hearths or in middens (rubbish dumps). If the paintings were created for the purpose of successful hunting, it would be logical to expect that the animals depicted on the cave walls were those featuring in the daily diet of the cave's inhabitants. But this correlation does not hold. At Lascaux, the animals painted were bulls, horses and red deer. Most of the bones discarded in the cave, however, were of reindeer. At Altamira they drew bison, but the associated bones were those of deer, goat and wild boar, with shellfish adding a little variety. Mammoths appear with some frequency in the caves of the Ardèche and Périgord regions, but not in the record of human subsistence at that time. As one archaeologist puts it, 'the Upper Palaeolithic painters had horses and bison on their mind, whereas they had reindeer and ptarmigan in their stomachs'.

If not propelled by hunger, why did they paint? Although the science of neurophysiology was in its infancy, Breuil and his contemporaries sensed that it was fundamentally unnatural for the human mind to produce and use representational images in the first place, citing the reported case of a Turkish Muslim who, having had no experience of pictures or drawings, failed to identify a two-dimensional image of a horse because he could not walk around it. The capacity for images, though quickly acquired, did not seem to be innate. If we need to have some mental experience or training in order to *recognize* symbols, how did we ever acquire the ability to *create* them in the first place? So the quest continued – the quest to explain how this peculiar human habit of representation began.

ART AS A SYMBOLIC SYSTEM

Anyone who considers the practicalities of interior decoration at Altamira and Lascaux will suppose that some system of scaffolding must have been erected for the painters. Experts confirm the supposition. Images were not casually scrawled on the walls, but laid out as part of a considered programme or scheme of decoration.

It is to the credit of another French scholar, André Leroi-Gourhan (1911–86), that the theory he offered as an alternative to art-for-hunting was based on an acceptance of Palaeolithic imagery as a grand project – anything but random sketches. Strongly influenced by the Structuralist school of anthropology (see page 89), Leroi-Gourhan proposed considering the cave-paintings as a symbolic system based on binary oppositions or pairings, with the essential division being that between man and woman.

Notoriously, there are very few images of humans in the caves. But what if certain animals were to be associated with males, and others with females? With reasons ranging from the elementary to the sophisticated, Leroi-Gourhan argued that horses, ibexes and deer were symbolically masculine, while aurochs and bison were feminine. His analysis defies summary: but ultimately – as might be guessed – it leads to the supposition of some kind of fertility rite staged in the caves, for which the images must serve as liturgy.

Some would say that Leroi-Gourhan's approach was music to the ears of anyone raised on the psychological doctrines of Sigmund Freud. Certainly there were Freudian overtones to the way in which Leroi-Gourhan explained the geometric motifs that recurred in the caves. Again he identified a male–female gender divide. Straight lines and dots signified male, while circular or enclosing forms were emblematic of female form. Other archaeologists had already noted certain painted shapes or graffiti suggestive of one particular part of female anatomy – the vulva – which favoured this sexually symbolic reading. Leroi-Gourhan himself, however, remained reluctant to specify the implied fertility rite.

Today it may be hard to resist being amused by the sort of interpretation that sees every straight line or spear as phallic, every circle as a womb. Yet, as even his critics agree, Leroi-Gourhan was surely right to persevere in his assumption that the Palaeolithic artists worked *intentionally*; that there was a method and a meaning to their work as a whole. But if one problem with his theory is that it depends upon a modern obsession with sexuality, then the general question arises of how we should proceed. We still need some explanation of how the knack or capacity for representation first clicked into place. Can any analysis bridge the distance between modern viewers and ancient artists?

OUT OF AFRICA

In the age of our great-grandparents – the generation for whom the work of J.G. Frazer was enlightening – there was little objection to making comparisons between the prehistoric past and communities of so-called 'primitive peoples' that had survived (by isolation) into the industrialized world. Today, it would be thought offensive and misleading to describe, for example, the existence of Australian Aborigines around 1800 AD as equivalent to the Stone Age. And yet the impulse to draw some analogies between a surviving or documented society of hunter-gatherers and the hunter-gathering

existence of people in the Palaeolithic past is difficult to resist, even if the distance is measured not only across time, but also across continents. Just such a non-judgemental explanation by analogy has lately emerged, injecting fresh energy in to the debate about the beginnings of humanity's gift for representation. The theory comes from Africa, and how it evolved is worth tracing in some detail.

The Drakensberg mountains are the main contours of southern Africa. To the east, beyond a coastal plain, lies Durban; due north is Johannesburg and the interior plateau or *veldt*; within the range, geologically, is the small, snow-topped kingdom of Lesotho. Most of the Drakensberg peaks now belong to the province of KwaZulu-Natal. In and around this area are many place-names that resonate in South Africa's modern history, sites of conflict between Boer settlers, British colonists and Zulu tribesmen: Spion Kop, Ladysmith, Rorke's Drift and more. But before the British, the Boers or the Zulus impacted on this landscape, it had been long occupied by a people whose official place in history is so uncertain that no one is quite sure what to call them. They used to be referred to collectively as 'Bushmen'; lately 'the San' has been preferred. In fact, both names have pejorative connotations, but since there is no ready alternative, we shall use the term 'Bushmen' here, for the sake of convenience and without disrespect.

The Bushmen's modes of habitation and subsistence in the Drakensberg changed very little over thousands of years. The men hunted animals, using spears and arrows tipped with poison; the women gathered plants, grasses and roots, with no other tool than a weighted digging-stick. Small communities moved from upland to lowland areas as seasons changed, making use of natural shelters where available. Like other nomadic peoples, the Drakensberg Bushmen needed very few possessions, so one might have guessed that they left few traces of their presence in this territory. This is, indeed, the case – except in the crags and crevices of the sandstone escarpment there are thousands of painted images.

Comparable in quantity to the rock art sites of the Kakadu area in northern Australia, the Bushmen paintings of the Drakensberg are not catalogued; unlike the Kakadu images, they are entirely anonymous and impossible to date. Paintings done only 200 years ago may look brighter than work done 20,000 years earlier, and certain scenes (such as men shown carrying guns) appear to be references to the colonial intruders. Essentially, however, the numerous images seem very similar and coherent within the region, and similar to paintings left in some other places occupied by the Bushmen.

These were not always recognized for what they were. In 1918 climbers exploring the Brandberg Massif (of modern Namibia) came across rock paintings in a certain ravine. Coloured copies were duly made and shown some years later to Henri Breuil, then attending a conference in Johannesburg. The Abbé pronounced that no indigenous people had made these images, but foreigners of 'Nilotic-Mediterranean origin' – perhaps émigrés from Bronze Age Crete, whose style seemed apparent in a particular figure dubbed by Breuil as the 'White Lady'. It has since transpired that this figure is male, and typical Bushman work; but to upholders of the apartheid system – whereby white and black people in South Africa were kept apart – Breuil's verdict was welcome proof that the earliest inhabitants of this land had been Europeans. The notion was so pleasing to the country's colonial administrators that, during the Second World War, they gave academic refuge to Breuil in Johannesburg – sponsored by none other than the country's premier, J.C. Smuts.

Breuil's preposterous gloss of the 'White Lady' is perhaps sufficient indication of how little specialist attention was devoted to the images left by the Bushmen – images that were, of course, gradually fading from modern view. The neglect more or less persisted until the early 1960s, when a young local schoolmaster started to explore the Drakensberg paintings more studiously. His name was David Lewis-Williams, and what began as a teacher's pastime led first to a doctorate, then a professorial chair, and ultimately a dedicated Rock Art Institute (at the University of Witwatersrand in Johannesburg).

The conspicuous subjects of Bushmen paintings throughout the Drakensberg are animals (*Fig. 11*). Often enough it seems there is a scene in which some four-legged prey, such as an antelope, is surrounded by figures armed with bows or spears. Casual viewers might readily suppose that these were characteristic reflections of daily life among the Bushmen, to whom hunting was supremely important (their disputes with the settlers arose mostly from access to game or cattle raiding). But, as Lewis-Williams showed, one does not have to look very hard at the Drakensberg paintings before realizing that these depictions of hunting are not so straightforward as that. Some of the human figures, on closer examination, appear to have hoofs for feet, and animal heads. Other figures, seemingly realistic at first glance, have their necks represented in lines of many white stipples. A certain large sort of antelope, the eland, did indeed appear often and prominently in the paintings. But the Bushmen had many other sources of food, four-legged or not. Why so much emphasis upon the eland? As for these hybrid

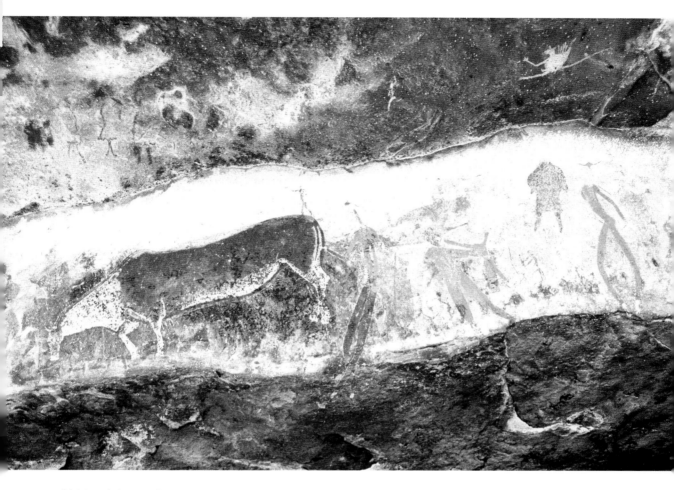

11 (above) A scene from the main frieze of the Game Pass Shelter, Kamberg, South Africa. Date uncertain.

12 (right) A drawing of a detail from the main frieze of the Game Pass Shelter, showing a dying eland and a figure with hooves and an animal head.

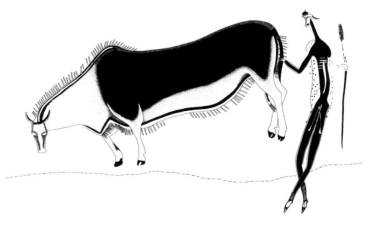

human-animal figures – therianthropic is the official descriptive term for them – why were some of them appearing to snatch at an eland's tail?

Lewis-Williams aired all these queries, which arose from interpreting the Drakensberg images as scenes of everyday life among the Bushmen. He was also aware that while hunter-gathering peoples may seem, in Western eyes, to be leading remarkably simple lives, at one with nature, anthropological research invariably demonstrated otherwise. Hunter-gatherers around the world tended to organize their lives around very precise and prescriptive systems of ritual and supernatural belief. Why presume any less of the Bushmen?

Answers to questions about the meaning of the Drakensberg images would, naturally, lie with the Bushmen who painted them. Despite near-genocide in the past, and the more recent imposition of borders and passports, Bushmen have survived in the Kalahari Desert, especially in parts of Botswana and northwest Namibia. But the problem for those trying to track down the meaning of Bushman art is that since their displacement from the Drakensberg to the Kalahari over a century ago, the Bushmen have not been able to sustain the artistic tradition. The Kalahari is a very different terrain from the Drakensberg: it offers few rock surfaces or shelters suitable for painting. What did persist among the Kalahari Bushmen, however, was a powerful strand of religious practice and belief that could be connected to previous images; also, the rare testimony of Bushmen voices recorded during the nineteenth century and kept in an archive at Cape Town. Combining these two sources, Lewis-Williams was able to make a convincing case that the thousands of Bushmen images in the Drakensberg were far from being scenes of daily life; rather, they belonged to the surreal experience of minds and bodies in a state of ecstasy.

An eland is in the throes of death (*Fig. 12*): its head hangs heavy; its dewlap – the thick fold of skin below the neck – is sagging; and its hind legs are crossed. The Bushmen say that the crossed hind legs of the eland are a clear sign of poisoned darts taking effect. Here, however, we notice something else. The therianthropic figure holding the eland's tail in one hand, and a spear in the other, appears to have *his* legs crossed too. He has an animal's head and hoofs. Can it be, then, that he is also dying? If so, is he a figure who not only connects between the realms of human and animal, but who also interacts between the living and the dead?

Transcripts of Bushman beliefs and practices point to the reality of just such a figure in the person of a shaman: a senior individual esteemed as a healer, a rain-maker,

an inspiration for the hunt, and someone with access to the spirit world. This is not only the stuff of archives: to this day, shamans exist among the Kalahari Bushmen. Being good-natured about visits from inquisitive researchers, tourists and film crews alike, the Bushmen have repeatedly confirmed the central significance of shamanic rituals to their society. Bushman shamans have their own metaphoric ways of recounting how they experience their connection with the supernatural; they speak in terms of being stretched on ropes, lines or threads to an almighty creator or some netherworld of ancestors. But (again thanks to an open disposition on the part of those concerned) it is also possible to witness a 'trance dance', in which a Bushman shaman performs.

This was how it happened in a small kraal or village not far from Tsumkwe in northwest Namibia. At dusk a fire was lit, around which the women of the village, with their infants, sat in a circle. They began to set up a rhythm of chanting and clapping. Various of their menfolk were around, including the aged headman of the village; some began to tread around the circle, humming along with the songs. The star of the show

THE BLEEK AND LLOYD ARCHIVE

DEFINED BY one anthropologist as 'the harmless people', the Bushmen communities of southern Africa were persecuted throughout the nineteenth century by white settlers and Bantu pastoralists alike. Many were exterminated; some were kept as convicts in Cape Town. It was among these prisoners that Wilhelm Bleek (1827–75) did his research. Bleek was a philologist, with a primary interest in the clicking language of the Bushmen. Aided by his sister-in-law Lucy Lloyd, he filled numerous notebooks with transcriptions of interviews covering all aspects of Bushman life and folklore. Alas, two notebooks carrying information about Bushman painting are listed as missing from the archive kept at the University of Cape Town. Others, however, provide a rich verbatim account of hunting techniques, stargazing, medicine and so on. It is from this record that we comprehend the centrality of ritual in the lives of the Bushmen. Christian missionaries thought them irreligious. On the contrary: the most powerful figures in any Bushman clan were its spiritual leaders, its ritual specialists. They have their own local titles: to term them 'shamans' is, for the sake of convenience, at least preferable to 'witch doctors'. Whatever we call these elders, the Bleek and Lloyd papers suggest that they were very likely to have been the artists of the Drakensberg and other Bushman-painted sites.

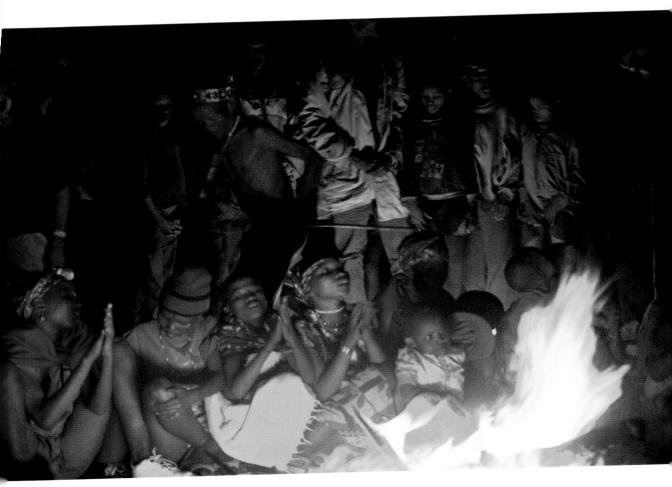

13 A Bushman dance at a village near Tsumkwe, northwest Namibia, in the summer of 2004.

then arrived: a diminutive, sinewy old man, wearing only a loincloth and a set of rattles about his ankles. He now led the stamping around the circle; and for the next two hours or so he hardly paused as lord of the dance. Sometimes he reached for the heads of those sitting down, as if to transmit some of his energy to them. Occasionally, he staggered away into the shadows, doubled up and gasping for breath; at one point, while weaving across the circle, he fell into the fire and had to be pulled out: sand was heaped over him to cool him down. Some of the women rose up and followed him. There was no weariness from them in clapping and singing. It seemed the ceremony could go on as long as the fire glowed under the stars (*Fig. 13*).

It is in such situations that a shaman can go into an 'altered state of consciousness'. Physically, this manifests itself in various ways: loss of balance, stomach cramps, hyperventilation and nosebleeds. Mentally, it can lead to hallucinations, the intense visionary experience of travelling out of body into strange yet convincing places. No one could draw or paint while in the midst of this sort of emotional seizure. But revealing or recalling what had come into vision during an altered state of consciousness … that would be truly marvellous, and proof, as it were, of the shaman's special status.

For several decades now, David Lewis-Williams has argued the case that the thousands of Bushman images left in the Drakensberg are best explained as 'shamanic': directly derived from the hallucinatory experiences of shamans while in an altered state of consciousness. There are, to begin with, clear signs that physiological effects of the trance dance are depicted: figures doubled up with abdominal spasms; figures with red lines (blood) streaming from their noses. The marked elongation of many figures may reflect the reported sensation of being stretched.

Rock surfaces, such as the Game Pass Shelter, became interfaces between reality and the spirit world, on which the imagery of the trance was recorded and displayed. To call these interfaces 'membranes' is not inappropriate. Figures of animals might emerge from cracks in the stone (as they do), and placing a hand upon the stone, too, might give some sense of its potent access to the domain of spirits and ancestors.

No summary matches the eloquence with which Lewis-Williams has pursued and published this theory: we may simply state here that many experts worldwide accept it. Anthropologically, it is not an isolated or eccentric phenomenon. Parallels can be drawn, for instance, between the Bushman shamans and those among various indigenous tribes of North America, such as the Yokuts and Numic of California, whose use

of hallucinogenic substances can be traced in petroglyphs (rock markings) left in sites of sacred significance. Evidence also suggests that shamans or 'clever men' among the Aboriginal communities of northern Australia played a particular role in creating the millennia-old imagery of that region. European colonists may have dismissed it all as so much mumbo-jumbo, although they were happy to accept stories (and images) of a man who could cure lepers with his touch and undergo an agonizing death without dying.

What, however, has this to do with the cave-paintings of Europe in the Upper Palaeolithic period?

THE NEUROPSYCHOLOGICAL MODEL

Readers may already have guessed the next move in the Lewis-Williams argument. It is not to suggest that Bushmen, Native Americans and Australian Aborigines are *culturally* comparable to people of the Stone Age, but to point out that all anatomically modern humans – including those of the Palaeolithic – share a brain that is hard-wired (pre-programmed) in a certain way. What occurs within this brain when we enter an altered state of consciousness is therefore predictable – a common human experience, as likely to have the same visual and visible effects today as it would have done 35,000 years ago.

There are many ways of inducing the altered state of consciousness: drugs, dancing, darkness, exhaustion, hunger, meditation, migraine and schizophrenia are among them. In the Western tradition it is by no means confined to hippies and a fashion for the mind-expanding substance known as LSD. Opium takers of the Romantic period, notably the English writers Thomas De Quincey and Samuel Taylor Coleridge, were generous in providing verbal descriptions of their visions. And in our own times scientists have discovered simple procedures of sensory deprivation that enable research into the brain's function when it comes to 'seeing things'. The research goes on, but already it is clear that the human nervous system exhibits certain features of response that can be generalized – providing, for archaeologists, a so-called neuropsychological model for explaining the very beginnings of symbolic representation.

Migraine sufferers do not need to be reminded of the fact that, even in a completely darkened room, and with their eyes firmly shut, they are persecuted by flashing lights. It is a common symptom of an altered state of consciousness: the sensation of brightness,

often framed in kaleidoscopic patterns – dots, lozenges, blocks, appearing in multiple units as networks, tessellations and suchlike. These patterns may be construed as certain objects in the world – a spider's web, or a honeycomb. In addition, the subject of an altered state of consciousness may feel that he or she is airborne, or in water, or plunging through some vortex or tunnel. Patterns slide one into another, and shapes are fluently transformed; in some hypnagogic (half-asleep) or dreaming moods we may see animals appear: to follow Shakespeare's phrasing, we will think a cloud to be very like a whale, or mistake a bush for a bear.

What characterizes all these sensations is how vivid they are. The nightmare victim wakes with a scream; the LSD addict maims himself terribly, convinced that his fingers are extending over the windowsill and on to the road outside. No external reality is there. Our reaction is entirely to what we see without any direct perception of the world around us. Such images have been termed as entoptic, 'within the eye'.

The Lewis-Williams hypothesis, then, is not just that Palaeolithic cave-painting was shamanic or shamanistic in origin. It is even more momentous; suggesting that the human knack of representational imagery was itself initially triggered by this neuropsychological process. In other words, the Palaeolithic painters were not making observations of the world around them; they were transferring on to cave walls the images they already had behind their eyes. They were displaying what had come to them in an altered state of consciousness; recollecting powerful visions; trying to recapture what they had seen in their hallucinations – even when these had flashed by as a series of abstract patterns (*Fig. 14*).

The acceptance of this model does not reduce all other cave-painting theories to nonsense. In societies where shamans are or were esteemed as authorities – including not only the Bushmen and other groups already mentioned, but also the Inuit or 'Eskimos' of Canada, tribes of Amazonian South America, and nomadic societies of Siberia, where the term 'shaman' originates – shamans claim power from and over animals. The trance dance of the Bushmen may celebrate a successful hunt, or serve to bring good fortune to an imminent expedition; either way, then, a measure of 'hunting magic' is implied by the shaman's central role. From shamanic lore, too, it is evident that certain animals can be invested with extraordinary power and significance. (For the Bushmen, the eland has such special status.) Siberian shamans would say that their souls were entrusted to animal guardians, or claim some personal familiar or daemon in four-legged form.

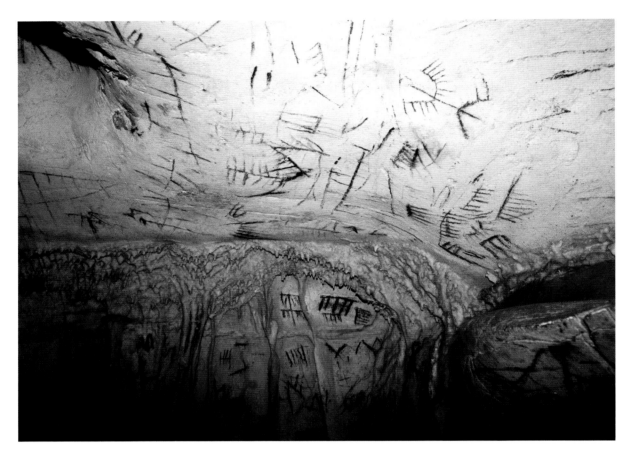

14 Abstract cave markings in the Cueva de la Pileta, Andalucia, Spain, c.25,000 BC. Such markings are typical of entoptic patterns generated within the mind during an altered state of consciousness.

So it may be right to suppose that certain animals possess symbolic value, full of luck and fertility, regardless of whether they feature as regular prey. But can we claim that shamans existed in prehistory?

> 'Let me tell you how I became a lion. It was a good dance several years ago … I felt the pull of the fire … and danced while staring at it … I saw the fire become very large … I saw a lion in it. I trembled when I looked at it. Then the lion opened its mouth and swallowed me. The next thing I remember seeing was the lion spitting out another lion. That other lion was me. I felt the energy of the lion and roared with great authority. The power scared the people.'

The recorded experience of a modern Bushman shaman while in an altered state of consciousness may directly illuminate, by analogy, several three-dimensional images discovered in the Jura region, the mountainous borderland between Switzerland and France. They evidently served as pendants or amulets, and their form is therianthropic – with the bodies of humans and the heads of lions (*Fig. 15*). The material from which they were made is of an animal source – the tusk of a mammoth. At the risk of being over-fanciful, we might say that the images were 'spat out' from the mammoth.

A number of caves contain paintings or engravings that seem to show hybrids of humans and animals, or human figures with animal masks and attributes. At Chauvet, for example, there is depicted a composite creature made up of a bison's head and body, and a pair of human legs. Is this some kind of minotaur or, as the discoverers of the cave preferred to call it, a sorcerer? Abbé Breuil had used the same term for an antlered, furry figure with human legs and feet among the images in a recess of the cave complex known as Les Trois Frères, in the French Pyrenees. Since it is well documented that much shamanic practice worldwide expresses itself in just such animal guise, the temptation to suppose that shamans operated in Palaeolithic Europe is hard to resist.

Hard to resist, and hard to prove. Conceptually, however, shamanism offers a persuasive route towards the neuropsychological model. The image of a lion-man was fashioned because it had been vividly *imagined* during an altered state of consciousness. The onus is upon sceptics to produce a more plausible alternative explanation. So far, none has been forthcoming.

FROM ART TO AGRICULTURE

The cave-paintings at Altamira were once disbelieved because they seemed too 'early'. In turn, archaeologists who accepted the earliness of such cave-paintings were faced with a problem of succession. In Europe, at least, the practice of painting in caves apparently came to an end about 12,000 years ago. We know that the emergence, several thousand years later, of the great civilizations in Egypt, Mesopotamia and the Indus Valley, was accompanied by an increasing use of, even reliance upon, the symbolic resource of images: this book makes further reference to that process in due course (see, for example, page 61). But in the meantime, what happened to the human ability to create images?

Until recently, there was no satisfactory answer to that question. It was possible, admittedly, to claim that in some parts of the world – notably Australia – the habits of representation that commenced about 40,000 years ago never lapsed. But this was impossible to prove. In terms of archaeologically stratified evidence, a definite gap existed, between the end of the Old Stone Age (the Palaeolithic) and the early phases of the New Stone Age (the Neolithic). Then a certain hilltop in southern Turkey disclosed its secret.

The Turkish-Kurdish town of Urfa (or Sanliurfa), near the Syrian border, is touristically billed as 'historic'. Here Abraham, the patriarch of the second millennium BC, venerated by Jews, Christians and Muslims alike, is supposed to have sojourned on his way from the city of Ur to the land of Canaan. But it now transpires that religious activity around Urfa pre-dates Abraham by thousands of years.

An archaeological survey in the 1960s observed in the hills around Urfa a particular site where several knolls of reddish earth arose from a limestone plateau. These knolls, and the rocky area nearby, were covered in the debris of flint-knapping – the flakes and chips of flint left by the prehistoric manufacture of tools and weapons. Some large man-made slabs of stone were also noticed, but assumed to be of much later date than the Neolithic debris. No further investigation was carried out until 1994, when Klaus Schmidt of the German Archaeological Institute visited the site and established that the knolls were not natural, but part of an artificial hill, heaped as a prominent mark in the local landscape. With experience of other sites in this ancient area of Upper Mesopotamia, Schmidt was immediately able to classify the site as a *tepe* or mound, datable to the early Neolithic phase before the use of ceramics (sometimes referred to as the Pre-Pottery

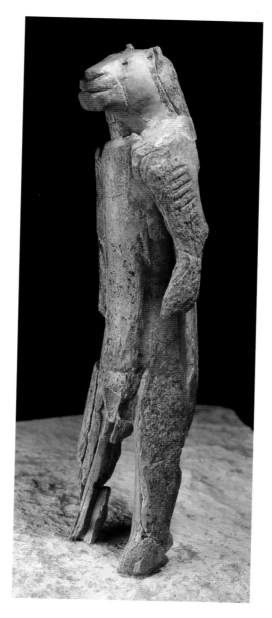

15 A lion-man statuette from Hohlestein-Stadel, south west Germany, c. 32–30,000 BC, possibly used as a pendant or an amulet.

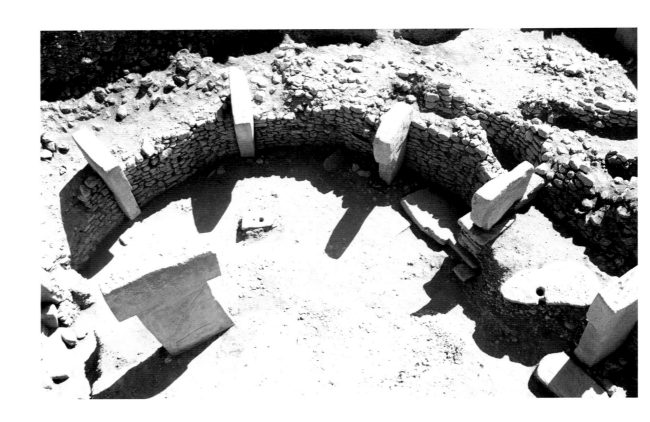

16 (top) Aerial view of a stone circle at Göbekli Tepe, Turkey, c. 9000 BC.

17 (above) Animal detail – probably a fox – from Göbekli Tepe.

Neolithic). He also suspected that the limestone slabs on this hill – henceforth known as Göbekli Tepe – belonged to some large prehistoric structure.

Digging into the mound not only confirmed Schmidt's intuitions, but revealed a dimension of Pre-Pottery Neolithic that no one expected.

The excavations at Göbekli Tepe are ongoing, with scope for more surprises. What has come to light so far is a series of walled enclosures, of which about 20 are built around massive stone pillars set in a circle (*Fig. 16*). Two separate pillars occupy the centres of these circles. Each of the pillars is fashioned out of solid rock into a T-shape about 7 metres (23 feet) tall. Rectangular carved doorways once provided marked or tunnelled access to the enclosures, and in the floor of one circle a small inset basin has been found, with an attached channel – possibly, as the excavator suggests, for the collection of blood. Food was consumed here, as indicated by many animal bones, but nowhere on the hillside are there signs of domestic habitation. So this was not, it seems, a place where people lived, but rather a special assembly point – some kind of sanctuary in the mountains that attracted people from a radius of settlements some 80 kilometres (50 miles) or further afield.

Like other prehistoric monuments, such as Stonehenge in Britain and the menhirs of France, Göbekli Tepe retains an enigmatic sense of unfathomed ritual significance. But not only is it much earlier than Stonehenge – by 7000 years – it is also much different in one key respect. The well-trimmed pillars of Göbekli Tepe are not just megaliths (big stones). They are *decorated* – embellished with images either engraved on to the surface or else picked out in shallow relief (*Fig. 17*).

It may come as no surprise that the principal subjects of this decoration are, once again, animals. Foxes and snakes dominate the repertoire, but gazelle, aurochs, wild boar, wild ass, cranes and a lion also feature. Spiders, too, are shown. In addition one block carries the image of a woman squatting in a sexual posture, though this may be of later date.

The pillars themselves appear schematically anthropomorphic or human-shaped, the shaft standing for legs and torso, the T-bar equating to shoulders and head. Carved arms are added to one of them, as if to confirm the intention. This in turn encourages the presumption that the images serve to harness forms of wildlife whose power belongs to these pillar-figures, or perhaps protects them. The foxes bare their teeth, the tusks of the boar are pronounced, and the snakes have been identified as venom-loaded vipers.

The possibility that the decoration of the pillars at Göbekli Tepe is shamanic has been seriously considered by the excavators. But, as they point out, the scale of structural enterprise at this site points to a society in which ritual was mediated not so much by shamans as by 'true priests'. The images, after all, were the ultimate phase, or finishing touches at least, to what had been a massive collective effort. At a small distance away from the main 'temple' area is the natural limestone amphitheatre from which the pillars were quarried. In the upper reaches of this quarry there is a marked cavity left by the removal of one T-shaped pillar much larger than any so far brought to light at the site; and right next to this space is a stone of similar size abandoned in a cracked and therefore unfinished state. Had it been successfully removed from the bedrock, it would have measured some 6 metres (20 feet), and weighed about 50 tonnes. To shift it across to the mound would have required the combined traction power of about 500 people.

Given that the mound itself is man-made, built from thousands of tonnes of earth and rock brought up from the plain below, we are bound to speculate that the measure of human organization required to build Göbekli Tepe was some way towards that required to build the Egyptian pyramids. Göbekli Tepe, in the words of its excavators, therefore stands at 'the dawn of a new world, a world with powerful rulers and a complex, stratified, hierarchical society'.

So this is a major revelation from current archaeology; and unlike the first 'reveal' of Altamira, it causes true wonder, not disbelief. And for those who like to regard art as an optional luxury in life, a pastime to be indulged only when the necessary business of survival and subsistence has been completed, Göbekli Tepe offers a particular challenge – with which we shall conclude.

For more than half a century, archaeologists have agreed that farming – the keeping of domesticated animals and the cultivation of crops – began in the Near East during the early Neolithic period, c. 9000 BC. Sheep and goats were the principal animals featuring in this agricultural revolution, while wheat and barley were the principal crops. Key sites providing evidence for animal enclosures and domesticated grains include Jarmo, in northern Iraq; Çatalhöyük, in western Turkey; and Jericho, in Palestine. The Jordan valley and the reaches of Upper Mesopotamia have also yielded specific clues regarding the transition from nomadic hunting and gathering to settled farming. The debate then arises about which came first: a demographic shift to settled communities, leading to a reliance

upon farming for food, or the intensive exploitation of certain livestock and cereals, leading to settled communities?

In the book of Genesis, the change occurs as a direct consequence of the expulsion of Adam and Eve from the Garden of Eden. The sons of Adam and Eve, Cain and Abel, are specified as a tiller of the soil and a shepherd respectively, fulfilling God's edict that mortals should henceforth survive 'by the sweat of their brow'. Göbekli Tepe raises an alternative possibility – that what instigated the first production of food was art.

About 30 kilometres (20 miles) south from Göbekli Tepe lies the Karacadag range. Research among these hills has shown that they are home to the closest wild relative of an early species of domesticated grain, einkorn wheat. The suggestion is that wild grain was brought from the Karacadag, and cultivated around Göbekli Tepe in order to feed all the hundreds of people building or simply frequenting the site.

So there is the momentous conclusion: that some 11,000 years ago imagery had become so powerful in the minds of human beings that it helped to bring about the greatest transformation in human history.

3

MORE
HUMAN
THAN
HUMAN

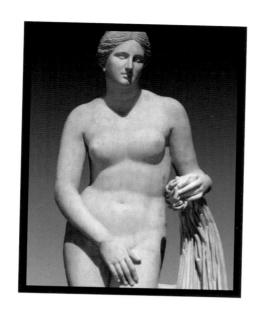

A WOMAN, UNCLOTHED, stands on a raised platform. She is posing for others who are studying her bodily features and trying to represent them on canvas. The scene captures one moment of a process that will certainly have endured for hours, probably days, and perhaps even weeks. It is an evocation of what many will recognize as a life class – a formal exercise in drawing, painting or sculpture that requires the apprentice artist to look very carefully at an example of the human body in order to represent it in two or three dimensions.

The life class has been a feature of institutional fine art training in the Western tradition since the sixteenth century. In Italy the Caracci family of painters made drawing from live models a key part of their 'academy' at Bologna, established *c.*1582. A generation or two later, the custom of practising draughtsmanship from male and female figures posed in the studio was taken up by Rembrandt van Rijn (1606–69) and his Dutch followers. Eventually, at around the time when London's Royal Academy of Arts was founded in 1768, the English language devised a special term to denote the content of such apprenticeship. This was 'the nude', which means a body not caught naked by surprise, but deliberately stripped bare and consciously posturing for viewers.

The life class is important for understanding the distinction between nudity and nakedness. But of more immediate concern, surely, is the apparent breach between what a life class demands of the aspiring artist and what the *successful* artist goes on to produce. From the time of Michelangelo (1475–1564) onwards, most of the great names of Western art have submitted themselves to the discipline of the life-class. (Michelangelo himself is listed as president of an *accademia del disegno* (school of drawing) at Florence in 1563.) From associated testimonies – or our own experience – we know that the traditional purpose of the life class is to gain an understanding of the human form in its natural, unveiled state. Proportions of limbs, anatomical structure, the connectedness of muscles, flesh and bones – these are usually the aims of the exercise. For some teachers the aim of the life class is all about getting it right: making an image that matches what can be seen; creating, therefore, an essentially realistic image of the human body.

So far, so good. Anyone who is *not* a professional artist will be thinking that this is how it should be. If artists are going to show us the human body, they ought (we expect) to know their subject properly. But as soon as we start to scrutinize the end results of studio training, we see the problem here. Take Michelangelo, whom many would regard as a consummate draughtsman of the human form. To his own contemporaries, however, the bodies he carved and depicted were not realistic, but rather invested with a certain *terribilità* (awesomeness). The Biblical and theological themes that Michelangelo painted on the Sistine Chapel gave scope for huge-shouldered hulks, colossal types that would dwarf even the extreme bodybuilders of today. Michelangelo *imagined* mankind created this way (*Fig. 18*); it is highly unlikely that any of his models even approximated such broad proportions. Conversely, to gain the effect of piteous attenuation, Michelangelo would also stretch his figures beyond normal length. That is clear enough from the piece he was still working on the day before he died (aged 89), a lamentation over the corpse of Christ (*Fig. 19*). Incomplete and unfinished as it is, the ensemble nonetheless relies upon exaggerated elongation.

We might suppose the case of Michelangelo to be merely a phenomenon of the past. But the extent of art's divergence from actuality is easily measured if we pause to ask ourselves how many of the images of the body displayed in our modern galleries and public spaces are essentially realistic.

The answer is very few – if any. There is no shortage of representations that appear to be based on the human form. But, on reflection, we seem to be confronted by another species …

18 (above) *The Creation of Adam* (detail) from the Sistine Chapel in the Vatican, Rome, by Michelangelo, 1511–12.

19 (left) The elongated figures of Michelangelo's *Rondanini Pietà*, which he was working on when he died in 1564.

20 *Les Demoiselles d'Avignon* by Pablo Picasso, 1907.

No period in Western art saw more experimentation with the range of representing the human body than the twentieth century.

21 *Draped Reclining Mother and Baby* by Henry Moore, 1983.

22 The Venus of Willendorf, c. 20–22,000 BC.

Why is this? What is it that makes us prefer unrealistic images of the body?

This is a mystery that takes us back to the very earliest images of the body made by humankind. Finding an answer will reveal something not just about our bodies, but ourselves – or at least, something fundamental about our human instinct for creating and responding to images *of ourselves*.

THE VENUS OF WILLENDORF: A CASE OF PEAK SHIFT?

Not everyone gets to open the cabinet containing one of the world's oldest sculptures. But since the curators of the so-called 'Venus of Willendorf' (*Fig. 22*) – a stone statuette carved some 25,000 years ago, and now conserved at Vienna's Natural History Museum – were kind enough to let the piece be caressed, one ought at least to share the experience, and report that permission to handle proved instructive.

The limestone figurine, a little over 11 centimetres (4¼ inches) in height, is surprisingly dense and heavy for its miniature scale. It also feels far more delicately finished than it can appear from photographs. But what the privilege of direct access confers above all is the distinct sensation of holding the Venus just as she was held in the remote past. She is a very tangible masterpiece, with her shape, size and heft all seeming to belong neatly in the palm of a hand. Certainly this was a portable *objet d'art*, and presumably it needed to be so – because although it was found in a Palaeolithic shelter-site, the statuette was not permanently installed there, but rather carried along as part of the minimalist baggage of the nomads to whom she belonged.

Willendorf is a village west of Vienna, lying along the banks of the River Danube in a region known as the Wachau. Today the landscape of the Wachau presents a picture of temperate habitation. Vineyards and apricot orchards occupy terraced slopes and valley meadows. Medieval turrets add to the effect of settled agriculture and economic importance. The pattern of farming here was essentially established over two millennia past, when the Danube formed the northern border of the Roman Empire. But it was not like this in prehistory. Around 40,000 years ago, when the first traces of human presence are located in these parts, it was a much colder and bleaker environment. This was Europe's last period of major glaciation. Dense pine forest and icy scrubland were roamed by hunter-gatherers – people who obtained their food by foraging, not farming.

The diet of these foragers was not necessarily poor, but even allowing for seasonal variability, it is hard to imagine conditions of easy surplus. One of the problems posed by the Venus of Willendorf is that she looks conspicuously obese at a time when it was undoubtedly rare or difficult for any individual to build up stores of fat. So how did she get that way?

We may counter that question by claiming that no one, actually looked like that – allowing this Venus to be a fantasy figure. And if we look more closely at the carving – done very delicately with some flint instrument – we see that there was no intention, originally, to make an accurate assimilation of human features. The hair has been rendered as a sort of bonnet, but the face is utterly blank. The hands and arms are included as if of slight or secondary importance, folded across the top of the breasts; but there is no attempt at all to show the feet. By contrast, certain other bodily parts have been very carefully defined: the nipples, the navel, the vulva and its labia.

Why the disparity? Why should certain parts of the body be specified and others ignored? And, in tandem with that demand, why are certain parts of the body – breasts, hips, buttocks – so strikingly exaggerated?

A somewhat predictable answer to the first question comes from the science of evolutionary psychology (or evolutionary *physiology*), which may be summarized as the explanation of human behaviour (or body shape) in terms of sexual selection. If we accept that the development of the human species was determined by the principle of the survival of the fittest, it follows that the primary criteria for assessing bodily fitness in a man or woman depend upon perceived or evident capacities to keep the species going. The predominant male and female physiologies that evolve will be those showing most promise of successful reproduction. This does not only involve the mutual display of functioning sexual organs. A man will also be judged by his physical ability to protect the family and supply it with shelter and food; a woman, by those bodily resources that help her to endure the trauma of childbirth, and the potentially difficult phase of first feeding. So the evolutionary explanation of the Venus of Willendorf may be readily summarized. Her wide hips and robust thighs suggest the strength to survive pregnancy and giving birth; her huge breasts, an abundant supply of milk; and the layers of fat, sufficient reserves to sustain her, too, through any eventual shortages of nourishment.

These factors may persuade us to indulge the usual description of the Willendorf Venus as a 'fertility figure', or even a 'fertility goddess' (though there is little evidence for any associated cult worship). We might also like to be reminded that there are

documented societies of hunter-gatherers, notably the Bushmen of southern Africa, where the actual condition of pronounced female steatopygia (fat-bottomedness) is demonstrably linked to local patterns of sexual selection. Nevertheless, the Venus is a statuette, a work of art. For some reason, the people who once hunted in the hills of the Wachau valley felt compelled to exaggerate *some* parts of her body, while completely ignoring others. If they were alone in this tendency for selective exaggeration, we might dismiss it as a local peculiarity. But the Venus of Willendorf is not, as a type, unique. Similarly proportioned female figurines have been found at a range of sites across central Europe, the Ukraine and Russia, with several also known from France and northern Italy. Carved mostly from some durable stone, they may have travelled long distances, and some show signs of having been often passed around.

Archaeologists may speculate about the use to which these statuettes were put (one suggestion is that they were a sort of Palaeolithic pornography). But the most vigorous explanation of why they are shaped as they are has come not from an archaeologist, but from a brain scientist.

Vilanyur Ramachandran has worked hard to popularize his theories about the 'science of art' beyond publication in specialized journals. What follows here is a digest of one part of a much wider hypothesis put forward by Ramachandran and his scientific colleagues about the universal principles operating in the brain whenever a work of art is instigated. We want to know why our Palaeolithic ancestors exaggerated, to a grotesque extent, certain features of these Venus figurines. In paraphrase, Ramachandran's answer goes like this. The Willendorf Venus and similar statuettes were made by hunter-gatherers living in a harsh ice age environment. In such circumstances, as we have observed, features of fatness and fertility would have been highly desirable. In technical terms, those features amount to hypernormal stimuli that activate neuron responses in the brain. This is a cognitive mechanism – something that comes naturally to us because our brains are hard-wired to concentrate perceptive focus upon objects with pleasing associations, or those *parts* of objects that matter most. For Palaeolithic people, the female parts that mattered most were those required for successful reproduction: the breasts and pelvic girdle. The circuit of the Palaeolithic brain, therefore, isolated these parts and *amplified* them.

The neurological principle here is that of 'peak shift'. It is, as Ramachandran points out, a principle well recognized in patterns of discrimination among other animals.

A rat, for instance, can be taught to differentiate between a square and a rectangle. Reward the rat with a piece of cheese every time it opts for a rectangle, and the rat learns to prefer not just a particular rectangle, but rectangularity itself. The more a rectangle is exaggerated – by elongating two sides, so as to look even more different from a square – the more promptly the rat will respond to it. As it happens, Ramachandran's favourite example of peak shift comes from the noisy world of the common seagull (see below), although neither gulls (nor rodents) produce works of art. Peak shift may account for the

THE HERRING GULL TEST

IT IS A BASIC tenet of this book that humans are the only creatures with the aesthetic capacity for making art. To hold such a belief does not mean, however, that there is nothing to be learnt from other species about how the human brain functions in terms of visual perception and response. This is one of the many applications of ethology – the study of animal customs and behaviour, with particular regard to evolutionary function. And it was a pioneer of ethology, the Dutch Nobel Prize-winning scientist Niko Tinbergen (1907–88), who conducted the experiment with herring gulls referred to above.

Herring gull chicks, like most animal offspring, begin clamouring for food as soon as they are born. They are fed with half-digested morsels from their mother's beak, which is yellow and distinctly marked on the lower mandible with a red patch. Habitually, the chicks tap the beak in their eagerness for food: whatever the extent of their eyesight, these new-borns apparently recognize their mother's beak as a sign stimulus for the feeding process. Such is the power of this sign stimulus that, as Tinbergen

discovered, its tapping response could be triggered not only without the mother gull's beak, but without any beak at all. Testing his theory a thousand times and more, Tinbergen found that gull chicks will seek food from a yellow or light-coloured stick marked with a red stripe. But what is most germane to peak-shift theory is how the effect of the red mark is increased by multiplication. A stick with one red stripe gets the chicks to beg for food. A stick with *three* red stripes gets them three times more excited. Given a choice of sticks – one with a single red stripe, the other with three red stripes – the chicks will peck more enthusiastically at the triple stimulus.

What is important, then, is not that the stick itself resembles a maternal beak, but rather the exaggeration of the red-patch signal in what Professor Ramachandran calls a 'superbeak' or 'ultrabeak'. 'If seagulls had an art gallery,' argues Ramachandran, 'they would take this long thin stick with its three red stripes, hang it on the wall, pay millions of dollars to purchase it, worship it, call it a Picasso … '

shape of a few figurines from prehistory. What happens next down the ages? Can a primeval instinct comprehensively explain why human beings like to create unrealistic images of the body?

EGYPT AND THE ORDERED BODY

At about the same time as the climate of central Europe began to soften and become more temperate – *c.* 10,000–5000 years ago, when the archaeological transition from Palaeolithic to Neolithic occurs – a large expanse of northern Africa became desiccated. An ecosystem reliant on lush vegetation was ended: the Sahara desert appeared. The hunter-gatherers who had roamed in this region were forced to move eastwards and congregate where water flowed. This water supply was a river that must have seemed miraculous – running for several thousand kilometres through arid land, apparently without tributaries or rainfall on its way, and then gushing over its banks between July and October – the driest time of the year. No wonder that nomads began to settle along the banks of the Nile, especially by its area of fullest inundation – the D-shape or delta formed where the river separates into the Mediterranean Sea. And no wonder, perhaps, that the agricultural subsistence they created along this river developed into a society characterized above all by its sense of precise and cosmic regularity. So long as the river flooded in season, farmers could plan ahead, and surpluses could be stored for the eventuality of crop failure or famine. Central organization was essential. From *c.* 3000 BC that central organization assumed a distinctly hierarchical structure. One ruler, who would be known as the pharaoh, stood at the peak. This ruler was divine in status, yet ruled only on behalf of, and with the support of, all those who made up the lower social levels. It is irresistible to liken this system to the shape of the pyramids that came to symbolize the civilization of ancient Egypt.

From the numerous illiterate peasants who tilled the floodplain of the Nile, to the priests and scribes who devised the picture-writing script known as hieroglyphics (literally 'holy engravings'), everyone within the ancient Egyptian hierarchy belonged, as it were, to the pharaoh. Somewhere in the lower middle section of the hierarchy were the artisans whose handiwork remains such a conspicuous presence in Egypt to this day. These artisans were not creative individuals at liberty to undertake commissions as they pleased. They lived and worked in groups, and they worked to a preordained set of rules

23 View of the ceiling and walls of the Tomb of Pharaoh Rameses VI, in the Valley of the Kings, near Luxor, c.1140 BC.

and specifications. There was no value of originality. Art existed to illustrate the cosmic order of things. Conformity was paramount.

There is no shortage of images of the human body in Egyptian art. In some painted regal tombs, such as that of Rameses VI in the Valley of the Kings near Luxor (*Fig. 23*), there are literally thousands of bodily images covering ceilings and walls. Descending into such a densely decorated space, one is immediately struck by its layered and patterned intricacy. The multiple hieroglyphs emphasize that effect, but so too do the bodies. Many are linked in registers, repeated as if in procession. But even when depicted in some particular gesture or action, these bodies are remarkably alike. Where some are unusual in size and shape, they do not represent ordinary mortals, but rather the pharaoh and certain associated deities, which in Egyptian religion are often zoomorphic – taking the form of animals. The rest appear almost to have been stencilled on the surface. Their proportions look identical, their repertoire of movement strikingly limited. Heads are mostly in profile, but with eyes shown front-on. Shoulders are frontal too, making arms, hands and fingers fully visible. But backsides, legs and feet are all depicted sideways. Each body is a predictable amalgamation of distinctive parts. The effect is one of orderly array. Even the pharaoh's enemies – a set of decapitated prisoners still kneeling with their hands tied behind their backs – have become a fixed motif.

Faced with such regular and repeated images, any search for the signs of peak shift here would seem to be somewhat irrelevant. True, aspects of the body have been simplified, and one could argue that such simplification involves selectivity. But these Egyptian bodies are not rendered unrealistic by exaggeration. They part with reality because they are schematic and conceptual.

'Schematic' means that these images belong to a plan, a preconceived arrangement. As such, there are no signs of individuality among the thousands of humans depicted in this tomb; their effect comes from replication and quantity. 'Conceptual' means something else besides. It refers to the thinking process by which the image was generated. The artists who used this image of the body were not concerned with the actual appearance of a human being, but something more like a dictionary definition ('Two legs, two arms, stands upright, etc.'). The shape of the body in Egyptian art was in this sense determined not by any direct observation – certainly not a life class – but rather a mental image.

This schematic and conceptual image, once established, was enshrined as virtually changeless; a divine gift that would be spoiled by any deviation from the norm. There

was just one notorious interlude in Egyptian dynastic history when the 'heretic' king called Akhenaten (1353–1335 BC) abruptly broke with convention, creating a new administrative centre at the site of Amarna and presiding over new styles of painting and sculpture. But this was a short-lived revolution. So to outside observers, one of the most amazing traits of Egyptian art remains its formal consistency over some 3000 years.

In fact, Egypt's iconographic stability was noted long ago – early in the fourth century BC – by the Greek philosopher Plato. Plato admired how the Egyptians had codified music with *kala schemata* (rightful rules), and approved a similar level of central control in the visual arts. 'If you go to Egypt and examine their paintings and reliefs, you'll find that work done 10,000 years ago – I mean it, literally – is no different from that of today. The artistry is just the same.' (Plato, *Laws* 656d) Plato has over-emphasized the timespan, but his impression would still be widely shared. The question then arises: how did the Egyptian artists achieve such steady, invariable results?

There is no surviving account from Egyptian sources about laws and customs governing the output of art. The finished products point to some prevalent method for maintaining relative proportions over a range of scale that ran from the miniature to the colossal. More clues, however, are to be found in work that was *not* finished.

A telling example of one such incomplete project is to be found in one of the several hundred known burial sites on the west bank of the Nile by Thebes (modern Luxor). This is the tomb-chapel of Ramose, who was governor of Thebes at the time (*c.* 1350 BC) when Akhenaten caused political and religious upheaval in Egypt. Not only was Ramose wealthy enough to commission a grandiose, pillared resting-place for himself, but he also had a useful family connection: his brother was chief of works at the royal capital of Memphis to the north. Outstanding craftsmen were evidently summoned to decorate the space with shallow reliefs and paintings. But, perhaps because of the abrupt change in regime, the tomb of Ramose at Thebes was left slightly unfinished.

The telltale marks are a number of fine red lines. These lines were evidently applied by dipping a length of string in red paint, stretching it taut by the tomb wall, and then twanging it against the plaster surface. Their purpose is clear enough. Regular horizontal and vertical spacings make up a grid on which images of the body were superimposed (*Fig. 24*).

Traces of similar guidelines have been found on other painted walls in Egypt (*Fig. 25*). And, of course, the grid can be retrospectively tried for size wherever images of the body

24 (above) An unfinished relief in the Tomb of Ramose, at Gurna, near Luxor, c.1350 BC, with the grid still apparent.

25 (above right) A detail of a figure in the Tomb of Tausert, in the Valley of the Kings, near Luxor, 12th century BC. Again the preliminary guidelines for the figure remain visible.

occur. Sure enough, a pattern emerges: figures shall be 19 squares tall … two squares are allowed for the face … the pupil of the eye shall be placed in one square off the central axis … ten squares are allowed from the neck to the knees, and six from the knees to the soles of the feet … the feet shall be two and a half squares in length – and so on. The absolute dimensions of the grid may shift over time, and some artists were less fastidious than others in keeping to the squares. But the principle of mapping figures by grids was generally established in Egyptian painting by *c.* 2000 BC, and the same principle applied to the making of statues, too – a network of lines etched on four sides of a block due to be carved into a human form. Discriminations of relative quality are not excluded by this system, but little is left to chance or artistic caprice.

The Egyptians, then, did not so much exaggerate their images of the human body as make a virtue of its sameness and predictability. It may be significant that the so-called Amarna period of Akhenaten's rule was marked by immediate signs of emphasis and distortion in pictures and statues, as if freedom to follow the peak-shift instinct had been suddenly indulged – though in fact the grid system was just altered, not banished (*Fig. 26*). But the methodical practices of the Egyptians – not only in painting and carving, but also in quarrying, dressing and transporting enormous blocks of stone – would exert a great influence upon the subsequent history of art in Europe and the West. It came through Egypt's connections with a people who can fairly be described as obsessed with the human body, in both art and life: the ancient Greeks.

EGYPT'S GIFT TO GREECE

The Egyptians – as noted, and well known – worshipped certain animals. Cats, crocodiles, cows – these were among the many creatures held in veneration, as they were, or incorporated into the nature of particular gods or goddesses. In the eyes of their Mediterranean neighbours, the Greeks, this zoomorphism seemed peculiar and fantastic, for the Greeks took quite a different view of divine manifestation. The Greeks were firmly and exclusively attached to the dogma of anthropomorphism – the belief that deities took human shape.

'Like a man in the bloom of his youth, lithe and powerful, with long hair streaming over his broad shoulders … ' – this was how one Greek god, Apollo, was invoked in a chorus composed *c.* 700 BC. The first known poets of archaic Greece, Hesiod and

Homer, readily envisaged the sun god Apollo and other supernatural powers not only assuming human shape, but even speaking and behaving in all too human ways. When Greeks went to the temples and sanctuaries deemed as the houses and precincts of these deities, it was in the expectation of encountering the divine presence. Apollo might be able to move 'swift as a thought', yet the idea of offering a prayer to an empty room was, for the Greeks, no less strange than bowing down before a hippopotamus. If Apollo was *there*, it ought to be possible to *see* him: to focus attention on some substantial image that matched the poetic invocation of the god.

This expectation put pressure upon Greek artists – sculptors, especially – to produce cult images. If that phrase evokes effigies veiled in smoke and incense, or jostled shoulder-high in loud processions, it may not be exact for the discreet idolatry enjoyed by Apollo and his fellow deities, for whom the quiet inner sanctum of a Greek temple was usually reserved, with sacrifices in honour of the god conducted at an altar outside. Nevertheless, pilgrims hoped to glimpse some semblance of the divine in residence, as it were. Such an image must be, above all, *credible*: as much a medium as a representation of supernatural power. In other words, Greek gods were not merely supposed to take human form; they should act the part, too – look lively with it.

The primary problem for Greek sculptors was one of size. Prior to the late seventh century BC, their work – mostly in clay and solid-cast bronze – remained small scale. There may have been some larger efforts using wood, but these have not survived. Excavations of Greek sanctuaries in their early phases – notably Olympia, where tradition has it that the athletic festival of the Olympic Games was founded in 776 BC – indicate a prolific use of figurines, but little more than figurines, fashioned in a simple geometric style. At Delphi, the mountainous site frequented by devotees who hoped to hear the very voice of Apollo, images of the god – or of those who sought his oracle – were made mostly in miniature (*Fig. 27*).

The technical leap to life size and over is unlikely to have come independently. But because the Greeks themselves did not like to admit external factors in the development of their art (preferring the invention of stories around a fabulously ingenious craftsman, Daidalos, to explain how various arts and crafts were born), we are forced to search for indirect clues. Fortunately, the Greeks' own 'father of history', Herodotus, has left us just the sort of detail we require. Herodotus compiled his *Histories* ('Inquiries') in the mid-fifth century BC; and, being the inquisitive sort, he devoted a considerable section

of his work to an exotic place he had visited and sought earnestly to understand – Egypt. In the course of reporting his own impressions of Egypt's remarkable monuments – including the pyramids at Giza, near modern Cairo – Herodotus tells us about how the Greeks first became acquainted with Egypt. There was, he relates, a certain exiled claimant to the Egyptian throne called Psammetichus. This Psammetichus received a prediction that he would gain power with help from mysterious 'men of bronze, arriving by sea'. Shortly afterwards, a number of Greek sailors – clad in bronze armour – were forced to disembark on Egypt's coast. Psammetichus promptly hired them as mercenaries, won control of the country, and then rewarded his Greek supporters with rights of residence and trade in the Nile delta. So, as Herodotus concludes, it was from the time of Pharaoh Psammetichus I, who came to power in 664 BC, that Greeks and Egyptians began to interact as never before (*Histories* 2.154). Can it be sheer coincidence that within a decade or so the first large-scale stone statues began to appear in Greece?

The circumstantial evidence for some exchange of artistic know-how is compelling. Commemorative images of pharaohs, scribes and other important individuals in the Egyptian hierarchy were widely on view to any traveller down the Nile (*Fig. 28*). In stance and attitude, these Egyptian monuments offered an impressive and exemplary model to Greek sculptors. The earliest Greek efforts at the full-sized male figures seem to copy from Egypt the striding left leg, and the clenched fists held at the side (*Fig. 29*). There are differences, of course, the most obvious being the Greek preference for nudity. But it looks likely that the stonemasonry skills that the Egyptians had practised for centuries were, during the second half of the seventh century, passed on to the Greeks. Tools, measuring devices, quarrying techniques and logistics of transport all belonged to Egypt's store of intellectual property.

The Greeks took what they needed. They had plentiful sources of marble, a stone just as dense and durable as Egyptian granite. More significantly, they had their own motives for undertaking the laborious task of cutting big blocks of marble and moving them around. Greek religion was like a bargain. The more you gave to the gods, the more you could expect by way of favours in return. Therefore, the presentation of a large and costly work of art in a hallowed place was a very good investment. Add to this the popular demand for lifelikeness, and it soon becomes clear why Greek sculptors so eagerly used Egyptian expertise to move from statuettes to statues. It also goes some way to accounting for the stylistic 'miracle' that ensued.

26 (left) A statue, probably of
Queen Nefertiti (wife of Akhenaten),
and probably from Amarna, c.1345 BC.
Akhenaten's rule was marked by
dramatically non-canonical art.

27 (above) A miniature bronze votive
statuette from Delphi, c. 630 BC.

 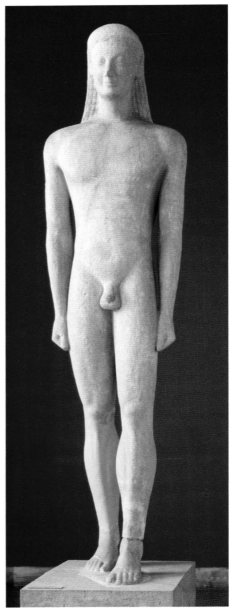

28 A colossal statue of Rameses II, at Luxor Temple, *c.*1400 BC.

29 A *kouros* figure from Melos, *c.*600 BC, clearly similar in stance to earlier Egyptian statues.

THE GREEK REVOLUTION

The Greeks may have borrowed heavily from Egypt in order to arrive at their first full-sized, free-standing figures. But the schematic principles of Egyptian practice were not transplanted. On the contrary: instead of working from grids and fixed mental images, Greek artists turned directly to the actual or intended subjects of their representation. Of course, not all these objects were visible. The poets could weave tales about many-headed monsters, but illustrating them remained a task for the imagination. But the gods on high, the heroes of the past, and contemporary patrons all shared the same essential form – that of the human body. To *represent* such subjects, to create a virtual reality with art, required Greek artists to depart from convention and use their eyes. So they did.

The Greek *kouroi*, the upright young men shown as if stepping forward, and smiling in their eagerness to advance, may truly be said – stylistically – never to stand still. At first, their bodies are mapped into basic patterns, with little regard for anatomical accuracy. But almost immediately there is development towards realism. Ears begin to look like ears, not curious curved objects attached to the side of the head. Instead of showing the upper body as a triangle containing certain ridges and grooves, sculptors began to locate clavicles and shoulder blades, abdomens and backbones. Each decade of this generic statue type – once thought to represent the god Apollo, but now understood to stand for any aristocratic would-be hero commemorated in his youthful prime – showed a further stage of similarity to actual human appearance. Within little more than a century, the artistic end was achieved: a sculpture of a man that looked like a man.

His eyes, made of glass paste for realistic effect, have dropped out. His head and body were found separately, and some parts of the body have never been found. Also, his surface paintwork that once gave him a healthy outdoor tan has disappeared, so he is not as natural as he once was. All the same, here is the ultimate *kouros*: a marble statue dedicated on the Acropolis, a great sanctuary overlooking the city of Athens. The young man is anonymous; the statue known only as 'Kritian Boy' (*Fig. 30*).

Kritian Boy gives us the effect of what has been hailed as the 'Greek Revolution'. The youth projects himself with a demure yet confident air: he wants to be admired, as well he might, because not only is the viewer inclined to think, 'What a wonderful body', but also because the artistry here gives us such direct visual access. It all seems so natural: flesh stretched taut over muscle and bone; one leg relaxed, the other assuming

the balance of weight; vertebrae forming a gentle curve; kneecaps and ribcage causing contours we can recognize. There is nothing schematic or conceptual about Kritian Boy. This is how we are: the human body at last 'discovered' in a work of art.

POLYKLEITOS AND THE PERFECT PHYSIQUE

The Greek word *gymnos* means 'unclothed', and no Greek city was complete if it lacked a gymnasium, literally 'a place to be without clothes'. The institutional centrality of exercising unclothed was one of the defining aspects of Greek culture. The Greeks were highly conscious, too, that their custom of competing unclothed at athletic festivals was peculiar to them – a custom that 'barbarians' or non-Greeks might regard as shocking. This nudity habit was, however, all the more visible for being culturally distinctive. At the Olympic Games – which, before the Macedonian and Roman conquest of Greece, were strictly confined to competitors of Greek ('Hellenic') ethnic origin – athletes who had triumphed without their clothes on were ostentatiously commemorated in that way, so victory statues proliferated. Some showed the athlete crowning himself with the garland of triumph; others, such as the well-known image of an all-rounder especially remembered for his discus-throwing, attempted to catch the dynamic effort that brought glory.

There was no shortage of victory occasions, so an artist could make a very good living from the production of commemorative pieces. One fifth-century BC Greek sculptor who supplied the demand for athletic statues at Olympia and elsewhere was Polykleitos, who took his work seriously – so seriously, it seems, that he came to regard the artist's role in defining a prize-winning body as equally important, if not more so, to that of the trainer in the gymnasium or wrestling-school.

Polykleitos aspired to make art a branch of geometry. He wrote a treatise about how to represent the ideal physique in bronze or stone, using a system of mathematical calculations. All we know about the details of this lost text by Polykleitos amounts to a few frustratingly enigmatic phrases cited in ancient literature, such as 'Beauty comes about from many numbers'. No statue has yet been found that can be confidently called an original work by this artist. However, a fair notion of the Polykleitan project can be gained from the many copies or adaptations taken from his original bronze-cast pieces. Men, boys, women – it seems the measuring-system devised by Polykleitos was flexible

THE BEAUTY OF KRITIAN BOY

IT WAS THE distinguished British art historian Sir – later, Lord – Kenneth Clark (1903–83) who, in one of his most engaging books, *The Nude*, handed Kritian Boy the absolute accolade of being 'the first beautiful nude in art'. We may not agree with such a generous verdict, but we can be sure that for ancient viewers this statue embodied a potent ideal of male beauty. Although Kritian Boy is not what we might understand as a portrait, it is probable that he represents an individual youth in his mid-teens who had been victorious at the Panathenaic Games – a regular festival at Athens, involving various physical contests. With his diaphragm filled, the figure may well be that of a sprinter, whose passing success has been caught forever in marble. But the very poise of Kritian Boy displays a winning body as esteemed by prevalent social and erotic values. In early fifth-century BC Athens there was no shame attached to pederasty, the custom of older men courting teenage boys for friendship and sexual favours. So one competition at the Panathenaic festival was simply a sort of beauty parade – a challenge to see who exhibited most of what the ancient Greeks termed *euandria* (fine manliness). All the evidence suggests a culture in which the most desirable male body – to men and women alike – came in the shape of a successful all-round athlete.

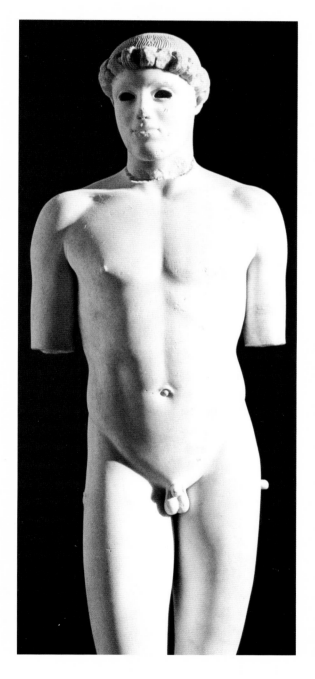

30 Kritian Boy, from the Acropolis of Athens, c. 490 BC. The scale is slightly under life size.

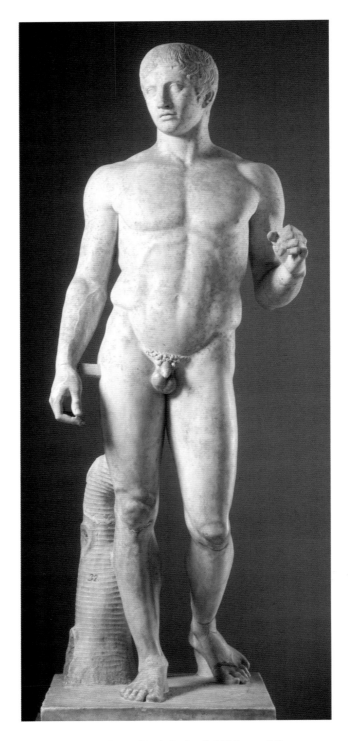

31 *Doryphoros* or 'Spear Carrier', after Polykleitos, c. 440 BC.

insofar as it could accommodate variations of both age and gender in human form. However, there was little range in the shape or *schema* of an aesthetically successful body as prescribed in the so-called *Kanon* of Polykleitos. The Greek word *kanon* gives us our 'canonical', which implies a standard to be respected, a central point of authority. If copies from the output of Polykleitos illustrate his rules (one work, the *Doryphoros* or 'Spear Carrier', is usually reckoned as constructed according to the sculptor's *Kanon*), then it is clear enough that 'aesthetically successful' in Polykleitan terms means a body dominated by qualities of tautness, symmetry and balance. A harmony of parts was what Polykleitos appears to have sought and articulated in solid form (*Fig. 31*). It was as if he created a series of theoretical rods passing through key points of the body. For example, if one knee was low and relaxed, then a rise and tautness must be caused across the axis of the opposing hips and legs. The effect of this system was to establish what must technically be known as a 'chiastic balance' – from the Greek *chiasmos*, implying diagonal tension – or, in Italian, as *contrapposto*: a matching of physical forces in human gait and posture.

For young men, the pressure to aspire towards a more or less predictable Polykleitan formula – broad shoulders, contoured thorax, firm waist, powerful thighs – was onerous. It was literally cast as a norm by one Classical sculptor after another. But was it an attainable ideal?

THE RIACE BRONZES: 'MORE HUMAN THAN HUMAN'

In August 1972 a scuba-diver exploring the coastal waters off Riace, near Reggio in Calabria, the southernmost province of Italy, made what he at first thought to be a horrifying discovery. A human hand was reaching out from the seabed about 9 metres (30 feet) below. Could it belong to some half-buried corpse? The diver, Stefano Mariottini, plunged down to investigate. To his immediate relief, the hand was made of bronze, and to his amazement, he realized that the hand was part of a statue – and this statue was not alone. Another figure, no less lifelike, lay encrusted in the sand nearby.

Brought to the surface, cleaned and now permanently displayed in Reggio's archaeological museum, these are the 'Riace Bronzes' – a pair of Greek statues probably made *c.* 450 BC. The most likely explanation as to how they came to be submerged in the straits between Calabria and the island of Sicily is that some ancient Roman connoisseur

APHRODITE AND THE BIRTH
OF THE FEMALE NUDE

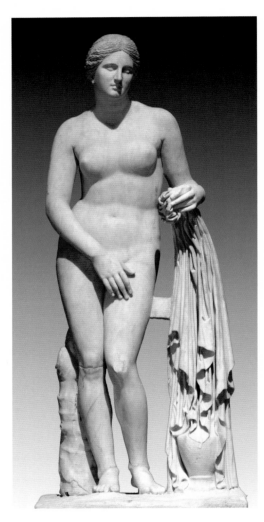

32 (above) Roman copy, c.180 AD, of Praxiteles'
Aphrodite of Knidos, c.350/340 BC.

33 (opposite) *Venus of Urbino* by Titian, c.1538.

WHY WAS THE Venus of Willendorf called
'Venus' by those who found her? Simply
because she is a woman without clothes, a female
nude; and the archetypal female nude is Venus, who
in turn equates to the ancient Greek goddess of
love, Aphrodite. This chapter has indicated how and
why the Greeks constructed the male nude as an
embodiment of athletic prowess, military valour, epic
heroism, ethical virtue and even mathematical
harmony. So what was embodied in their creation of
the female nude? Pornography is a word with roots
in ancient Greek. *Porne* means prostitute; *graphein*,
to depict or describe. 'Prostitute description' will
not equate to all that modern usage implies by
'pornography'. But the moral delicacy of 'the nude' as
a category in Western art can only be understood
by considering its ancient origins.

Fertility goddesses, some with proportions akin to
those of the Willendorf Venus, others clearly pregnant,
are known from various Neolithic and Bronze Age
sites in Anatolia and around the Mediterranean.
More specific is the identity of the Phoenician
goddess Astarte, whose cult from c.1300 BC seems
to have involved some kind of 'sacred prostitution' –
temples staffed by women serving as 'priestesses',
whose bodies offered 'union' with Astarte. Images
of Astarte are sexually explicit, and may have
influenced the eventually 'shocking' representation
of Astarte's Greek equivalent, Aphrodite.

Was it so much of a shock? Only copies survive
of an original marble statue made by the Greek
sculptor Praxiteles around 360 BC (*Fig. 32*). The story
is that Praxiteles produced two images of the Greek
goddess of love at the request of the citizens of the
island of Kos. One was draped, the other nude.

The people of Kos chose the former. It was a nearby Greek colony, Knidos, on the Asian mainland, that made a bid for the undressed Aphrodite – or, more precisely, the figure of Aphrodite espied while taking a bath. This became notorious around the Mediterranean. In Roman imperial times, we are told, boatloads of tourists went to Knidos with the prime purpose of sharing the sight. A special circular temple was constructed, allowing visitors a front or rear view according to their erotic preferences; bushes and couches were made available in the sacred enclosure for those wishing to perform 'Aphrodite's business'. One boy committed suicide after ejaculating over the statue. But the notoriety of the piece did not stem just from its implied artistic audaciousness in representing a female deity without clothes. Greater offence was caused by the rumour

that Praxiteles had used as a model his own mistress, a well-known courtesan called Phryne. This was the same woman who, when brought before an Athenian court on charges of impropriety, gained acquittal simply by exposing her breasts to the jury. Could *she* – a mortal, for all her charms – be the icon of Aphrodite?

Whatever the original issues of taboo and transgression, this statue had a lasting influence in the Western tradition of art (*Fig. 33*). The Aphrodite of Knidos makes a gesture with her hand, as if to cover her clitoris. But the move to hide the *pudenda* – a Latin word meaning 'those things of which we should be ashamed' – serves also to draw attention to that area of the body, making the gesture utterly counterproductive, and furthering the thrill of some voyeuristic intrusion upon personal privacy.

of Greek art – perhaps an emperor such as Nero – once intended them to grace the walkways of his villa or palace. The vessel transporting the statues had foundered, and they were not salvaged until espied by Stefano Mariottini on his summer vacation.

Modern connoisseurs cannot agree which great name of Classical Greek sculpture may have produced the Riace Bronzes. One suggestion is Pheidias, mastermind behind the decoration of the Parthenon temple on the Athenian Acropolis. Another is Myron, whose 'Discus Thrower' was admired and copied by the Romans. A further candidate is Polykleitos, also highly popular with Roman collectors. The problem is that while Greek sculptors of the fifth (and fourth) century BC preferred hollow-cast bronze as a medium for free-standing statues, very few such statues have survived. (Ancient descriptions of the site of Olympia, for example, indicate that the sanctuary was once congested with gleaming brazen images, but later predators broke them up and melted them down.) For the Riace pair, therefore, the name of the artist remains as elusive as the identity of the statues – rather disappointingly known only as 'Statue A' and 'Statue B'. Statue B once wore a tipped-up helmet on his head; both figures evidently carried large round shields, and weapons too.

Relaxed in stance, and with their lips slightly apart – as if conversing or taking breath – the Riace Bronzes appear at first glance to be perfectly realistic. They have been planted very firmly on their bases in the Reggio museum (for fear of earthquakes), yet they seem light on their feet, tall but not ponderous. The veins on their arms and hands are unnervingly subtle and 'alive', a delicate feature of ancient bronzeworking technique, the accomplishment of which is judged by some modern practitioners to be unattainable today (*Fig. 34*). But on closer scrutiny, the impression of absolute naturalism begins to fade. It was Protagoras, a Greek philosopher of the mid-fifth century BC, who insisted that 'man is the measure of all things'. But is *man* the measure of the Riace Bronzes, or have these statues gained their form as a result of many calculations: measurements taken to extremes?

In fact, neither of the Riace Bronzes is anatomically correct. One of them – Statue A – has been deemed almost hermaphrodite: his pronounced backside, according to expert analysis, is more like a woman's. But both statues exhibit departures from normal human

34 Detail of one of the Riace Bronzes (Statue A), the delicate veins clearly visible on the arm and hand.

35 A curvaceous *yakshi* figure, in the Great Stupa of Sanchi, central India, *c.* 50–25 BC.

resemblance. No one, however athletic, will ever look this way. The division between upper and lower body has been emphasized by raising the edge of the so-called iliac crest, a band of muscle and ligament that most men fail to find on themselves. At the front of the body this contour may not be anatomically impossible, but its continuation around the back is so powerful as to strain belief. The suspicion dawns that what matters here is not faithfulness to reality, but geometric symmetry. An implausibly deep groove runs up the centre of the chest. The length of the legs has been extended to match the length of the upper body. The muscles of the back are tense and over-defined. And as for the channel of the vertebrae – not only is it deeper than would ever be seen on an ordinary mortal, but it descends into the cleft of the buttocks with no interruption from a coccyx, the bone at the base of the spine that helps us to sit down (*Fig. 1, page 2*).

In other words, the Riace Bronzes display exaggerated specifications of the human body; a further case, then, of peak shift.

EXAGGERATION RULES

'Human kind,' in the words of the poet T.S. Eliot, 'cannot bear very much reality.' That observation may be enough to account for the peak-shift principle, or make a case for people liking to 'accentuate the positive'. Either way, the human trait of distorting images of the body seems to be pervasive in many cultures, and recurrent across many centuries. In most contexts it is simply the image that is distorted, such as the *yakshi* figure curvaceously symbolizing wealth and fertility in the bracket of a Buddhist shrine (*Fig. 35*). Where bodily beauty has become a commodity, direct means of exaggerating personal appearance may be marketed, to the extent of cosmetic surgery offering a virtual sculpture of the flesh. The tendency for exaggeration, to create bodies 'more human than human', is very much alive. What began with the Venus of Willendorf is not just a thing of the past.

PORTRAITS AND CARICATURE

'THE MIRROR is the master of painters,' according to Leonardo da Vinci. But is it? The various portraits assembled here suggests that a version of the peak-shift principle is at work whenever artists successfully produce a specific 'likeness' of human individuality. To put it another way, distortion is part of the portrait-making process, and is, for some artists — for example, the twentieth-century British painter Francis Bacon — paradoxically the only way of getting a 'truthful' record of appearance.

36 (below) *Sixteen Grotesque Heads* by Leonardo da Vinci, from the 16th century. We are told that whenever Leonardo spotted *teste bizarre* (fantastic heads) in the streets, he would follow them, memorizing their features. Nevertheless, an element of caricature is embedded in these and many other portrayals (notably of warriors) by Leonardo, and seems to express his belief — exemplified in the 'character studies' of the 12 disciples in his Milan fresco, *The Last Supper* — that physiognomy was indicative of sentiments and character. (Our concept 'personality' derives, significantly, from *persona*, the Latin word that originally entailed a theatrical mask.)

37 (above) A fleeting supercilious look transfixed, or an enigmatic, meditated composition? This painting of 1476 by Antonello da Messina, entitled simply *Portrait of a Man*, combines both aspects of portraiture, and so reminds us that a portrait is not a copy, but has a life of its own. The successful portrait conveys 'an increase of being'. The painter (or photographer or sculptor) does more than hold up a mirror. What is represented is not only what can be seen at a glance, but gathers — as has been said of this particular portrait — 'the feeling of a human monument'.

38 (above right) Polynesian sculpture typically isolates the head of a figure as the seat of personality or *mana* (spirit). This colossal image of the Hawaiian god of war, Kukailimoku, from Hawaii, c. 1800, goes further, by incorporating facial gestures of aggressive disrespect: pronounced frown, wide grimacing mouth and jutting chin. But it is not necessary to be a local believer in Kukailimoku to interpret this as a mask of intimidation. In 1872 Charles Darwin showed that expressions of emotion — especially facial expressions — were universal to humans around the world. These expressions commonly caused distortion of the face, and, as Darwin pointed out, 'reveal the thoughts and intentions of others more truly than do words, which may be falsified'.

4
ONCE
UPON A
TIME

... THERE WAS A STORY.

It was told, we suppose, to people crouched around a fire: a tale of adventure, most likely – relating some close encounter with death; a remarkable hunt, an escape from mortal danger; a vision, or something else out of the ordinary. Whatever its thread, the weaving of this story was done with a prime purpose. The listeners must be kept listening. They must not fall asleep. So, as the story went on, its audience should be sustained by one question above all. *What happens next?*

The first fireside stories in human history can never be known. They were kept in the heads of those who told them. This method of storage is not necessarily inefficient. From documented oral traditions in Australia, the Balkans and other parts of the world we know that specialized storytellers and poets can recite from memory literally thousands of lines, in verse or prose, verbatim – word for word. But while memory is rightly considered an art in itself, it is clear that a primary purpose of making symbols is to have a system of reminders or mnemonic cues – signs that assist us to recall certain information in the mind's eye.

In some Polynesian communities a notched memory stick may help to guide a storyteller through successive stages of recitation. But in other parts of the world, the

activity of storytelling historically resulted in the development or even the invention of writing systems. One theory about the arrival of literacy in ancient Greece, for example, argues that the epic tales about the Trojan War and the wanderings of Odysseus – traditionally attributed to Homer, a blind Ionian bard of the eighth century BC – were just *so* enchanting to hear that they had to be preserved. So the Greeks, *c.* 750–700 BC, borrowed an alphabet from their neighbours in the eastern Mediterranean, the Phoenicians. A full text of Homer's verse was not established until over a century later; meanwhile, at least snatches of his matchless oral expressions could be inscribed on clay and stone.

The custom of recording stories on parchment and other materials can be traced in many manifestations around the world, from the priestly papyrus archives of ancient Egypt to the birch-bark scrolls on which the North American Ojibway Indians set down their creation-myth. It is a well-tried and universal practice: so much so that to this day storytime is probably most often associated with words on paper. The French word for a narrative is *récit*, implying some oral delivery, and our conversations may be full of stories; but the formal practice of narrating a story aloud would seem – so we assume – to have given way to newspapers, novels and comic strips. This, however, is not the case. Statistically it is doubtful that the majority of humans currently rely upon the written word to get access to stories. So what is the alternative source?

Each year, over 7 billion people across the world will go to watch the latest offering from Hollywood, Bollywood and beyond. It means leaving their homes to sit with many others in a darkened room; yet they go. This is what prevails: not one voice by cosy firelight, but numerous sounds and images projected on to a big screen. The supreme storyteller of today is cinema. In 1948 a French critic prophesied that cinema would develop into 'a means of writing just as flexible and subtle as written language'. Even the author of a book – albeit a book commissioned to accompany a television series – must concede that prediction to be fulfilled.

It was in 1895 that the Lumière brothers of France put on the first shows of 'motion pictures' using a device called the cinematograph. The *movies*, as distinct from still photography, seem to be an essentially modern phenomenon. This is an illusion, for there are, as we shall see, certain ways in which the medium of film is indebted to very old precedents of arranging 'sequences' of images. Those precedents will become evident in the course of this chapter. But any account of visual storytelling must begin with the recognition that *all* storytelling beats with a deeply atavistic pulse: that is, a 'good story'

relies upon formal patterns of plot and characterization that have been embedded in the practice of storytelling over many generations.

Thousands of scripts arrive every week at the offices of the major film studios. Each one is loaded with the hope of becoming the next big box-office hit. Specialized courses are offered by experts in the field (such as Robert McKee) to assist in achieving that dream. But aspiring screenwriters really need look no further for essential advice than the fourth-century BC Greek philosopher Aristotle. He left some incomplete lecture notes on the art of telling stories in various literary and dramatic modes, a slim volume known as *The Poetics*. Though he can never have envisaged the popcorn-fuelled actuality of a multiplex cinema, Aristotle is almost prescient about the key elements required to get the crowds flocking to such a cultural hub. Critics and directors often reach for the language of sorcery to describe what happens with successful storytelling – a film is 'spellbinding', or contains 'magic moments' – but Aristotle analysed the process with cool rationalism. When a story enchants us, we lose the sense of where we are; we are drawn into the story so thoroughly that we forget it is a story being told. This is, in Aristotle's phrase, 'the suspension of disbelief'.

We know the feeling. If ever we have stayed in our seats, stunned with grief, as the credits roll by, or for days after seeing that vivid evocation of horror have been nervous about taking a shower at home, then we have suspended disbelief. We have been caught, or captivated, in the storyteller's web. Did it all really happen? We really thought so – for a while.

Aristotle must have witnessed often enough this suspension of disbelief. He taught at Athens, the city where theatre developed as a primary form of civic ritual and recreation. Two theatrical types of storytelling, tragedy and comedy, caused Athenian audiences to lose themselves in sadness and laughter respectively. Tragedy, for Aristotle, was particularly potent in its capacity to enlist and then purge the emotions of those watching the story unfold on the stage, so he tried to identify those factors in the storyteller's art that brought about such engagement. He had, as an obvious sample for analysis, not only the fifth-century BC masterpieces of Classical Greek tragedy written by Aeschylus, Sophocles and Euripides. Beyond them stood Homer, whose stories even then had canonical status: *The Iliad* and *The Odyssey* were already considered literary landmarks – stories by which all other stories should be measured. So what was the secret of Homer's narrative art?

AN ESSENTIAL STOCK OF STORIES?

'THE WORLD'S stories are innumerable. To begin with, there is such a prodigious variety of story types, each diffused in different forms – as if any material were useful to mankind in the making of stories. A story can be carried by articulate language, spoken or written; by images, still or moving; by gestures, or by an ordered combination of all these. A story is present in myth, legend, fable, tale, novel, epic, history, tragedy, drama, comedy, pantomime, painted tableau … stained glass, cinema, comics, daily news and conversation. And more: within these almost infinite forms, the story exists at all times, in all places, amid all societies. Storytelling starts with human history itself; there is not, nor has there ever been, anywhere, a group of people without stories … international, transhistorical, across all cultures, storytelling is just *there* – a part of life.'

This eminently quotable declaration comes from the French theorist Roland Barthes (1915–80). The activity of storytelling – or 'narrative', as the French *récit* is often translated – is, he observes, a basic element of human coexistence. The narrative theory Barthes proceeded to develop from this premise is termed 'Structuralist'. For Barthes belonged to an intellectual camaraderie, based in Paris, whose various members (including the anthropologist Claude Lévi-Strauss and the historian Michel Foucault) were united in the belief that structures of nature, language, society, psychology and so on ultimately determine how individuals think and act. We may not be aware of those structures underpinning and overarching our lives; but they are there all the same. So stories may be prolific beyond counting, and pervasive around the globe, but there will be recurrent patterns to these stories, imposed by structures that lie far beyond individual control.

It was Lévi-Strauss who sought to prove, from research among ancient storytelling traditions in North and South America, that myths and rites are generated from a primal human craving to impose order upon the world. He was also preoccupied by the power of myth to operate in human minds at a covert or subconscious level. The desire for order may have been, in his phrase, a characteristic of 'primitive thinking', but its persistence was yet to be felt.

Another influential intellect of the twentieth century, the Swiss psychologist Carl Jung (1875–1961), theorized the existence of a 'collective unconscious' – a worldwide reservoir of archetypal symbols and stories in which all human minds might find echoes of their own dreams or experience. But at a popular level, no one has done more to define the recurrent and cross-cultural power of myth than Joseph Campbell (1904–87), whose books – most notably *The Hero with a Thousand Faces* (1948) – have been all the more effective for their permeation of the Hollywood scriptwriters' world. For Campbell, there exist throughout the many local myths and stories of the world certain pervasive patterns of action: for example, an abandoned child who eventually claims great power; or the hero whose journey takes him through various tests and setbacks before finding self-knowledge. Campbell himself was disdainful of the cinema, but a number of successful film directors (especially George Lucas, maker of the *Star Wars* trilogy, and his collaborator on the *Indiana Jones* series, Steven Spielberg) acknowledge Campbell's doctrine that myth is primal, coherent, and all-explanatory, and the basis of every great movie (*Fig. 39*).

39 Harrison Ford as Indiana Jones in *Raiders of the Lost Ark* (1981), directed by Steven Spielberg.

It was not hard to find. Homer created credible heroes. His heroes belonged to the past, they were mighty and magnificent, yet they were not, in the end, fantasy figures. Homer reported the speech of Achilles, Agamemnon, Ajax, Hector, Odysseus and the rest as if he had heard it himself. He made his heroes sulk, bicker, cheat and cry. They were, in short, characters – protagonists of a story that an audience would care about, would want to follow, would want to know what happens next. As Aristotle saw, the hero who shows a human side – some flaw or weakness to which mortals are prone – is intrinsically dramatic.

'Hero' comes from a Greek word (*heros*) with certain venerable overtones in antiquity. But we would not be totally unjustified in rendering this status in the jargon of the movies, and saying that Aristotle recognized the key importance of a *lead role*.

While he may be credited with such foresight, what Aristotle did not know – or did not care to admit – was that the first hero-driven story did not arise with Homer. It came from a long way eastwards – and from a long time previously. Our mission to discover the origins of film's ultimate storytelling power must therefore make that journey, to the ancient land contained between the rivers Tigris and Euphrates – Mesopotamia.

GILGAMESH: THE WORLD'S FIRST HERO

Its name in the Bible is Erech. The people of present-day Iraq know it better as Warka. Collective memory prefers Uruk. All refer to a ruin roughly halfway between the urban sprawls of Baghdad and Basra – one of the world's oldest cities, and a site known mainly in association with the world's original hero, Gilgamesh.

There are the relics of a ziggurat at Uruk, and the foundations of several scattered temples in the sand. Along with Ur (further south), Uruk was a principal centre of the kingdom of Sumer, later known as Babylonia. Although only traces remain of an 8-kilometre (5-mile) circumference of walls, and visitors today find little to impress (*Fig. 40*), it is not absurd to claim that when Gilgamesh ruled over the city some 5000 years ago, Uruk was the prototype of urban design, raised high with kiln-fired bricks.

Many levels of occupation have been archaeologically identified at Uruk. What was found at the fourth of these levels, dating to *c.* 3200 BC, is of particular significance: a number of clay tablets that appear to constitute the earliest evidence anywhere in the world for the symbolic system we call writing. These first signs from Uruk are, admittedly,

more like pictures than words: a 'script of things', in which abbreviations of form are used to denote a certain object (an ox-head, for example, means an ox). But at Uruk and other Sumerian cities we soon find symbols evolving by the power of association: the image of a sun denoting the concepts of 'day' and 'brightness', or the image of a foot used to show the activity of walking. A third stage of development sees symbols given phonetic value, and set down in cuneiform (wedge-shaped) letters.

Cuneiform is the key to civilization in Mesopotamia, and further afield, because it was a system of writing that travelled. A version of cuneiform served, for example, the Hittites who dominated Anatolia (modern Turkey) in the late second millennium BC; later, a similar script was useful in the empire of the Medes and Persians, based in the deserts of what is now Iran (see page 168). This diffusion of cuneiform helps to explain why a tale about just one king of Uruk was not a piece of local history, but an enduring and archetypal myth.

The legend of Gilgamesh is extremely old, yet quite literally dynamic: an epic poem that is still growing as new fragments of cuneiform text come to light. Nevertheless, an essential storyline can be summarized. It goes like this.

Gilgamesh is the arrogant young overlord of the city of Uruk. Semi-divine by birth, imposing to behold, he rules Uruk by fear, greedily asserting his royal privilege to have sex with every new bride on her wedding night. His tyrannized subjects appeal to the gods above. The divine response is to create from clay the creature called Enkidu – hairy, uncouth, reared with gazelles in the wild grasslands. Enkidu comes to Uruk and challenges Gilgamesh. Their fight shakes the city, but is soon halted; they become close friends. Then Gilgamesh persuades Enkidu to join him on an expedition to the cedar forests of Lebanon. The precious timber is guarded by Humbaba, a fearsome monster. Hand in hand, the heroes set off to acquire glory by slaying Humbaba. They do so, decapitating the ogre. On their triumphant return to Uruk, Gilgamesh angers the goddess Ishtar by refusing her advances. Ishtar sends the Bull of Heaven to punish him, and again Gilgamesh unites with Enkidu to slaughter the beast. But sadness ensues. Enkidu dreams of his own end, falls sick and wastes away to a miserable death. Gilgamesh grieves over his friend for a week, refusing to give the body up for burial till a maggot crawls from Enkidu's nose. He stages a generous funeral; then, oppressed by the prospect of mortality, the king wanders away from Uruk to search for the secret of eternal life. Eventually he reaches the distant abode of Utnapishtim, 'Finder of Life', who

had survived the Great Flood by building an ark and loading it with all living creatures. Utnapishtim immediately challenges Gilgamesh to go a week without sleeping. If he cannot defeat sleep, how much more unlikely is it that he will overcome death? But Utnapishtim does disclose that there is a 'plant of heartbeat' growing on the ocean floor. Gilgamesh dives to fetch this coral wand, but is soon robbed of his prize by a snake. At last he realizes there is no hope. He was born to die, like his friend Enkidu. Disconsolate, he trudges back to Uruk. The walls are high; the city's expanse is great. So it ends for Gilgamesh. Are these, the bricks of his kingdom, the hero's sole claim upon posterity?

Gilgamesh the king is left in despair: he has failed to secure life everlasting. Yet Gilgamesh the hero lives on.

> He is Gilgamesh, perfect in splendour,
> Who opened up passes in the mountains,
> Who could dig pits even in the mountainside,
> Who crossed the ocean, the broad seas, as far as the sunrise,
> Who inspected the edges of the world …
> There is no one among the kings of teeming humanity
> Who can compare with him …

The poetry of *Gilgamesh* sings of a reputation that must defy oblivion; and it is the poetry, not the brickwork of Uruk, that has kept the hero's mightiness intact. Even incidental episodes within the story – such as the swift, impromptu slaying of lions by a Gilgamesh still furious with grief, tersely related in Tablet 9 of the established text – have become emblematic. So in later imagery from Mesopotamia and the Near East the 'Gilgamesh motif' signifies a regal figure firmly dispatching a pair of beasts, usually lions (*Fig. 41*). Do such images qualify as illustrations of the story? Some scholars are unhappy at linking them with Gilgamesh at all. But another site from Mesopotamia gives us direct evidence of how the story of Gilgamesh became a classic in the region. It may be no coincidence that the same site offers generous evidence, too, of how ancient artists tackled the various problems of presenting or representing a story in which images, not words, do most of the work.

How this site was found is, needless to say, a story in itself.

40 (above) View of Uruk as it looks today.

41 (left) 'The Gilgamesh Motif', c. 400 BC, showing a bearded hero mastering a pair of lions.

'GILGAMESH II': THE RELIEFS OF ASHURBANIPAL

For many centuries, the hill called Koyunjik was simply a mound on the east bank of the River Tigris, opposite the Iraqi city of Mosul. As a long-standing place of pasture (the name means 'many lambs'), Koyunjik seemed nothing more than contours in the landscape. But on 20 December 1853, by the light of the moon, gangs of men began to dig trenches in the northern part of the hill. They worked nocturnally because full permission to do so had not yet come through. No one knew for sure what might lie underneath, but the leader of excavations, Hormuzd Rassam, had a hunch that something would be found. At dawn the digging ceased, to resume the following night. This time fragments of a wall appeared, along with further debris from a grand building that had been deliberately destroyed. Then, on the third evening, the shout went up that *sooar* (images) had been found. The images belonged to a marble panel carved in low relief. They showed a kingly figure wearing a high peaked hat gathering weapons from assistants while mounting a chariot. The team of horses pulling the chariot were to be seen there too, being harnessed by royal stablehands. It soon became clear what was represented on this stone. These were the preparations for a ceremonial lion hunt, and they featured a ruler who boasted that he was 'Lord of the Universe'. Hormuzd Rassam had uncovered one of the great secrets lying beneath the hill of Koyunjik. This was the palace of Ashurbanipal, the most illustrious of all the kings of ancient Assyria.

The discovery of this once-magnificent residence came at a time of great popular and academic excitement about Assyria, the kingdom that dominated the upper reaches of Mesopotamia from *c.* 1900 BC until its downfall *c.* 612 BC. Old Testament writers knew about this empire from its hostile incursions into Hebrew lands; ancient Greek and Roman historians were also aware of its former glory, probably basing their semi-mythical figure of Sardanapalus – a caricature of the 'Oriental despot', excessive in both his wealth and his cruelty – upon Ashurbanipal, who ruled from 668–627 BC. But Assyria's collapse into dust had been dramatic. In the early nineteenth century the English poet Lord Byron could fantasize about the debaucheries of Sardanapalus, and imagine an Assyrian chief who 'came down like the wolf on the fold', but almost nothing was known then about the topography and archaeology of Assyria. Substantial discoveries came only in the 1840s, with a number of European enthusiasts, among them Rassam's friend and mentor Austen Henry Layard. Layard was an eloquent writer and

adroit at popularizing his researches at Nineveh and other Assyrian sites. Many of the Victorian public had heard of Nineveh from the Bible story of Jonah, the Hebrew prophet. (Nineveh was the 'wicked' city that Jonah was trying not to reach by sea when he was thrown overboard and swallowed by a whale.) Thanks to Layard, they were able to view a fully reconstructed 'Nineveh Court' at London's Great Exhibition of 1851 – prefiguring the modern resort to computer graphics.

Probed by Layard, the southern section of Koyunjik had already yielded the remains of the palace of Sennacherib, Ashurbanipal's grandfather, who monumentalized Nineveh during his reign (704–681 BC). Following the example of his royal predecessors, Sennacherib had adorned his 'unrivalled residence' with bas-reliefs illustrating his grandiose exploits – notably the siege and sacking of the Judaean city of Lachish – which Layard had transferred to the British Museum. It therefore came as no surprise that Ashurbanipal's palace should likewise be decorated with scenes defining *his* absolute power. But Rassam's consignment of finds to the British Museum was nonetheless exceptional, for the excavated contents of Ashurbanipal's headquarters included something unique: the remains of the king's library. It had been wrecked when the Medes and Babylonians laid waste to Nineveh in 612 BC. However, among the thousands of fragments of cuneiform tablets were several complete versions of a story that Ashurbanipal evidently held dear: the epic of Gilgamesh. In fact, Ashurbanipal may be said to have saved the Gilgamesh tale. Without the complete copies he commissioned for his library, we should have a very imperfect knowledge of the text.

It is presuming too much to claim that Ashurbanipal saw himself as a second Gilgamesh. Yet visitors to his palace could hardly have failed to notice the symbolic similarities that were made between the present glorious ruler of Nineveh and the legendary king of Uruk. True, the reliefs installed along the palatial corridors and around reception rooms were thematically in keeping with Assyrian royal iconography as established by the forebears of Ashurbanipal: it was not radically new to show the king dispatching lions, receiving tribute from other potentates, or in company with the winged beasts who are his supernatural bodyguard (*Fig. 42*). But Ashurbanipal's artists elaborated on these themes with innovative energy and a flair for making stock scenes come alive as never before.

We are immediately struck by this flair when we gaze on the various representations of Ashurbanipal as the dauntless lion-slayer. Beyond any emulation of Gilgamesh, there

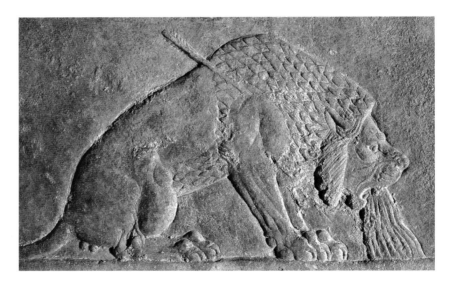

42 (top) Relief from the reign of Ashurnasirpal II, 883–59 BC. Ashurnasirpal's great palace at Nimrud was first excavated by Layard in 1845–51. The lion hunt had already become part of Assyrian royal iconography.

43 (above) A detail of the lion-hunt scene from the palace of Ashurbanipal at Nineveh, c. 650 BC. The lion is clearly in distress and its death throes are accurately recorded.

are further symbolic elements here – the king asserting his mastery over the 'king of the beasts', the king keeping his subjects safe from a predator (lions were still part of the local fauna when Layard was in Iraq). Yet the sculptors have not contented themselves with formulaic motifs. There is a strong sense of 'documentary' realism here. We are shown, quite candidly, how Ashurbanipal conducted his sport. It seems to take place in some kind of park: above this enclosure, at a safe distance and height, spectators are gathered, some of them with picnics. The prey is brought in a cage to its hunter. A minion on top of the cage releases lions in the king's direction, before shutting himself into a smaller, self-protective cage. Guards with large dogs stand at the edge of the enclosure, ready to block any big-cat escape. The king is mounted on a chariot, ready to shoot with his bow. Supplied with arrows by beardless eunuchs nearby, he can hardly miss. But there is no shortage of drama as recorded on the reliefs. One of the loosened lions seems nearly upon Ashurbanipal and his shield-man, as the darts are fired, although attendants with spears may hold a lion at bay, the kill is reserved for the king. Another lion is caught in the motion of leaping, using a 'freeze-frame' technique that anticipates animated cartoons; the lion is shown at three moments of action, before being caught by an arrow in mid-flight.

All of this looks acutely observed. If the artists did not feel some empathy with the victims of the hunt, they at least recorded the throes of wounding and death in the spirit of pathological diagnosis. We see a lioness hit by three arrows. At least one bolt has entered her spine, and accordingly caused paralysis of the lower limbs. Elsewhere we find a sensitive study of a lion in distress (*Fig. 43*). The animal is hunched and spewing blood, with an arrow lodged deep in its forequarters. Veins on its muzzle are prominent; its claws are stretched in a final effort to grip the ground and stay upright; its eyes have sunk into the fixity of astonishment and absence that is the sight of death.

So Ashurbanipal advertised his dominion over lions. As for his prowess in fighting fellow humans, this was a more complex story to relate. Embellishing both his own quarters and a room in the palace of his grandfather Sennacherib with similar compositions, Ashurbanipal chose to display his achievement of victory over Elam, a state that lay to the southeast of the Tigris valley in what is now southern Iran. Ashurbanipal quarrelled with Teumman, king of the Elamites, and *c.* 658–7 BC launched a punitive invasion. The decisive battle, it seems, was fought by the site of a mound called Til-Tuba. From the account of Ashurbanipal (logged in cuneiform records as well

as the two sets of friezes), it was more of a massacre. Certainly, the main impression made by the reliefs is that of a one-sided mêlée. The Elamites are made distinctive by their headgear, a sort of knotted bandana, but it is easy enough to pick them out as the ones in retreat and trouble. Closer inspection of the registers, combined with a knowledge of events derived from texts, reveals that this is not however a panoramic snapshot, but the visual unfolding of a story that has a beginning, middle and end. The diplomatic incident that caused the war is shown (an insulting message on a tablet from Teumman); a number of key protagonists are picked out and given captions of direct speech; and various post-conflict resolutions are specified, including select scenes of punishment and torture. A separate relief puts the seal on victory with a vignette of Ashurbanipal and his queen dining luxuriantly in a verdant enclave, and the head of Teumman dangling among the foliage.

There is, then, a defined plot to these Assyrian war reliefs. Arguably, Ashurbanipal's campaign against Elam is done as a three-act drama. What will confuse most modern viewers, accustomed to reading texts on a page, is the arrangement of episodes, lacking obvious sequential direction either from left to right, or top to bottom. But perhaps what is more unsettling here is the absence of any emotional engagement. By contrast to the lion-hunting scenes, the epic of Til-Tuba is devoid of any effort to convey the realities of pain. The sheer quantity of death, ignominy and retribution is abundant, but no one is shown wincing or screaming. In this sense it is a totally impassive piece of storytelling.

The same observation might also be made of Egyptian narrative art. From the earliest examples of visual storytelling in Egypt – notably the Narmer Palette, an engraved stone of *c.* 3000 BC – through to the large-scale temple reliefs of later pharaohs, the primary purpose is that of testifying to supreme power. Ancient Egypt was not a culture without an oral and literary tradition of myths – fables about deities, folksy tales about shipwrecked sailors, and so on – but the repeated theme of stories chosen for public viewing was basically a single message: the king always prevails over his enemies. Witness the scenes carved on temple walls in and around Luxor, including the campaigns of Seti I and Rameses II as recorded at Karnak, and the wars of Rameses III as massively inscribed at Medinet Habu. The pharaoh looms over all other figures: with outstretched bow aboard a colossal chariot, he rides full tilt at and through the enemy. Captions may be added to the scene: they seem somewhat redundant, given that the action is so obvious. ' … smiting the Asiatics, beating down the Hittites, slaying their

chiefs, toppled in their blood, charging among them like a tongue of fire, making them into that which is not.'

As with the Assyrian reliefs, thousands of figures are shown either in violent throes of death or else on their knees and begging for their lives. But, amid this tumult, is anyone – the rampant pharaoh included – showing any kind of emotion? No, none at all. Again we are confronted by a vista of mass suffering in which there appears to be no attempt on the part of the artists to describe any details of pathos or agony. To borrow a distinction made by the art historian Ernst Gombrich, it is as if the purpose of visual storytelling in Egypt and Assyria were to relate *what* happened, but not *how* it happened.

Egyptian art was, as already discussed (see page 61), essentially non-illusionistic. The sculptors who showed Rameses II scattering his foes were employed to emphasize the divine status of the pharaoh, not to render an eye-witness or even convincing account of battle and capitulation. Clearly it was not a concern of theirs to make the viewers of this scene feel as if they were really present.

This is very much at odds with not only the aims of modern cinema, but also the objective of much visual storytelling in Western art since the late thirteenth century, when European painters and sculptors representing gospel stories made strenuous efforts to engage beholders, especially in pictures and sculptures of Christ's Passion – the ordeals of Jesus Christ condemned to crucifixion. So when was it that artists first tried to make us care?

SUSPENDING DISBELIEF: THE NARRATIVE GIFT OF CLASSICAL GREECE

Mount Helicon, for the ancient Greeks, was home to the Muses, the nine delightful daughters of Zeus who inspired mortals to do wonderful things not only in literature, music and dance, but in philosophy and astronomy too. In fact the Greeks owed cultural and intellectual debts to neighbouring civilizations far senior to their own. 'East of Helicon', these included the various kingdoms and empires of Anatolia and Mesopotamia; Egypt's influence, already encountered in Chapter 3, was also substantial.

Stories from the Orient undoubtedly filtered into the repertoire of what we call Greek myths. (One simple index of this is the alarming number of lions featured in Greek mythology, bearing in mind that lions were never part of the local wildlife.) But

E.H. GOMBRICH: *THE STORY OF ART* AND THE ART OF THE STORY

IT HAS SOLD more than 6 million copies worldwide and been translated into over 30 languages, including, to its author's pride, Icelandic and Albanian. *The Story of Art* by Ernst Gombrich (1909–2003) must rank as the most engaging account of art history ever written. Originally announced in the 1950 autumn catalogue of its publisher (Phaidon Press) as 'a book to be enjoyed by young readers and by adults with young minds', it is often cited as the first (or the only) art book that many people possess.

Allegedly dictated to a secretary over just six weeks, Gombrich's text remains eminently readable. He was, in person, a genial raconteur, and in his writing always took care to avoid obscurity, keeping his readers both instructed and entertained. For Gombrich, even complex and ponderous issues of art-historical interpretation could be explained in terms that children could understand. (He once summarized his doctoral dissertation on the Italian Mannerist frescoes of the Palazzo Te at Mantua as 'a fairy story about a prince who built a beautiful palace'.) And his own narrative panache – unusual, if not despised, in modern academic circles – was in keeping with his sense of storytelling's radical importance in the history of art. In another widely read book, *Art and Illusion* (1960), Gombrich asked why it was that one culture in particular, that of the ancient Greeks, had developed illusionistic art, which imitated reality so closely that it caused viewers to confuse art with illusion. What had brought about this Greek Revolution (see page 71)? His answer was unequivocal. The illusionism of Greek art was rooted in the illusionism of their storytelling style. From Homer onwards, the poets and dramatists of Greece favoured mimesis, or imitation. Their stories were almost invariably mythical, yet they peopled these myths with believable characters: 'rounded' characters described as if actively alive, and using direct speech. Was Homer himself present when his heroes Achilles and Hector shouted challenges at each other and joined combat? Of course not. Yet the poet relates exactly what happened on that distant occasion with all the enthusiasm and immediacy of an on-the-spot reporter. For artists and sculptors, Gombrich argued, this was like a challenge to their respective skills. Could a painting or a sculpture extract such empathy or engagement from its viewers?

whatever was borrowed by the Greeks, they put their own very distinctive stamp on it. As Gombrich saw, what Homer did with a story was unparalleled in any previous literature. Effectively, he anticipated Aristotle's principle of suspending disbelief. To make his audience feel as if they were witnesses to battle on the plains of Troy, or lurching around in high seas with Odysseus and his crew, Homer focused vividly upon *how* a story went: how one thing led to another, how the characters were feeling as it happened, how those characters expressed themselves – and so on.

A perfect example of this comes in Book 9 of Homer's *Odyssey*. Odysseus, attempting to get home by sea after the end of the Trojan War, is forced to anchor off a strange island. He goes ashore with some of his crew, taking a jar of wine and seeking hospitality. But the island is occupied by Cyclops, one-eyed giants who live in caves with their flocks of sheep. Imprisoned by a giant called Polyphemus, Odysseus comes up with a ruse that involves getting the Cyclops drunk, then plunging a hot, sharp stake into his eye. The blinded Polyphemus squats at the mouth of his cave, blocking escape, so Odysseus and his men get out by clinging to the woolly underbellies of the Cyclops' sheep as the herd files out to pasture.

So what impact did this elaborately woven storytelling technique have upon the visual arts? The answer to that question might be outlined in three distinct proposals.

1 Stories such as Homer told, circulating at large in the Greek world from *c.* 750 BC onwards, encouraged artists to produce illustrations of those stories, commonly on the sides of vessels used for the formal symposia (drinking parties) at which poetic recitations were heard.

2 The descriptive detail of Homer's storytelling proved stylistically formative. So although the first narrative scenes on Greek pottery were geometric in style – composed of stick figures difficult to identify – artists were soon striving for a more illusionistic effect. An early depiction of the Polyphemus story, for example, shows the Cyclops emitting a cry as the stake is plunged into his eye. Within the same medium of painted pottery, we see artists attempting to include more references to the story, such as a couple of dismembered limbs in the Cyclops' grasp (*Fig. 44*).

3 Ultimately, Greek artists sought to invest their work with such expressive realism as to create a suspension of disbelief on the part of the viewer. Some kind of receding perspective was developed in large-scale painting of the fifth century BC, especially for theatrical scene design (though little direct evidence of this survives). The three-dimensional medium of sculpture, however, yielded more opportunities for creating complex narrative tableaux, with life-sized scale aiding lifelike effects.

Proposals 1 and 2 are debatable, but there is no doubt regarding the end achievement of Greek art as summarized in proposal 3. And there is no better way of gauging the extent

THE UNIVERSAL CYCLOPS

FOR THE CHILDREN of a certain tribe in Papua New Guinea, his name is Baya Horo: a monster of gigantic size, whose teeth are long and sharp, and highly suitable for munching his favourite victims – children. He has one huge eye and he lives in a cave. Using masks, the children play games in which they enact the terrifying stories associated with Baya Horo. The stories are of local origin, passed down from the elders of the tribe by word of mouth.

Baya Horo is not Polyphemus. No one supposes that the tales of Homer's *Odyssey* somehow penetrate the dense rainforests of Papua New Guinea. But Baya Horo shares some key monstrous features with the Cyclops, and comparable similarities have been noticed in diverse storytelling cultures from all around the world – Arabic, Slavonic, Nordic and so on. In the collection known as *The Arabian Nights* (or *The Thousand and One Nights*, as it was introduced to European readers in the early eighteenth century), for example, we find a tale about Sinbad the Sailor in

which the hero and his shipmates are stranded on an island, and encounter a savage giant 'as tall as a palm tree', who shuts them in his palace and begins to eat them each evening, one by one. How will they escape? While the giant is absent, Sinbad hatches a plan. There are some large iron roasting-spits to hand. Sinbad and his companions wait for the monster to return, devour one of their number, then fall asleep. The captives heat these rods in the giant's own oven and drive them into his eyes. They dodge past his sightless efforts to catch them, and get away on rafts. The furious giant stands on the shore, lobbing boulders after them …

We have, so to speak, heard it before. Or rather, the story of an adventure involving close confinement with a cannibalistic giant, and escape brought about by blinding the predator, is part of a worldwide web of mythology. It is further proof that storytelling is a generically human habit – and suggests, again, that we of today are essentially telling the same stories as were told thousands of years ago.

of that achievement than to witness how three Greek sculptors presented the story of Odysseus and Polyphemus to a Roman emperor in the early first century AD.

SPERLONGA: STORIES BY TORCHLIGHT

It was in September 1957 that a road-building project along the Italian coast between Rome and Naples brought to light a hoard of thousands of fragments of marble statuary inside a large cave. This cave was very close to the shoreline, and sea water was channelled into it as part of an extensive architectural complex suspected to be a villa

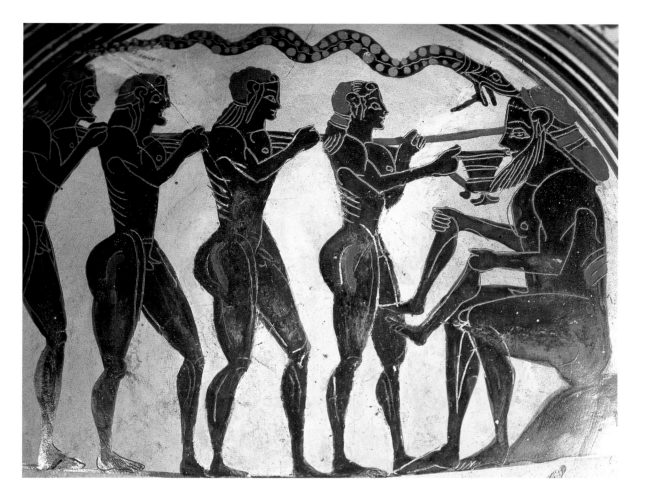

44 A Greek vase painting from the 6th century BC, showing the blinding of Polyphemus by Odysseus and his companions. Polyphemus holds the legs of one of his victims; as the stake is driven into his eye, a cup of wine is also offered. The snake above signifies danger. So this is a synoptic overview of the story.

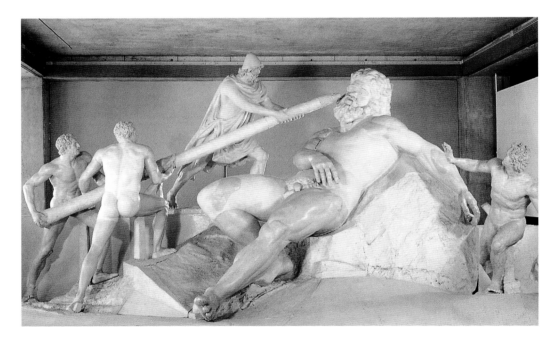

45 (top) View of the grotto at Sperlonga as it looks today.

46 (above) A partially reconstructed plaster sculpture of *The Blinding of Polyphemus* in the Museo Archeologico at Sperlonga.

retreat of the emperor Tiberius – successor to Augustus in 14 AD. The cave (*spelunca* in Latin) had been a celebrated site for centuries, and gave its name to the nearby hilltop town of Sperlonga. A number of antiquities had already been recovered from the site, which senior locals still fondly recall as ideal for amorous meetings. But the discovery of these multiple fragments in 1957 caused international excitement. A number of them clearly belonged to some dramatic ensemble of figures. One piece carried an inscription attesting the workmanship of a trio of Greek artists: Athenodoros, Hagesandros and Polydoros. Could these be the same three sculptors from the island of Rhodes who, by Roman tradition, had created one of the best-known statues from Classical antiquity – the Laocoön group – famously displayed in the Vatican since its excavation at Rome in 1506?

Excitement was local, too. When lorries came to transport the marble pieces for study and restoration in Rome, the inhabitants of Sperlonga set up blockades. They were not going to lose control of such a significant find.

So what did all these pieces of polished marble represent? At first it was thought that another version of the Laocoön story had been found. Laocoön was the Trojan priest who, when a huge wooden horse was left outside the city of Troy, voiced his suspicion of the object: 'I fear the Greeks, even when they come bearing gifts'. (The story of this fateful gift was scripted in the late first century BC by Virgil in Book 2 of his *Aeneid* – the epic poem of Rome's mythic origins.) It eventually became clear, however, that while tales of Troy were among the subjects of these sculptures at Sperlonga, the hero of the cave's thematic 'programme' was from the Greek side. Odysseus, or Ulixes (Ulysses) as the Romans knew him, was known to be a favoured alter ego of the emperor Tiberius. The hero's quick-mindedness and opportunistic cunning endeared him to a politician notorious for those qualities, so it is plausible that Tiberius himself commissioned the quartet of sculptural scenes once installed in the seaside cave.

The sculptures decorated what was an unusual private dining room, foundations of which may be seen today (*Fig. 45*). Guests reclining on couches upon a rectangular island had a view into the cave, which would have been lit by torches. Four statue groups featuring Odysseus, each in a different location, were to be seen. One showed the hero rescuing the body of his fellow warrior Achilles from the battlefield. Another, situated as if rising out of the water, represented the ship of Odysseus beset by Scylla, a monster from the deep (*Fig. 47*). Yet another represented a daring act of theft – Odysseus and a comrade stealing a precious image of Athena from the citadel of Troy. But the main

image of this spectacle was surely the scene of Odysseus directing a great wooden pole into the eye of a slumped and slumbering Polyphemus.

The group has been partly reconstructed in the nearby museum (*Fig. 46*), and its original effect may be imagined. The very setting, of course, evoked the cave in which Odysseus and his men found themselves trapped. As if departing from that initial advantage, the sculptors have spared no exuberance in making the fabulous episode as lifelike as possible. So Polyphemus is indeed gigantic and laid out in the typical sprawl of a drunken stupor, while the postures and facial expressions of Odysseus and his crew are studies of mingled fear and determination. We naturally reach for the word 'dramatic' to describe the storytelling climax that has been frozen by this sculpture. But no doubt the artists who made it prided themselves that such a powerful and violent event could never be so effectively conveyed upon the theatrical stage.

TRAJAN'S COLUMN AND THE INVENTION OF 'CONTINUOUS NARRATIVE'

Most Greek storytelling, verbal or visual, was mythical in subject. A typical narrative focused upon the biography or 'life description' of a hero such as Herakles or Theseus. These were, however, full-time heroes. (In the case of Herakles, prodigious acts of strength were being accomplished almost as soon as he was born, and continued well into old age.) Literary compositions might run on for hundreds or thousands of lines in poetry or prose. Given the obvious limits of their allotted materials, logistics and space, how could painters or sculptors possibly match this sort of continuity? Some early visual narratives in Greek art attempt a synoptic approach – giving an overview all at once of a story's beginning, middle and end. Another solution was to reduce a particular epic or heroic career into a cycle or series of various episodes, usually featuring the same principal character. For example, if the architectural design of a temple offered 12 separate compartments for carved scenes, then a dozen different exploits of Herakles might be selected for representation (this is, in fact, what happened *c.* 460 BC with the decoration of the Temple of Zeus at Olympia). Mostly, however, Greek artists contented themselves

47 Head of Odysseus, his ship under attack from the sea monster Scylla, as represented at Sperlonga.

with 'monoscenic' images: that is, a single 'snapshot' of narrative action, such as Herakles wrestling with a lion, or holding up the skies.

This evocative method of storytelling relied very much upon the 'beholder's share': counting on viewers who were mentally primed and equipped to supply further details – what had caused the action, what happened next, and so on. How and why Herakles had found himself in these exciting situations, and how they were eventually resolved, were taken as read and left to the imagination. So long as visual stories were drawn from a pool of commonly known myths or folktales, artists could assume such general knowledge on the part of their clients. But what if the story to be represented were not mythical, but some narrative of history or current events?

It was the pressure to concoct a sort of visual history – something like a documentary in television terms – that led to a further development in Classical art: the technique, predominantly in sculpture and painting, of continuous narrative.

Whether Greeks or Romans invented this visual mode is debatable. It may, however, be a futile debate, since most artists working at Rome were Greek by ethnic origin. But there is no doubt that continuous narrative was an artistic device highly suited to the needs and expectations of Roman patrons, especially those Roman emperors who wished to follow the example of Augustus (see page 186) in broadcasting to the public their account of *res gestae* (things done). Military adventures, political reforms, negotiations, acts of magnanimity – these may have been Herculean tasks, but it was essential to convince viewers that they had really happened and were not the stuff of myth. The Roman general Julius Caesar set the tone when he compiled a stern, meticulous and credible account of how he conquered the province of Gaul (France) *c.* 50 BC, written as a supposedly third-person commentary on how those Gallic Wars were waged. The challenge was for artists to match this lucid exposition of events, using images instead of words. Logic, accuracy, accountability – these were now paramount criteria of a good story.

The style of continuous narrative that ensued has historically been regarded as *the* great accomplishment of Roman art. And of all the works of Roman art exhibiting that style, none is more monumental than a marble pillar rising over 40 metres (130 feet) high in the centre of the city of Rome (*Fig. 48*). We call it Trajan's Column; it happens also to be the tomb of the emperor Trajan, who died in the summer of 117 AD and who surely never saw the final glory of his tombstone. Some scholars believe that it was his

48 Trajan's Column in Rome, erected in 117 AD, with its carved narrative frieze spiralling up from the emperor's tomb.

successor, Hadrian, who ordered the column to be decorated with a carved frieze in commemoration of Trajan's campaigns in Dacia – a region equivalent to modern Romania, along the lower reaches of the Danube. It is also possible that this carved frieze was indebted to painted scrolls, done by war artists attached to Trajan's army and perhaps displayed on the occasion of a triumphal procession to mark victory over the Dacians (in 107 AD). Trajan himself had left a testimony, in the style of Caesar, of how Dacia (and its lucrative mineral resources) had been won. In any case, the carved narrative was executed in such a way as to leave viewers with a strong impression of verisimilitude. Modern scholars use Trajan's Column as a primary source of information not just about the Dacian campaigns, but about how the Roman imperial army routinely operated, down to the smallest details of logistics, weapons, battledress and impedimenta. Ancient onlookers were reassured. Here, in Trajan – who appears 59 times in the frieze, and whose statue once adorned a small dome on top of it all – was a commander visibly in control of a great collective enterprise. He was *there*, in the thick of things: these scenes were honest, direct dispatches from the front line.

As a masterpiece of ancient visual storytelling, Trajan's Column appears to have everything. Running unbroken over some 200 metres (660 feet), it was once brightly painted 'in glorious Technicolor'. Its hero, of course, must be Trajan, but the emperor is not some fantastic, flowing-haired hero like Alexander the Great (see page 176); rather he is a calm and solemn figure conducting sacrifices, addressing his troops, receiving embassies, supervising supplies, and so on. There is a villain, too – the Dacian leader Decebalus, who fought and schemed hard to save his country's gold mines from falling into Roman hands. The climactic moment of the frieze comes when, deep in woodland, Roman cavalry is closing in on Decebalus, who shows his defiance to the last by cutting his own throat and so denying Trajan the triumph of parading him as a captive to the people of Rome. There is also an epic supporting cast of some 2500 extras, whose actions and expressions are all carefully rendered.

Using the language of film here may be anachronistic, but it is irresistible because the designer of Trajan's Column was anticipating certain film techniques familiar to studio directors. Trees, for example, appear not just as elements of landscape, but serve to divide distinct scenes, as today a director would use a visual cut. The frieze also makes adroit use of multiple viewpoints, especially the aerial perspective or bird's-eye view, to heighten the drama of battle, and also to give extra narrative information.

Like a camera mounted on a helicopter, the view from above permits us to see what is taking place behind high walls – a scene of mass suicide, in one case, or the covert non-compliance with treaty terms. And for those passers-by daunted by the prospect of gazing up at a spiralling frieze, it seems that the creators of Trajan's Column thoughtfully provided a sequence of narrative highlights – something like a cinematic trailer – up the column's northwest vertical axis. This introduces Trajan, emphasizing that he undertakes military action only after due rites of sacrifice to the gods; tells us that Decebalus and his followers will stop at nothing – torture, arson, betrayal – to antagonize the forces of law and order; and predicts that the winners of this contest will be those who have divine support.

The entire story is, in a sense, predictable. The viewer on the ground needs only to glimpse the lower scenes to apprehend that the very method of the Roman army mobilizing – setting up supply bases on the Danube, building forts and bridges and so on – is enough to guarantee ultimate victory. This is one huge military machine, whose force will prove irresistible wherever it is deployed. If this is the core message of Trajan's Column, then as a piece of Roman imperial propaganda it seems perfectly effective. Later in the second century, the name of another emperor – Marcus Aurelius – would be honoured with a similar monument, also still standing in the heart of Rome. However, to acknowledge the ingenious features and imposing effect of Trajan's Column is not the same as admitting it to be a thoroughly engaging piece of storytelling.

It may be hailed as an epic frozen in stone, the greatest visual narrative produced by the ancient world. But quite apart from the practical impossibility of following the helical trail of events, can anyone claim to be transported by Trajan's Column to the killing fields of the Roman Empire? For all that its artists have anticipated certain storytelling devices of the modern cinema, Trajan's Column lacks the power to captivate. This is not just because the figures are not moving, and the continuous thread of storyline keeps vanishing from sight. Some fundamental element seems to be missing.

INTERWEAVING WORDS AND PICTURES

The same individual appearing more than once in a single composition: that is one way of defining continuous narrative as an artistic strategy. It is a fundamentally unnatural device because ordinarily we cannot be in two places at the same time. This peculiarity was

49 A detail of the Bayeux Tapestry showing King Harold being fatally wounded at the Battle of Hastings, late 11th century. Harold is probably the figure falling in front of the horse.

elaborated both as an achievement of Roman art and as a problem of later European art by a group of Viennese scholars at the end of nineteenth century. In late antique and early medieval Europe there was, it seemed, tacit acceptance that stories needed illustrations, and that tales told by images must also carry words. A fifth-century manuscript in Vienna contains tales from the Hebrew Book of Genesis, with 48 'illuminations' leading from Adam and Eve to the death of Jacob. This appears to indicate artists aware of the Roman tradition of continuous narrative, yet is a text with pictures, not a story told by images alone. And when, some 500 years later, a bishop of the town of Bayeux commissioned a 70-metre (230-foot) tapestry to celebrate the successful invasion of England by his half-brother, William, Duke of Normandy, embroidered Latin inscriptions in capital letters were deemed necessary to make sense of the continuous sequence of images (*Fig. 49*).

So had the inherently unnatural device of representing one figure repeatedly in the same scene proved unworkable? The art historians of Vienna (notably Franz Wickhoff) earnestly debated the question, perhaps aware that the recent invention of moving images on film was rapidly developing as an art form in its own right. At the same time, however, discoveries were being made on the other side of the world that would reveal a storytelling tradition that predated Trajan's Column, the Vienna Genesis and the Bayeux Tapestry by many thousands of years. And only by understanding the long-sustained vigour of that tradition, 'old yet always new', would it become clear why the movies have become the most powerful mode of storytelling in the modern world.

'Whatever may have been the age of these paintings, it is scarcely probable that they could have been executed by a self-taught savage.' The first Europeans to come across Aboriginal images in Australia, such as Sir George Grey, a British explorer of the Kimberley region in the 1830s, were either sceptical that such art was done by indigenous people, or else inclined to dismiss it as nothing but childish daubings and doodles. There was a sense that these images were very old, but the colonists had little notion of what was represented, and little interest in finding out.

It was not until the early twentieth century that attitudes began to change. In the summer of 1912 a biologist and anthropologist by the name of Baldwin Spencer arrived at a small settlement called Oenpelli, in Arnhem Land, just across from the East Alligator River. Spencer had lately been appointed Chief Protector of Aboriginal interests, a belated official recognition that colonization had done terrible damage to the indigenous communities of Australia. Although he was hosted at Oenpelli by a cattle-farming settler

of European descent, Spencer's sojourn there was motivated by a serious concern to make a record of local folklore and customs.

He had spent time with other Aboriginal communities in central Australia and the Northern Territory, but nowhere had Spencer so far encountered such a lively practice of painting as at Oenpelli, among the people he called the Kakadu (Gagudju). It was facilitated, perhaps, by an environment offering plentiful food – thanks to the annual monsoon rains from November to April – and the abundant local supply of artists' materials. A length of frayed bark served as a brush to apply a background wash, while outlines and details were painted with a piece of trimmed sedge. Pigments were derived from organic sources, such as haematite and kaolin, and comprised black, white, red and yellow. Collecting these colours might involve a long journey, but the surfaces for painting were nearby. Broad slabs and overhangs projected from the sandstone escarpment extending across Australia's 'Top End', with many rocks densely covered with layer upon layer of images. In western Arnhem Land it was also customary for painting to be done on strips of eucalyptus bark (*Fig. 50*). Bark pieces were used to construct shelters during the wet season, so the painting provided a sort of interior decoration.

As Spencer recalled: 'Today I found a native who, apparently, had nothing better to do than sit quietly in the camp, evidently enjoying himself, drawing a fish on a piece of string-bark … ' Although his tone sounds slightly disparaging, and he specified a measure of 'play-about' in the local habit of making images, Spencer took care to acquire and commission a number of paintings on rectangular bark pieces for conservation and display in the Museum of Victoria at Melbourne. So Aboriginal art therefore became portable and collectible, and gradually outsiders became aware of the remarkable longevity of the cultural tradition to which this art belonged. The artists witnessed at Oenpelli by Baldwin Spencer in 1912 were, for example, painting images of estuarine fish, such as barramundi, which had entered the artistic repertoire when the very estuaries formed – about 8000 years ago. Not only subject, but style and execution had changed very little over thousands of years.

Awareness of this longevity came in various ways. Certain animals depicted on the rock surfaces were species that had become extinct, such as the thylacine or Tasmanian tiger, which disappeared from the Australian mainland some 4000 years ago. Other large fauna recorded, such as the marsupial tapir, had roamed the area in even more remote, pre-estuarine times. Since the images were layered, one upon another at many sites, it

50 Painting bark at Oenpelli, northern Australia, 2004.

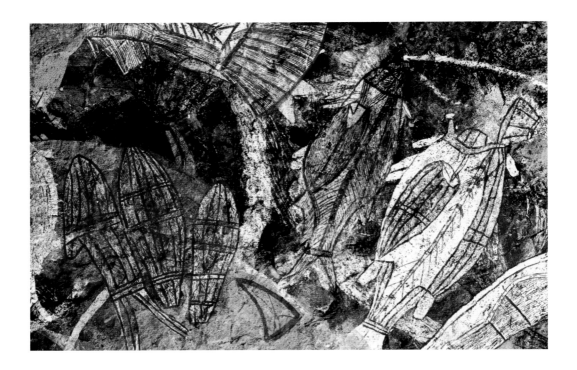

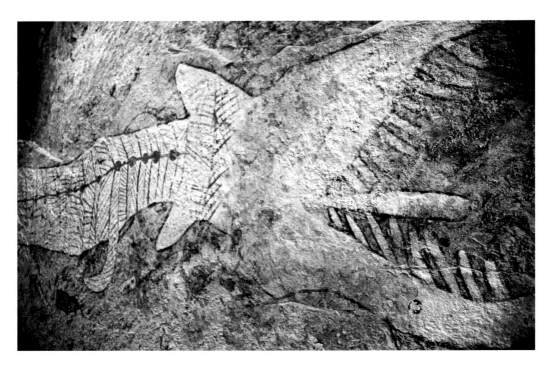

51 Images of barramundi on the rock walls at Injalak Hill, near Oenpelli, Arnhem Land, Australia. Date uncertain.

52 The Rainbow Serpent: detail of a rock painting near Mt Borradaile, Arnhem Land, Australia. Date uncertain.

became possible to surmise that some stencilled hands and other marks were left by early human inhabitants – about 50,000–40,000 years previously. Further ecological changes could be traced from shifts in the repertoire, as (for instance) freshwater swamps became seasonal habitats for waterfowl, such as egret and ibis. Later still, there were depictions of animals introduced in historical times, notably the buffalo, and clear references to at least a visual acquaintance with people from elsewhere. So there were images of the sailing ships of the Macassan traders from Indonesia, fishing off the coast for trepang or sea slugs; and eventually, of course, spectres of the colonists with their horses and flintlock guns.

In terms of quantity, the images that dominate the output of Aboriginal artists in western Arnhem Land relate to elements of the local diet – birds, turtles, fish, marsupials, crocodiles. It was (and is) a particular feature of regional style to represent the innards of these creatures. Subsequently dubbed the 'X-ray style', this feature lends support to the general notion that the imagery offers an illustrated menu of subsistence, with the anatomical revelations prescribing, perhaps, how portions of fat and protein were to be distributed among those sharing this food. We know that refuge had to be taken in bark shelters or under rock crags when the wet season prevailed, and that the best time for catching turtles or barramundi was as the waters receded. So when we see the clustered images of turtle and barramundi on a rock wall in the cliffs above Oenpelli (*Fig. 51*), we might suppose they simply reflect wishful thinking about the next meal. But, as anthropologists came to realize, the image of a barramundi was not, to Aboriginal eyes, simply the depiction of an eminently edible fish, occurring in creeks and water-holes as a natural phenomenon. Rather, it was a symbolic form intricated into a cryptic network of law, land, ancestry and myth, and it could not be understood in isolation from the complementary media of story, song and dance.

The term 'myth' is inappropriate here if it suggests that the stories associated with the images convey anything less than truth; and we shall see elsewhere in this book how Aboriginal mythology is radically fixed to aspects of terrain and topography. No wonder the first Europeans who encountered Aboriginal art were reluctant to acknowledge its complexity: the extent of their colonial intrusion would have become all too evident.

'Charms against injury and sickness … charms to hurt enemies … charms to revive persons who had died by violence; songs sung during totemic increase ceremonies … initiation songs … charms to control weather; songs of human beauty, love charms; songs celebrating love of homeland … death, the sky dwellers … ' All these occur in an

THE SONGLINES OF
ABORIGINAL AUSTRALIA

TO THE FIRST European settlers the interior of Australia appeared like a vast wild expanse, dauntingly barren and featureless. Looking down from an aircraft window today, the red-baked outback can still seem that way. But for its indigenous inhabitants, this continent has for ages been criss-crossed with trails of stories left in the 'Dreamtime' by the movements of totemic ancestors; these 'songlines' as they are called, serve not only as routes for wandering, but also invest the land with ritual and spiritual significance. The concept was popularized by the charismatic English writer and traveller Bruce Chatwin (1940–89); who in turn was much influenced by the work of Theodor Strehlow (1908–78).

The son of a Lutheran missionary, Strehlow was born and raised in the arid centre of Australia, not far from Alice Springs. This was the territory of the Aranda clan-group. Strehlow so immersed himself in Aranda customs that he could eventually claim to be not only an initiate, but a 'wise man' of Aranda

ceremonies. Ultimately, his betrayal of ceremonial artefacts and sacred secrets brought him disgrace. But Strehlow's close understanding of the Aranda language enabled him to convey something of the resilience and delicacy of song cycles among this Aboriginal society. The results of over three decades' work are published in his *Songs of Central Australia* (1971), a passionate account not only concerned to explain Aranda poetic culture in its own terms, but also, by transcribing an oral tradition, to relate Aboriginal storytelling to the canon of Western literature. Any notion that Aboriginal songs were simple was conclusively dispelled. Strehlow showed, for instance, that the Aranda had no fewer than 27 particular expressions used to measure different stages of day and night. These included the point in twilight 'when the tufts of grass cannot any longer be distinguished apart'; or a portion of dawn 'when the eastern sky is all aflame with the fingers of the rising sun'. This, for Strehlow, was poetry to match Homer.

inventory of themes to be found in the songs of the Aranda people living around Uluru (Ayers Rock), first documented in the late nineteenth century by Baldwin Spencer (with Frank Gillen), and more thoroughly several decades later by Theodor Strehlow (see above). Strehlow's work showed how myth among the Aranda amounted to a sort of historical, religious and legal charter, elaborating in scrupulous detail the precedents set by ancestral beings. Researchers elsewhere – notably Ronald and Catherine Berndt, and C.P. Mountford, who all did fieldwork in Arnhem Land – confirmed the rich and highly localized variety of Aboriginal mythology. The Milky Way is a very conspicuous

constellation in the southern hemisphere, but different communities along the East Alligator River might have quite different stories about how the Milky Way was formed.

Historical recordings made of Aboriginal storytelling sessions – which can last for hours, even days – indicate that the oral transmission of this or that story may scarcely alter over a hundred years of its telling. Word for word, the tale is passed on from one generation to another. So just how old are these stories? Here the art can help us because it is, of course, an integral part of the tradition. Around Oenpelli – in fact across Arnhem Land and beyond – many stories feature a composite creature known as the Rainbow Serpent. Its composition varies, but usually shows a snake's body combined with crocodile jaws (*Fig. 52*). Stories about the Rainbow Serpent often locate its presence in a particular place, and attribute it with punitive powers. At Oenpelli, for example, the tale is told about how a small orphan boy was continuously crying because his adoptive family had been feeding on yams and given none to him. A sympathetic older brother then summoned the Rainbow Serpent (here known as Ngalyod), who rose up angrily, devoured the greedy family, and turned the little boy and his brother into rocks, which can still be seen by a local water-hole.

Dates, as ever with rock art, are speculative, but archaeological contexts for images of the Rainbow Serpent in Arnhem Land suggest that stories such as this go back some 4000–6000 years.

STORY AND SOUNDTRACK

So what is the secret? How is it that this Aboriginal tradition of storytelling has endured so vigorously over such a long time?

The answer, surely, is that in this tradition neither images nor written words have detached stories from the *performance* of telling stories. Spencer and Strehlow bore witness to the essential cohesion of music, dance and recital in Aboriginal culture. Many of the images that accompanied this process will never be seen because they were traced in the sand where a ceremony took place, or painted on the bodies of those who took part. And many of the images ought not to be seen because the occasions for which they were created were sacred events, not intended as a general spectacle. Some anthropologists have been privileged to view such ceremonies. In the early 1960s a young David Attenborough was able to record one ceremony on film – a film that cannot

be screened today because it disturbs Aboriginal sensibilities about the public exposure of closed ritual. So there is a sense in which no outsider should even hope to understand the particular potency of this tradition.

For thousands of years, Aboriginal artists painted not for the sake of museums and collectors, but to provide images that were cues for the storytelling performance, and a means of passing on stories from one generation to another. Now resigned to the world's commercial demands, they produce 'works of art' more or less *related* to the traditions of the past, but intrinsically removed from them. Similarly, Aboriginal groups will stage dances for the benefit of spectators, choreographed according to tradition, but again deprived of their original encoded and sacrosanct purpose (*Fig. 53*).

Yet we, the onlookers, gain an inkling. We see and hear how the dancers are truly *grounded* in their moves, emphatically stamping the sand and raising dust with their heels. We sense the energy of repetition and chanting underscored by the low rumble of the didgeridoo, or beaten out on clapsticks. We observe how the young ones follow the elders, and how the symbols of yams, honey ants and goannas quiver on their bodies as they dance. And we realize that at the heart of this storytelling there lies a soundtrack.

Film-makers got wise to this around 1894. What movie epic would be without it?

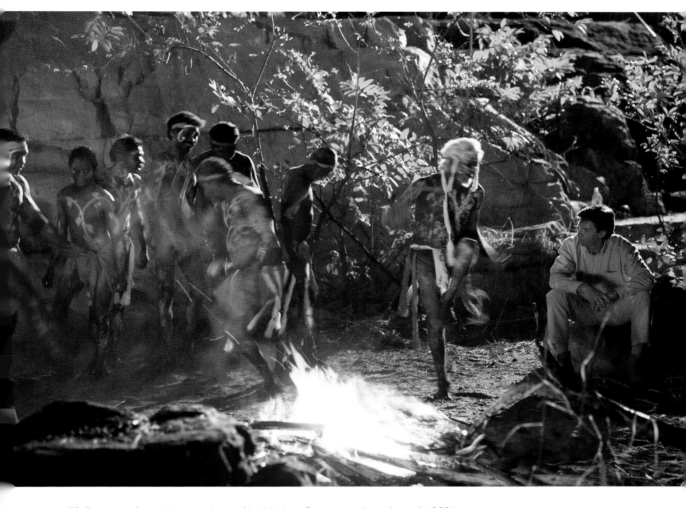

53 Dance performed by associates of Injalak Arts Centre, northern Australia, 2004.

5

SECOND
NATURE

CAPTAIN JAMES COOK was not a bad man. The private journal of the British navigator reveals an essentially decent, well-intentioned individual, reluctant to cause ill feeling or harm among the indigenous peoples he encountered on his voyages in the Pacific region. (From the European perspective, it was Cook who 'discovered' Australia and New Zealand in 1769–70.) But one entry in his diary is now terrible to read. It is the overture to a tragedy that the explorer would not have foreseen. His ship, the *Endeavour*, was making its way along the east coast of Australia. Putting ashore for fresh water and supplies, Cook tried to make friends with some Aboriginal people who came to see what was going on. All sorts of enticements and gifts were laid out, but these offerings were left untouched by the Aborigines. As Cook recorded, 'all they seemed to want was for us to be gone.'

Cook continued up the coast towards the Great Barrier Reef. As he went, he gave names to landmarks on the way. Partly this was to assist with making a map of his journey, but it was also an act of appropriation. Cook himself might sail away never to return (he was killed in Hawaii nine years later), but he had planted the British flag, claiming the territory for the realm of King George III. The British would be back.

Cook described the Aboriginal inhabitants of Australia as 'timorous and inoffensive', living very happily without the 'necessary conveniencies so much sought after in Europe'.

To later settlers, however, the Aborigines' apparent disregard for property and material goods was proof of some subhuman state. So British administrators decreed the entire continent to be *terra nullius* – a Latin legal term meaning 'empty land', or 'land belonging to no one'.

Australia was anything but no one's land. In the eyes of its nomadic population, the entire continent was everywhere marked by the shapes and signs of ancestral handiwork – a visible, substantial legacy from the spirit world. The genesis of all plant and animal life lay with totemic ancestors; so too the creation of mountains and sandhills. Every creek, lagoon and water-hole had a story of how it had come to be (see page 116). To the outsider, Australia en masse might seem a huge wilderness, but it was a place in which no Aboriginal wanderer was ever lost.

The tragedy prefigured by Cook's encounter with Aboriginals, who simply wanted him to go away, may be summarized in the phrase 'blood on the wattle': implying the near-extermination of Aboriginal communities across Australia and Tasmania as the process of colonization gathered momentum after about 1800. Even in the mid-twentieth century, Theodor Strehlow (see page 118) could sourly note 'the ordinary routine shootings deemed necessary to make the country safe for cattle-breeding'. British and other European settlers did not care to recognize that this 'new world' had been not only occupied for over 40,000 years, but supplied by its occupants with spiritual significance for eternity. To this day, lawyers deliberate how far Aboriginal mythologies may constitute 'land rights' in particular cases of disputed property. At the heart of the matter, however, lies a conflict that is not unique to Australia.

It is the conflict – referred to several times already in this book – between two modes of subsistence. On the one side there is the system of hunting and gathering by which humankind survived through most phases of prehistory. On the other side there is agriculture, the settled raising of crops and animals that began approximately 10,000 years ago in the Middle East and Anatolia (see page 48). For some archaeologists the diffusion of agriculture, with its capacity to produce surpluses of food, led to urban settlements and 'the birth of civilization'. And because we are inclined to think of farming as a stage of chronological progress in human history, we tend to forget that hunter-gatherers still survive in certain parts of the world, such as the Amazonian jungle and around the Arctic Circle.

Many generic differences could be outlined between hunter-gatherer societies and their agricultural rivals, and perhaps none is more conspicuous than the contrast in

attitudes towards the environment. Broadly speaking, this contrast could be expressed
as follows: hunter-gatherers work *with* the environment; agriculturists *against* it.
Or, as anthropologists would confirm, hunter-gatherers tend to revere the environment,
investing it with spirits of the place, while agriculturists regard it as a resource to be
managed, a force to be subdued.

To make this general paradigmatic opposition is not to deplore the many boons and
benefits brought about by the intensive raising of crops and domestication of animals.
Nor is it to revive the antique notion of a 'noble savage' – the fantasy of some supremely
unfettered and virtuous human existence in the wilds. (This was a romantic notion made
intellectually fashionable in Europe at around the time of Captain Cook.) Hunters have,
in some places, hunted certain species to extinction, and the Australian Aboriginal
practice of creating seasonal bushfires arguably qualifies as working against the *— not true*
environment. But beyond any ecological debate lies a simple distinction of lifestyle that
demands our acknowledgment here. Why so? Because for all that agriculture has become
the dominant mode of human subsistence, and human populations across the world are
now concentrated in cities, we still reserve *feelings* for the land. Aesthetically, if in no other
way, we respect the 'natural world'. So, as a matter of sheer probability, it is likely that if
readers of this book have at home any pictures on their walls, those pictures will fall into
the category of landscape.

Is this a guilty conscience – our primal instinct showing through?

NOTIONS OF NATURE AND LANDSCAPE

A photographic vista of the characteristic landscape of the Kakadu National Park in
Australia's Northern Territory easily earns the tag 'an area of outstanding natural beauty'
(*Fig. 54*). The variegated greens of paperbarks and other eucalyptus trees comfort the
eyes. Flocks of white egrets collect over stretches of water where pink lilies bloom. The
limestone escarpment, warm and unthreatening, rings the horizon like some cosy
theatrical backdrop.

Visitors to Kakadu may be content to enjoy the scenery, spotting the birds,
snapping the blooms, perhaps getting a glimpse of a crocodile. But even with earnest
effort, they will never perceive the forms and features of this land as its Aboriginal
inhabitants do. Leaflets issued by the park authorities emphasize that Kakadu, for its

54 View of Kakadu National Park, Northern Territory, Australia.

'traditional owners', is a habitat shaped by the spiritual ancestors of the Dreamtime (see page 118). Not only did these ancestors create all landforms, plants, animals and people, they also bequeathed laws to live by – ceremony, ritual, language, kinship and ecological knowledge. Having taught people how to live with the land, the Dreamtime ancestors resided at certain sites of their own making. There they stayed, and there they were to be respected. If disturbed or angered, they would react. To define certain senior Aborigines – such as Bill Neidjie, who did much to make the park possible – as 'owners' is in this sense misleading. The land may have custodians, but it is no one's property.

The hunter-gatherer view of terrain without fences and title-deeds perplexes 'civilized' people with mortgages or even second homes, but we can at least try to imagine that view. And we need to do so, if we are to gain any understanding of the relation of images to territory.

> 'It will be found that the decorative art of primitive folk is directly conditioned
> by the environment of the artists … To understand the designs of a district,
> the physical conditions, climate, flora, fauna, and anthropology, all have to be
> taken into account.'

This was the message delivered to a late Victorian readership by the Cambridge anthropologist Alfred Haddon, whose monograph entitled *Evolution in Art* (1895) was based upon his own fieldwork in the islands of the Torres Straits, north of continental Australia. Almost too late, subsequent studies among the world's few remaining hunter-gatherer societies have confirmed Haddon's insight, while disproving his further conviction that 'backward people have to be taught to see beauty in nature'.

It is, rather, the civilized ones who need that teaching.

A survey of sites deemed sacred by the Algonquian people in the Canadian regions of Quebec and northeast Ontario found that various factors may combine to render a place special: local acoustics, the shape of a particular rock, or some configuration of cracks and striations in a cliff, the feel of a certain stone. Ancestral spirits are deemed to reside in a tree or boulder, and offerings will be left accordingly – tobacco, biscuits, beaver bones. Other places are recognized and marked as shamanic venues. Disturbance of such sites entails trouble, even doom.

This amounts to a sort of insider knowledge. And the hunter-gatherer understanding of initiation to such knowledge is curiously matched by a recurrent feature of Western art history: the ideal that those who aspire to be good or great artists must apply themselves to 'study nature'. John Constable, probably the most widely loved of all English landscape painters, saw it as not only a matter of diligent apprenticeship to make close studies of trees and leaves and suchlike (*Fig. 55*), but also a near-mystical vocation. 'The art of seeing Nature,' Constable declared, 'is a thing almost as much to be acquired as the art of reading Egyptian hieroglyphics.'

THE NATURE OF NATURE

'STUDY NATURE.' That command to the artist seems simple enough. There is the world and all its weathered texture; there on display are the facts of creation. Take the tools of recording, and look. See what nature reveals. But what *is* nature?

To play with the word is immediately to expose its looseness. We may let it mean anything prone to be flattened by concrete and bricks. A nature trail will take its followers upon a programmed discovery of birds, bugs and botanical gems. Yet what is natural should happen of its own accord. Mother Nature is her own agency, free from the culture and contrivance of humans. When we hail a tract of scenery as unspoilt, we mean that maternal Nature has had her way; we may speak of 'virgin' territory, as if the possession and cultivation of land by human beings were an act of coupling or rape. To be 'at one with nature' is to imagine an easiness between our cultured selves and the natural world. But when hurricanes happen, or we watch a natural history film that shows a pack of jackals disembowelling a

doe with their jaws, we allow nature a temperament too ('Nature red in tooth and claw').

Naturists are humans who like to take off their clothes and have nothing between themselves and the world: what is natural in this sense implies whatever is spontaneous, unchecked or removed from human tampering. Yet beyond geology and oceans there is precious little upon the Earth's surface that can be described as natural in this way. Certainly not the tropical rainforests: the Amazon, for instance, is densely clustered with species of fruit, nut and edible palm trees planted there by humans several thousands of years ago. To enter a modern nature reserve is usually to trespass upon some kind of former human occupation, however ancient.

To study what nature reveals is not, therefore, a very clear command. Nonetheless, we have learned what to expect from an artist whose subjects derive from the natural world: tree stumps, not skyscrapers.

55 Constable's *Study of the Trunk of an Elm Tree, c.*1821. As one of his friends observed, the sight of a fine tree caused Constable to go into 'an ecstasy of delight'.

'A picture representing natural inland scenery.' That is how *The Oxford English Dictionary* defines a landscape. This is the 'civilized', Western understanding of an aesthetic environment. We take 'land' to constitute the surface of the world, while 'landscape' is something apart. Landscape is the effect of that surface upon us. Landscape is our viewing of land, what we perceive of land, and something else besides. In historian Simon Schama's definition, 'landscapes are culture before they are nature'. Our view is shaped by the way in which see, and by what we were expecting to see; and then our view may be further shaped, by what we wish to represent.

The active principle here is confirmed by the fact that English usage also deploys 'landscape' as a verb. To landscape is to create a particular environment, a prospect; anyone tending a garden is acting as a landscape gardener, and by the same token there is no such thing as a 'natural' garden, only a plot overrun with weeds.

So if land equates to property, which some call 'real estate', perhaps we should think of landscape as being 'ideal estate', permeated as it is by moods, dreams and wistful thinking. As the nineteenth-century American essayist Ralph Waldo Emerson decreed, 'in landscapes, the painter should give the suggestion of a fairer creation than we know'. A chorus of similar voices could be cited from colonizing, industrialized Europe. In the words of Paul Cézanne (1839–1906), who typically shunned city life for the reflective calm of the south of France, 'painting after Nature is not copying the objective; it is realizing one's sensations'. For John Ruskin, the dominant art critic (and advocate) in Victorian Britain, a zealous love for the pertinent geology and botany of the landscape was part of the landscape painter's vocation. 'Make intimate friends with all the brooks in your neighbourhood,' he urged novices of drawing, 'and study them ripple by ripple.' Ruskin volubly deplored the tendency to invest 'inanimate Nature' with feelings and temper: to say that a hillside looked 'forbidding', or a rainfall came 'kindly', was foolishly to suppose an emotional capacity in such objective matters, a weakness that he condemned as 'pathetic fallacy'. But in his fantasies about 'mountain gloom' and 'mountain glory', Ruskin could not help surrendering to an essentially romantic vision of the countryside. It was a Western tradition much older than he realized.

ARCADIA: THE CLASSICAL VIEW OF LANDSCAPE

Arcadia was a fabled site of ancient Greece and Rome – a place of tranquility, where people could be at one with the spirits of the place. In the art of Egypt, Greece and the ancient Near East there is nothing that properly equates to our modern understanding of a pictorial landscape. Elements of flora and topography, if they appear at all, supply a basic setting – no more. The professional painters of stage sets for the Classical Greek theatre, whose work was in demand from around the mid-fifth century BC onwards, are presumed to have experimented with large backdrops in receding perspective, but this is only supposition. The first recorded notice of an artist specializing in landscapes is made by the Roman writer Pliny the Elder.

Pliny's fame rests with the compilation of a *Natural History*. Dedicated to the Roman emperor Titus *c.* 79 AD, the multi-volume project may be considered as a sort of inventory of the Roman Empire – a survey and stocklist, of everything in the world that the Romans possessed or thought worth possessing. So we find that the Western concept of landscape is linked, right from the start, with realities of territorial expansion.

Pliny names one Studius (also transcribed as 'Ludius') as the pioneer of painting walls with 'most agreeable scenes' of villas and porticoes set in manicured gardens; along with 'groves, woods, hills, fishponds, canals, rivers, coasts – whatever could be wished – with people strolling about … ' (*Natural History* 35, 116–17). It is clear from Pliny's phrasing that this Studius based his pictures very much upon a countryside that had itself been ornamentally landscaped, and then served as much for retreat and recreation as for the rural economy. Pliny locates the artist as working during the rule of Augustus (31 BC–AD 14), a period in which the consolations of rustic escape were hymned by poets close to the emperor, such as Horace and Virgil. Studius probably worked for patrons imbued with that poetic dream of pastoral ease. And Pliny specifically tells us that the artist did it with a whimsical sense of humour. Whether the people incorporated into these landscapes by Studius were amorously wandering, goading donkeys, stalking wildfowl or harvesting grapes, no one here was over-exerted. The purpose of such painting was to conjure the perfect *locus amoenus* (pleasant place).

Nothing survives on ancient Roman walls that is actually signed by Studius. However, from the time when he is reported as making his name, the manner of Studius can be deduced from other Roman frescoes and mosaics. Before his day, in fact, a certain

56 Nilotic mosaic from Palestrina, east of Rome, c.120–10 BC.

taste for panoramic vistas was already part of Roman interior decoration. At its most expansive, this pretended to encompass, on the space of a single wall or floor, the entire valley of the River Nile (*Fig. 56*). In the foreground of the best-known of such Nilotic views there are urban structures that seem to stand for civilization. Temples, shrines, kiosks and groves host various pursuits, including picnics and fishing parties, as our gaze travels upstream from the busy delta. The seasonal event that is celebrated here is the Nile's annual breaching of its banks (see page 61). Priests, bureaucrats and punting marsh-dwellers are among the local people shown greeting the September inundation, with its promise of burgeoning crops. But the synopsis is sprinkled with details of local flora and fauna; as the river is followed to its first cataract and beyond, so its gentler features (such as lizards, ducks and water-borne lotus blossoms) give way to more peculiar or threatening sights. Crocodiles, wart-hogs, hippopotamuses wander the riverbank, while farther off, where the terrain turns rocky, giraffes, big cats and Nubian tribesmen stalk antelope and cranes.

This mosaic, with its instructive scatter of labels (in Greek) is a form of geography – literally 'description of the world' in Greek. In the later history of European colonization, as we have seen, connections would develop between landscape art, the making of maps, and the proprietorial laying of claims to land. (Perhaps the Roman viewers of this piece already had inklings that Egypt would come under Roman control, as it did after the death of Cleopatra in the year 30 BC.) But it seems that the work of Studius and others was not directed towards justifying imperialism, nor giving lessons in the fauna of the Upper Nile. What their genre supplied was essentially idyllic.

'Idyll' derives from the Greek word *eidyllion*, meaning 'little image'. In antiquity the term was annexed for a type of versifying that evoked life in the countryside, in particular life as viewed through the eyes of those whose task was keeping the flocks. As it happened, the port metropolis of Alexandria, at the mouth of the Nile, was where the literary fashion for such pastoral evocations developed. Some of the learned mock-goatherds at Alexandria, notably Sicilian-born Theocritus (*c.* 300–260 BC), would become canonical favourites in Western literature. In direct homage to the *Idylls* composed by Theocritus, Virgil supplied his Latin audience with a sequence of *Eclogues*, so fostering the taste for landscape staffed by idling pipers. Like Theocritus, Virgil allowed rough and illiterate rustics to sing exquisitely, even the mythical one-eyed monster-herdsman Polyphemus (see page 101), who is imagined lovesick for a sea nymph, Galatea:

'Come hither, Galatea …
Here Spring purples; here, by the brooks,
Earth doles her bounty of flowers;
Here the white poplar bows over the cave,
And coiling vines weave dens of shade.'
(*Eclogues* 9, 39–43)

The terms of seduction offered by Polyphemus are those of Roman landscape painting at this time: indeed, one wall-painting in a villa not far from Pompeii (and, like Pompeii, caught in the volcanic eruption of Vesuvius in the year AD 79) shows Galatea keeping a coy distance amid the waves as Polyphemus sings to her of his leafy retreat and buckets of milk. A generic name grew attached to this idealized place – Arcadia. It was taken from an area of central Greece whose inhabitants legendarily enjoyed their music and dancing, undisturbed by war and toil. Only later did European writers and painters add the warning, sometimes inscribed upon a human skull: *Et in Arcadia ego* (I belong to Arcadia, too), meaning that death was not absent from this seemingly carefree pastoral habitat of shepherds and nymphs.

So while Studius remains a shadowy figure at the beginnings of landscape art, the ideals of the genre as it formed in the West are clear enough. These ideals should not be regarded as entirely whimsical: many Romans took their gardening seriously, and the poet Virgil wrote authentically about how to keep bees, spread manure and prune hedgerows. But this was an art that not only presented a fairer creation than was known, but rendered it sacrosanct. Many landscapes painted around the time of Augustus have been referred to as 'sacral-idyllic' precisely because they contain, amid the slopes and sheep-pens, tokens of rural piety: altars and shrines, not neglected, but freshly decked with garlands. Arcadia is not merely the green refuge from urban stress. It preserves the age-old rapport between people and their deities – the 'spirits of the place'.

So in Arcadia everything is at one with everything else; and that is a supernatural state.

Livia, the wife of Augustus, must have had something like Arcadia in mind when she commissioned someone like Studius to paint the dining room of her villa outside Rome (*Fig. 57*). It is, as we instantly understand, a natural, or at least horticultural, scheme. It would seem ironically so, given that it belongs to Livia's villa, not to her residence in the capital. Why did the empress need pictorial reminders of birdlife, fruit and flowers when

57 Wall painting of 'improved' nature from the Villa of Livia, at Prima Porta, near Rome. The entire room is now on display in the Palazzo Massimo, Rome.

they were there, as it were, on her doorstep? But if we look closer at what Livia's painters devised, we see that it is much more than a record of some garden at its prime. It is not nature, but nature 'improved' – nature rendered impossibly perfect.

Two low boundaries set the distance for our view. Trained close to the further balustrade are flowers and shrubs: roses, chrysanthemums, periwinkles and poppies. Beyond is a tangle of laurel, oleander, myrtle and assorted fruit trees; and beyond that is a thicket of oak, pine and cypress. To the casual glance, this simply collects a profusion of growth – the sort of unbridled abundance that Livia might have wanted as symbolic of the gilded peace promoted by her husband's steady rule. But it is more than that. Not only is everything in blossom and ripely laden, but the quince and the pomegranate, which bear fruit in late autumn, are there with blue periwinkles that flower in early spring. Close by are the lavender poppies of early summer.

Birds alight amid these breeze-bent bushes: what can be spotted of their variety includes quail, thrushes, orioles and nightingales. Their jostling is odd, but comprehensible. Just as this is a year depicted without seasons, so it takes no count of migratory needs. All can happen at once. This is the pictorial enchantment of Livia's dining room: a rendition of nature gathered into the imperial embrace; nature made subject to the beneficial regulations of Augustan control.

PARADISE: THE ORIENTAL VIEW OF LANDSCAPE

Although it originates from the East, the idea of paradise has been adopted by Christianity as the destination of souls eternally blessed. But first of all it was the *pairidaeza* of Persian royalty: an enclosed orchard, pleasure ground and hunting park delectably reserved for the king and his close associates. Persian kings, like others before them and after, used dominion over lions as symbolic of their right to rule. A paradise was where they could rehearse the actuality of shooting down big cats (very like their Assyrian predecessors – see page 95).

Paradise could be made - on Earth and out of earth. Although nothing of them survives beyond hearsay, the Hanging Gardens of Babylon, laid out by King Nebuchadnezzar II in the early sixth century BC, and counted in Classical antiquity as one of the Seven Wonders of the World, probably influenced the Persian tradition of paradise parklands. Further east, the fabled pleasure-dome of Kubla Khan in Xanadu

belongs to a similarly long-established prerogative of a ruler to annex his own recreational space; complete with specially engineered lakes, mountains and waterfalls. Records of the Han dynasty in China (206 BC–AD 221) not only tell of such full-scale imperial landscaping, but also attest a miniature, though no less significant, version: the practice of making model scenery, using diminutive, bonsai-style trees. These models, tiny but three-dimensional, would be mounted on trays, and incense burnt at the base served to generate the illusion of cloud-swathed summits.

So the Oriental construction of a paradise landscape was substantial enough. And it provides the background to a history of landscape painting, in China and neighbouring countries, that runs continuously from at least the period of the T'ang dynasty (618–907), when most of China – south of the Yellow River – was organized under a central administration. The precepts of contemplative retreat issued by both Confucian and Taoist philosophers underpin this history: many paintings produced in its course indicate particular or ideal sites of worship, perhaps permitting us to use the term 'sacral-idyllic' here, too (*Fig. 58*). The arcane skills of interpreting space for habitation – the geomantic science known in Chinese as *feng shui* (wind and water) – were also pertinent, especially if we bear in mind that the Chinese word corresponding to the English 'landscape' is *shan shui*, literally 'mountain water'.

Above all, this was an art form with its own closely associated literature. Accounts of Chinese landscape painting are often sprinkled with lines and stanzas of poetry, because citations or distillations of poetic sentiment, done in calligraphic flourishes, were integral to the painting. Moreover, it was not unusual for esteemed exponents of this art to divulge the secrets of their accomplishment and lay down the laws of success. Even at a distance, it becomes clear – largely thanks to the intense complicity of writing and painting – how finely nuanced these landscapes could be in form, style and function.

Poets of the T'ang period include those still venerated as absolute doyens of Chinese verse, such as Li Po and Tu Fu. However, it was their contemporary Wang Wei (699–761) who earned the greater reputation for both poetry and painting together. Of his paintings we have no direct proof, and his poetry is stripped of its calligraphic grace as soon as it goes into translation. Nonetheless, Wang Wei's lyrical address to his friends, his surroundings and his own solitude helps us to measure, if roughly, the significance of landscape in marking shared sensibilities.

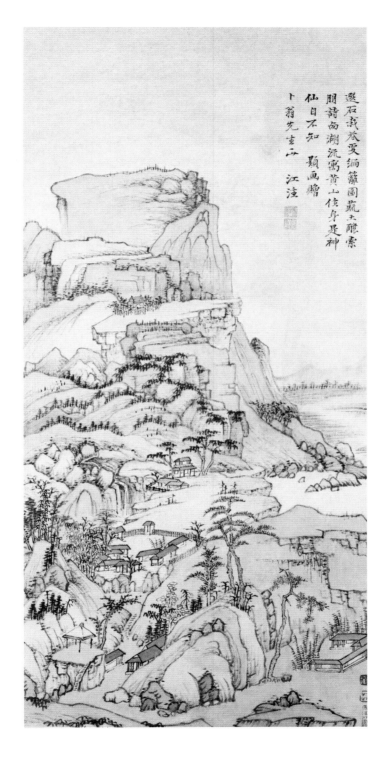

選石試茶炎夏編
籬園蔬大醸素
明詩向湖流寓黄山倚身是神
仙自不知 題画贈
卜翁先生正 江注

58 | 7th-century Chinese landscape painting. Verses hymn the delight of
'living like an immortal' among the pines and streams of Huang-shan,
where the artist, Jiang Zhu, lived as a monastic recluse.

The man of the mountains – wants to go home

Clouds dark dark – rain driving down

Waters surging – green rushes swaying

White egrets suddenly – wheeling about

My friend you must not – hitch up your clothes

Mountains many layered – all one cloud

Heaven and earth confused – indistinguishable

Trees dim and dark – air heavy

Monkeys not seen – only heard

Suddenly west of mountains – evening light

We see among eastern fields – a hundred miles clear

I am sad – thinking of you

('Song for a Friend Going Home to the Mountains')

Typically, a poem is prompted by what can be seen: a curl of smoke from a woodcutter's lodge; cassia flowers in bloom; rain thrashing the willows and hills. Typically, this view causes a pang of sentiment, mainly melancholic: regrets of old age and loneliness, though like other T'ang poets, Wang Wei overtly took solace in wine. But throughout there is the steady projection of self reconciled with the world and its jagged contours. The poet, the painter, the scholar, the government official - all alike find themselves sealed into a scenery that at the same time inspires and mocks their efforts to be wise.

Wang Wei bequeathed nuggets of advice on his art. 'When one paints landscape,' he ruled, 'concept precedes brushwork.' A title might give more guidance than a view, for there was an ordained hierarchy of mountains, and rules existed for the correct arrangement of fishing skiffs along a strait. Such principles were elaborated in an essay *On the Secrets of Landscape Painting* by Li Cheng, a practitioner in the tenth century. He dictated on matters of mood and tone in representing a prospect. 'The atmosphere of the mountain in spring is clear and charming; the trees in summer are thick and luxuriant; the autumnal forest is forlorn and solemn; and the winter trees are resigned and deathlike.' A little later, Kuo Hsi, a painter whose work we possess, urged his apprentices to empathize all the same with what they were depicting. 'A mountain has water as blood, foliage as hair, haze and clouds as its spirit and character,' he wrote. He also advocated the therapeutic utility of a painted landscape. For those not subject to

dutiful postings in faraway districts, the landscape on a scroll made a substitute retreat. 'Without leaving your room,' Kuo Hsi explained, 'you may sit to your heart's content among streams and valleys. The voices of apes and the calls of birds will fall on your ears faintly. The glow of the mountain and the colour of the waters will dazzle your eyes … '

Diversities of religious belief modulated the messages of particular scenes: we know, for example, that Wang Wei was a Buddhist at a time when one strand of Buddhist doctrine extended the quality of enlightenment to non-sentient objects: trees, plants, grasses and rocks. But it is broadly true that painting and poetry during and after the T'ang period shared similar visual cues. Plum blossom, for example, could cause delight by its outburst in hard winter months, or regret by its flimsy transience. And the inscriptions attached to many Chinese landscape scrolls confirm what we might have deduced from the occasions and allegories of Wang Wei's poems: that these images are not merely what they seem. Produced for certain rites of passage – birthdays, farewells, retirement parties – they carry a freight of hopes, thanks and congratulations.

A landscape with pine trees was suitable to honour longevity because pine trees symbolized resistance to the passing years. A landscape with cranes might wish good luck because cranes were auspicious birds. A landscape with faraway peaks would be appropriate for bidding farewell, since the composition itself implied distance and separation. A landscape steeped in mist and clouds, perhaps with calligraphic references to 'sweet rain', or a 'timely downpour' might have been painted in homage to a local administrator, whose beneficent order ensured that crops were always watered; or in itself, the painting may have served as some kind of charm against drought.

These are messages understood from scripts that belong to the pictures. Thanks to the triple alliance of poetry, painting and calligraphy – which during the Sung dynasty (960–1279) was recognized as a formal aspiration, the 'Three Perfections' of artistic endeavour – we also appreciate that many of these landscape paintings feature the painter's own ambience. Wang Meng's *Dwelling in the Ching Pien Mountains*, for example, gives us a view of his family estate near Wuhsien, to the west of Shanghai. But matching a picture with a given prospect was not a priority for these artists and their patrons. It was a Confucian principle that 'the virtuous find pleasure in mountains'. As mountains were hard work to climb, so their negotiation in art and verse required agility of intellect, moral stamina and the sustained application of effort. Plain viewing was for lesser souls.

A PLACE OF LEISURE – OR TOIL?

THE ROMAN EMPEROR Nero earned notoriety from many excesses of autocratic behaviour during his rule (AD 54–68); for some contemporaries, it was his private residence in Rome, the *Domus Aurea* (Golden House), that caused most offence. Nero commandeered a prime urban area for the project, and spared no expense upon its structure and decoration. And this is how the grounds were laid out:

> 'An enormous pool, more like a sea than a pool, was surrounded by buildings made to resemble cities, and by a landscape garden consisting of ploughed fields, vineyards, pastures and woodlands – where every kind of domestic and wild animal roamed about … When the palace had been decorated throughout in such lavish style, Nero dedicated it, condescending to remark: "Good, now at last I can begin to live like a human being!"'
> Suetonius, *Life of Nero*, 31

Knowing what we do of Roman landscape painting, and the cleverness of Roman muralists in creating the effect of rapidly receding depth (*trompe l'oeil*), we can understand what underlay the affront at Nero's scheme. Other inhabitants of Rome contented themselves with painted evocations of extensive countryside surrounds. Nero, by contrast, flagrantly swept aside illusion. For his Golden House, the truth was installed, whatever the cost. It was an index of his absolute power; it marked him apart – to own a piece of land that for everyone else was the stuff of dreams.

This is lordly vanity by no means unique to Nero. Centuries later, Mughal rulers in Afghanistan might look with satisfaction at a portrayal of their own paradise gardens that showed in the foreground the strain and labour entailed in its creation: the digging, the hoeing, the planting (*Fig. 59*). Likewise, we presume that the early fifteenth-century French patron of a series of vignettes known as 'The Splendid Hours of the Duke of Berry' was pleased to see a record of unremitting toil on his estate, charted month by month. It is almost as if the tenant farmers have been put under surveillance. In October, for example, we see one figure on horseback, raking the soil to a tilth, and another wearily casting seed from his apron; neither they nor the armed scarecrow nearby seem very concerned by the eager magpies and crows pecking about (*Fig. 60*). The moated castle beyond is where the gentry abide, and whence they will emerge – in April to go courting, and in May to go hunting, and so on.

درختهای انار هم هست کرد ا کرد حوض تمام سه بکه زار

59 (above) Babur supervising work in the 'Garden of Fidelity', from the Baburnama manuscript, c.1590.

60 (opposite) *Les très riches heures du Duc de Berry — the month of October,* c.1416.

NATURE AS DIVINE REVELATION

To his followers in medieval Italy, the monastic revivalist St Francis of Assisi preached the kinship between mankind and all of God's creation. Legendarily, he exemplified it by his own rapport with nature – feeding the birds, befriending a wolf.

Still in Italy, some two centuries later, the soothing potential of painted landscapes was acknowledged by the architect and all-rounder Leon Battista Alberti (*c.* 1404–72). 'Our minds are cheered beyond measure by the sight of paintings depicting the delightful countryside … the games of shepherds – flowers and verdure … ' More specifically, Alberti saw direct psychosomatic applications for this sort of art. 'Those who suffer from fever,' he wrote, 'are offered much relief by the sight of painted fountains, rivers and running brooks.'

In medieval Europe, following an older Arabic tradition, painting had been put to another medical purpose, namely, making meticulously illustrated almanacs of pharmacological plants and herbs. It may have been with this tradition partly in mind that the German artist Albrecht Dürer produced his arresting close-up of *Das grosse Rasenstück*, (*The Great Turf*), or section of meadowland (*Fig. 61*). It gives a cricket's-eye view of grasses, dandelion, plaintain, yarrow and more; indirectly it conjures up a piquant image of the artist himself laid flat on his belly amid the damp sedge for the sake of this microscopic masterpiece.

'Art lies in Nature,' Dürer ordained, 'so whoever can extract it, possesses it.' This wisdom came from his own faith in a divine creator whose handiwork could not be bettered by any artist. The artist's vocation was to study, and never swerve from studying, the world that God bestowed.

The logic of Dürer's credence is severe, taking us far beyond herbalist manuals. The conclusion is that all landscape – from dandelions to glaciers – is a show of divine revelation.

THE SANCTION OF THE PICTURESQUE

Still-life painters stopped the clock of nature; the painters of Arcadia let it run to eternity.

It was not signalled as such, but by the eighteenth century, Arcadia was effectively established within the educational curriculum of young European aristocrats. Having been schooled in Greek and Latin literature, they put the final polish on their upbringing

61 A painstaking close-up view of meadow grasses – *The Great Turf* by Albrecht Dürer, 1503.

62 (top) *Goethe in the Campagna*, by J.H.W. Tischbein, 1787.

63 (above) *A Pastoral Landscape* by Claude Lorraine, 1677.

by taking a journey down to the lands of Virgil, Theocritus and the rest. Greece, then under the Islamic rule of Ottoman Turks, was perhaps too much of an adventure, though both Greece and Turkey held rich pickings for those who wished to appropriate large-scale souvenirs of Classical sculpture and architecture. Italy was easier. 'Do you know the land where lemon trees bloom?' crooned the German writer Johann Goethe, around 1783. The eighteenth-century Grand Tour was a secular pilgrimage that usually culminated in Rome, whose hinterland (the *campagna*) travellers discovered to be rolling, verdant and gratifyingly staffed by shepherds, who wore hide jerkins and took shelter in straw-roofed huts.

Goethe commissioned a portrait of himself in the midst of that scenery (*Fig. 62*); already it was being treated by painters as a place where Classical myths or historical events might have taken place. So as safe, pleasant or even familiar as the landscape seemed, it was also the setting for extraordinary happenings – where, for example, the blinded giant hunter Orion once trod, seeking to reclaim his sight by the sun's rays. And as everyone schooled in Virgil knew, it was along the River Tiber that the boats came carrying Aeneas, founder-father of the Roman race: the hero was greeted by the same lounging locals as were still to be seen with their flocks. Since any sketchbook view of the *campagna* was likely to include a tumble of ruins, the evocation of ancient epic was not hard to achieve. This was a countryside that Italians would call *suggestivo* – full of murmurs from the past.

Claude Lorraine (1600–82) was one of the painters who made capital of this suggestive quality in his work (*Fig. 63*). His pictures became much sought after by the Grand Tourists who, returning to their gloomier homelands, hankered for the countryside where lemon trees grew. Such was the appetite for this scenery in eighteenth-century Britain that a gadget was produced, 'the Claude-glass'. It comprised a slightly convex and tinted lens through which the viewer of any country prospect gained the characteristic mellow hues and lustre of a Claude Lorraine painting – nature softened and subdued. And if this device were not sufficient, then wealthier individuals summoned professional translators of Claude into three dimensions: such ingenious figures as Lancelot 'Capability' Brown, so called because of his eye for the capabilities of turning a British country estate into a Claude-style scene of picturesque charm.

'The picturesque', a term found in French, Italian and other European languages, means 'like a picture', or 'something seen as a painter would see it'. While this definition

is accurate enough, it does not quite cover the force of the notion as it emerged in
the eighteenth century. People could pose to be picturesque, and so could their gardens.
But *the* picturesque was something else. It was a slice of the Earth's crust that had to
be seen to be believed; it was a tranche of scenery that provoked not only intense
satisfaction, but perhaps also incredulity - to the point of exhilaration, or fear, or both at
once. It was a place that begged to be hymned, sketched, moulded or somehow recorded
for art. If someone had done so before, no matter. Pictures were necessarily what the
picturesque brought forth.

The ex-European settlers in America certainly felt that way. There was a romantic
logic to their choice of sites to serve as the first 'national parks': each one (Grand Canyon,
Rainier, Zion, Yellowstone and Yosemite) is marked by outcrops, chasms and cascades;
no swamps or plains encroach. If indigenous peoples occupied these prime sites, they
were swiftly dislodged. For romanticism was here reinforced by a powerful doctrine of
divine permanence or revelation in the land; an affirming of some sacral rapport between
these colonists and their adopted home. (That the Indians before them had also steeped
their environment with divine spirits was perhaps further reason to assert the Christian
claim.) In New England, Ralph Emerson and his junior disciple Henry David Thoreau
(1817–62) were the most articulate of these visionaries. In his 1836 essay *Nature*,
Emerson wrote of the self-effacement gained by surrender to the pulsing forces of stream
and sap ('all mean egotism vanishes … the currents of Universal Being circulate through
me; I am part or parcel of God,' he enthused). Thoreau, meanwhile, cultivated the
'society of Nature' from a house he built for himself by the edge of Walden Pond, a
contemplative space within walking distance of his home in Concord, Massachusetts.

Lines of longitude and latitude were projected on to America by the country's
third president, Thomas Jefferson. This was done chiefly to facilitate the definition of
administrative districts, but in Jefferson's compilation of data about his home
constituency – *Notes on the State of Virginia* (1787) – we see a founding father laying
down the ideal of righteous possession. Of a naturally formed bridge in Virginia,
Jefferson concluded that it was 'impossible for the emotions arising from the sublime,
to be felt beyond what they are here: so beautiful an arch, so elevated, so light, and

64 *The Natural Bridge, Virginia* by F.E. Church, 1852.

65 T.H. O'Sullivan's atmospheric photograph, taken in 1871, of Black Canyon on the Colorado River, Arizona.

springing as it were up to heaven … '; it must be the handiwork of 'the Almighty'. Landscape painters were duly lured to the spot, notably Frederic Edwin Church (*Fig. 64*), whose own locality (overlooking the Hudson River in upstate New York) was also officially perceived as picturesque.

Church did also seek beyond the United States for his views, painting in the Arctic and in the tropics. For most Americans, however, the wonders of their own land were sufficiently venerable, and to be witnessed with proper trepidation even if captured on camera. When Congress dispatched a geological survey to the Great Basin areas of Nevada, Arizona, Utah and New Mexico in 1867–74, the expedition was accompanied by the photographer Timothy O'Sullivan, who took care to convey the fearsome aspect of the scenery he recorded. Few of his compositions lack a human figure as some minuscule indicator of scale; so even when conditions were evidently sunny and placid, the sense of an immanent Almighty is installed with due apprehension (*Fig. 65*).

ART ON LAND

The very first use of a photographic device, in 1826, seems to have been for a shot of scenery, producing what we might want to call a landscape. Again, we are reminded of art's tenuous rapport with the environment – attempting to capture a view that is destined to change. But what if artists acknowledged the rhythms of formation, erosion, submergence and decay, and worked with them?

'Land Art' is a phenomenon that emerged in the late 1960s. It may be documented photographically – for the record – but otherwise defies norms of permanence, transport and replication. This is art whose materials are not only often organic – pebbles, ferns, deer droppings, bark – but sometimes also naturally pre-shaped (icicles, sand-drifts) or else naturally liable to metamorphosis (a cluster of buds that will break into flower). This art is complacent with decay. The sites of such ecological cooperation are not necessarily remote, though its practitioners tend to capitalize on what is untouched about the world's surface. The British artist Richard Long once simply created a circle in the Sahara desert by clearing shingle to expose sand – enough to say one human had passed that way and left a print.

Land Art may have no message for those who see it, save to make them ponder on the passing of time. It is overtly contemporary art, not made to last; yet, as Richard Long

and others have made clear, the inspirational debt to prehistory is great. Perhaps no other mode of art has had such a keen sense of its own potential archaeology.

One herald of the genre was the American Robert Smithson, whose 1970 'earthwork' entitled *Spiral Jetty* cannot presently be seen, except on celluloid (*Fig. 66*). Smithson talked of conducting through his work 'a democratic dialectic between the sylvan and the industrial'; but we may now sense opposing forces differently. In order to extend his anti-clockwise coil into the waters of the Great Salt Lake, the artist took out a 20-year lease on the land. His bid to posterity went no further than that. Perhaps the shape suggested a collapsed tower, or a snail shell; perhaps it was left there like some giant question mark. In any case, it makes a point – by being submerged. Using dumper trucks, Smithson laid out what would seem like a monumental inscription upon the Earth's crust, more solid, we should say, than any tenuous arrangement of particles in oil paints and canvas. Yet it did not resist a water-level rise. The *Spiral Jetty* was as nature is: grained into the energies of flux, growth, weathering and instability. It may yet reappear, one day – or centuries from now.

66 A 1970 photograph of Robert Smithson's temporary *Spiral Jetty*.

6
ART
AND
POWER

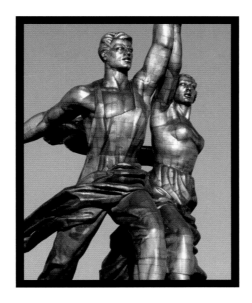

IN THE ANCIENT WEST AFRICAN KINGDOM OF BENIN, the king ruled by divine right. He was known to his people as the 'oba'; his realm was defined as that area in which the oba held the power of life or death over his subjects. His mother, the 'iye oba', was a figure of great supportive importance, maintaining her own palace and staff of retainers and dignitaries; and the oba could not assume rule without permission from a council of king-maker chiefs. But once established, the oba laid personal claim to what his territory contained: the coral of its shoreline, for example, all belonged to him. Myths of the Edo, the people who were the oba's tribal subjects, attributed the oba with control over animals: so crocodiles, for instance, were his 'policemen of the water'. He was deemed to command natural elements, too: the resources of air and water depended on him. The oba was, in short, a personage to be signified apart. From the fourteenth century onwards, the favoured sculptural medium for this distinction was solid-cast bronze or brass.

Alloys of copper and tin or copper and zinc respectively, bronze and brass are non-rusting metals. This rust-free quality gives both materials the value of conveying the willed permanence of kingly power. Moulded into free-standing statues and busts, or more often plaques in high relief, the effigies of the oba can be arranged in a chronological sequence according to variations of headdress and other insignia.

Typically, the oba will be shown almost walled behind a high choker of coral beads, with a net-like cap – also linked with coral beads – enclosing his brow (*Fig. 67*). On a plaque, which would be fixed to a pillar within the palace complex, he may be shown with raised sword, and decked with further items of office: necklace of leopard's teeth, tasselled crown, bracelets and beaded sash.

Over centuries, the adornments accrued and commissioned by each successive oba of Benin accumulated into an enviable store. One palace courtyard seen by a European visitor in the eighteenth century was estimated to contain some 3000 elephant tusks. What eventually happened, as the Dark Continent of Africa began to be penetrated by European colonists, is perhaps predictable. In 1897, a small detachment of British troops on a 'diplomatic mission' in West Africa was ambushed – allegedly by Edo warriors from the kingdom of Benin. The British promptly mobilized a larger force, which descended upon the royal capital of Benin City. The oba's palaces were burnt to the ground, but not, however, before thousands of items of regalia had been seized. The Edo territory was annexed and made part of the British colonial state of Nigeria.

An empire had swallowed a kingdom. The British soldiers who sacked Benin City had sworn an oath of loyalty to their monarch, Queen Victoria (1819–1901). She had already taken the title Empress of India; large parts of Africa were already annexed in her name. And by tradition, colonial expansion was marked at home by the arrival of treasures. The marbles of the Parthenon and whole parts of Assyrian palaces were – thanks largely to assistance from the Royal Navy – installed in the British Museum, as if a great showcase of imperial might. From the British Protectorate territory of Egypt an almost symbolic exchange of goods occurred. Huge packing cases were delivered to the museum's gates: they had been sent out to Egypt and the Sudan filled with ammunition and military hardware; they came back containing statues, mummies and all sorts of treasures from Pharaonic times.

In certain situations of tribal conflict, we are told, the chief of a victorious tribe would eat his opposing number. Supposedly civilized conquest does something similar – only by symbolic means. Transfer of power is signalled by the ingestion of symbols of power. What was precious to the enemy becomes the victor's spoils. If Queen Victoria was not conscious of this symbolic process, then she might have looked more closely at the collection of art within her own regal premises. At Hampton Court, a previous British monarch – Charles I (1600–49) – had purchased a series of paintings by an Italian

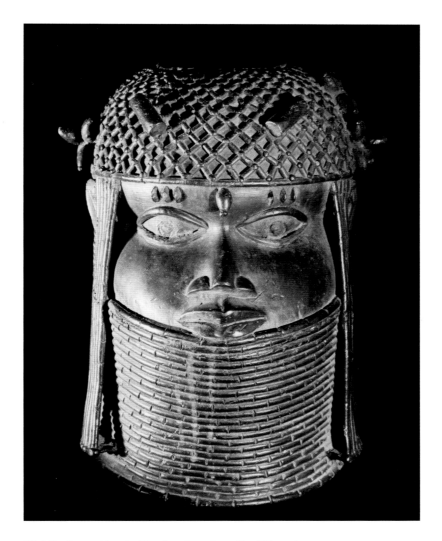

67 A Benin royal head with winged cap from the 19th century.

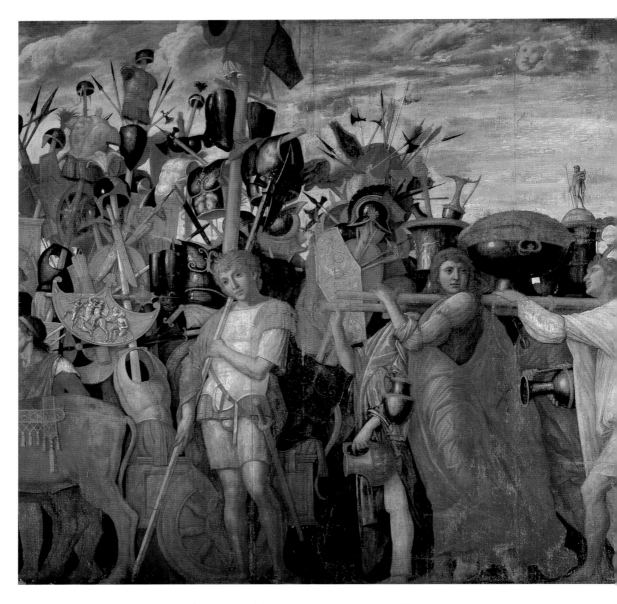

68 Booty in Procession: Panel IV of *The Triumph of Caesar* by Andrea Mantegna, 1485–6.

Renaissance master that imaginatively re-created an ancient Roman triumph (*Fig. 68*). The Roman army has been abroad; now it comes home and makes a procession of its success. The city of Rome has absorbed another foreign state or kingdom: the city will be duly embellished with the ostentatious and often exotic trophies newly acquired.

The truth underlying this process is that systems of power essentially rely upon symbols of power. 'The pen is mightier than the sword' goes one adage, meaning that words and persuasion can be more effective in gaining power than sheer brute force. History is packed with proof that 'winning the peace' is more difficult, yet more conclusive, than simply prevailing in battle. The British in Benin were aware of this. They possessed outright military superiority, which of course underpinned their political manoeuvres in the region. But destroying the oba in person was unlikely to bring about colonial stability. So the action taken at Benin City was symbolic. To seize the oba's bronzes was to remove those adornments that proclaimed his power. To this day his title exists and is filled, but that is all.

This chapter, then, is about the symbolic expression of power – beginning with the devices used to state individual claims to pre-eminence and authority, and ending with the development of techniques of mass persuasion. If there is any truth in Thomas Jefferson's democratic declaration of 1776 that 'all men are created equal', then what follows may be read as an analysis of the social chemistry whereby that truth evaporates.

STATING SUPERIORITY

'Art at court' is one way of classifying this symbolism of authority, and it is tempting to identify some universal characteristics of court commissions. We might observe, for example, what appears to be a basic inclination of all human potentates: the penchant for borrowing motifs from the animal world. Supremacy becomes a paramount eagle with outstretched wings; fearlessness, a roaring lion. Heraldry, the system of symbolic devices designed for the world's nobility and royal dynasties, relies very firmly upon such associations, even in countries where neither eagles nor lions exist. So monarchical strutting can look rather like the displays of distinctive gaudiness in other species, especially birds, as shown by one Polynesian chief encountered by European missionaries in the nineteenth century (*Fig. 69*). The same behavioural logic underpins both this 'primitive' dressing-up and the masques at 'sophisticated' courts, such as that

of Louis XIV of France (1643–1715), who was preened by his advisers to act as *le Roi Soleil* (the Sun King). When Louis appeared to courtiers in the guise of Apollo, the ancient Greek god of enlightenment, it was in a flame-fringed costume topped with feathers, making an effect as visually shrill as any mating peacock (*Fig. 70*).

It seems like pantomime. And anthropologists have formulated a concept, the 'theatre state', to explain the place of parades and pomp, furs and feathers in autocratic government. The concept was first used to explain the pattern of public ceremonies in nineteenth-century Bali, a relatively small and insignificant kingdom, but that does not detract from the sincerity of histrionic power shows within its bounds. For Clifford Geertz, who made this Balinese case study, it was a 'state in which the kings and princes were the impresarios, the priests the directors, and the peasants the supporting cast, stage crew and audience'.

History tells of many autocrats ejected and overthrown; history also vouches for the fact that threats to a monarch's power usually come from his or her own confidantes or privy counsellors, not from the people. It would be facile to assume, then, that all royal ceremonials were staged to dissuade the masses from revolt. And when we gaze upon the art and accoutrements that bolstered a royal claim to rule, we may want to keep in mind the angry response of Shakespeare's King Lear, when challenged on his necessity for a retinue: 'O reason not the need!' Followers, panoplies, carriages, trailing robes – who can say what is surplus to requirement in matters of regalia? 'Pomp and circumstance' is how the show goes on.

But when did all it begin?

THE ARRIVAL OF THE 'BIG MAN'

Although under 1.8 metres (6 feet), he was tall for the time, and, apart from a damaged knee, in robust physical health. He was about 40 years old, which in those days was a grand old age, and he had travelled some distance to reach Amesbury, the place where he was eventually buried, not far from the most impressive monument of British prehistory – Stonehenge. Isotopic scrutiny of his bodily remains suggests that he originated from central Europe, somewhere close to the Alps.

The man's name will never be known because in Europe *c.* 2300 BC, which is the date of his burial, no one could read or write. They could, however, recognize symbols of

69 (left) Te Po, a chief of Rarotonga, after a painting by John Williams Jnr, *c*.1837.

70 (above) Louis XIV as Apollo, 1654.

power when they saw them, and this sturdy, venerable foreigner came loaded with just such potent symbols. In his hair he wore curled pieces of beaten gold, small but gleaming; about his person he had not only a bow and a quiver full of flint-tipped arrows, but also a number of knives with copper blades. These knives, like the hair-clasps, were not large, but their metal made them very special possessions.

We can imagine how this individual once appeared. Discovered in the spring of 2002, he has soon gained a reputation as the hypothetical 'King of Stonehenge'. The title is almost irresistible. So far as we know, he was the first person in Britain to parade gold jewellery, and his grave seems to be the earliest of a series of 'Big Man' burials in this region of the southwest known as Wessex. Beakers of pottery and metal, axes and daggers, bracelets, pendants and other adornments of well-worked gold – these mark the status of presumed overlords. That they had large numbers of subjects under their rule is inferred simply from the size of the earth mounds and standing stones erected in the area. An assessment of the labour required to build Stonehenge (*Fig. 71*) – usually dated to between 2400 and 2200 BC – estimates some 50 million man-hours of effort. It is hard to believe that in command of such a grandiose project there was not some supreme individual equivalent to a king.

Ancient Egypt provides a model for supposing such a hierarchy (see page 61). And where the burial of a pharaoh has been found intact, the association of gold with power can seem almost overwhelmingly close. But distinctive ornament and hoards of precious metal are not the only signs of social stratification. Consider the operations of power that affect *us* on a daily basis – the tax bills, the traffic wardens, the signs that say 'Keep off the Grass'. When did such mundane systems of order and bureaucracy take root?

Along with other aspects of what archaeologists define as civilization, the origins of administrative systems are to be found in Anatolia and Mesopotamia. The transition from nomadic hunting and gathering to settlements and agriculture, which happened in these areas during the early Neolithic period (10,000–7000 BC), naturally entailed *controlling* the food supply – keeping animals fenced in, harvesting grain for storage. The recourse to pottery, and eventually (*c.* 3400 BC) sturdy vessels shaped on a wheel, greatly facilitated the grain-storing possibilities: but still the stored food had to be monitored. At one hilltop site in southern Turkey, Arslantepe, the remains of a palace structure of the fourth millennium BC have been uncovered, revealing a number of storerooms, where large lidded jars were stacked. These containers were sealed with clay in such a way that

the lid could be opened only by breaking the seal. The same anti-pilfering measure was applied to baskets, sacks and doors. And to guarantee the authenticity of the seals, engraved clay stamps were impressed upon them, thus labelling the wares within.

By *c.* 3000 BC, these clay seals gave way to pieces of stone or some other durable medium, cylindrical in shape and carved with a design in relief, which could be rolled into moist clay, leaving a particular motif. So goods that had been brought into a particular centre for deposit and redistribution were 'signed and sealed'. What began as a system for maintaining equal access to resources by all the members of a settled community became a system of economic control by some people over others. An elite was formed, composed not only of supreme individuals, but intermediary staff who were the prehistoric forerunners of the types we know as bureaucrats.

This much may be inferred from the local iconography of the royal seal in Mesopotamia. Used exclusively by a particular Mesopotamian potentate and his or her staff, the cylinder seal could be worn like a jewel or carried like a key in the corridors of power. Epitomizing royal status, it depicted the king slaying a lion, or the queen at a banquet (*Fig. 72*).

The so-called cylinder seals are small and numerous signs of a larger process of defining royal status. From southern (Sumerian) Mesopotamia there survives an item of regalia that might serve as an ideal possession for all monarchs ever after. This comes in the form of a sounding-box, once part of a musical instrument, inlaid with shells and precious stones, and presenting registers of what might be termed the princely lifestyle, whether in times of peace or war (*Fig. 73*). In the friezes of battle there are files of men to command, eager horses and the latest gleaming equipment (the appearance of chariots here is a novelty, as far as we know). All that remains to complete the picture is an enemy, either prostrated in homage or else laid to rest. The imagery of regal valour assists in justifying the privileges and prerogatives of kingship, which include the very possession of this object. The box makes music for the king's ears; it is constructed out of precious materials, which are part of the king's treasure store; and it was put together by skilled craftsmen working by royal appointment.

The relic was excavated from a tomb in the royal cemetery of the city of Ur. Archaeological evidence suggests that whenever a monarch died here, a number of attendants were slain and buried alongside, as if to accompany their superior into the world to come. This phenomenon, as we shall see, is not unique to ancient Mesopotamia

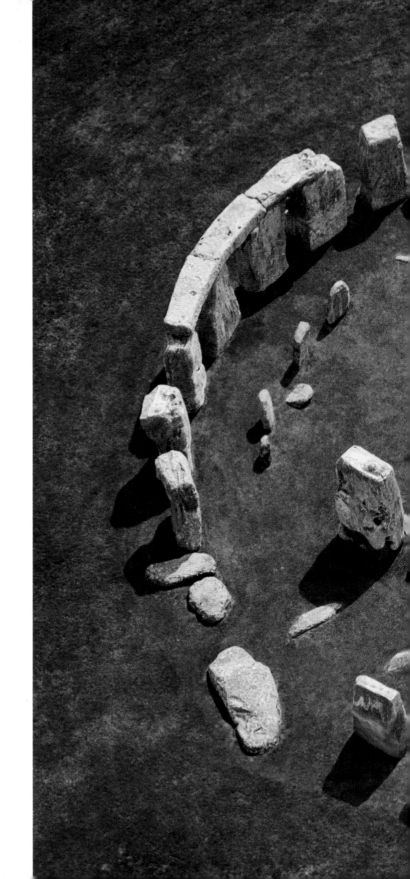

71 A view of Stonehenge, as it looks today.

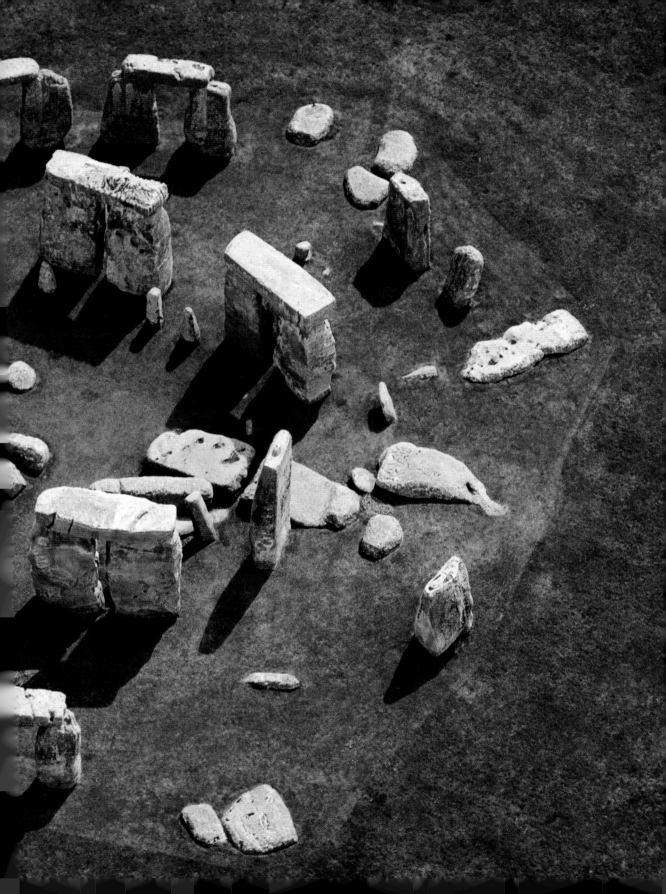

72 (top) *Queen Puabi Feasting* – an impression of a Sumerian cylinder seal from Ur, c. 2600 BC.

73 (above) Detail of the Sumerian sounding-box from Ur, from the 3rd millennium BC.

(see page 270). One determining factor, however, was the divinity claimed by the steward of earthly power, as we gather from the words of a hymn chanted at the coronation of a Sumerian king called Rim-Sin in 1822 BC.

'You have been chosen rightly for the shepherdship of Sumer and Akkad …
May the god fix the holy crown on your head.
May he install you grandly on the throne of life,
May he fill your hands with the sceptre of justice,
May he bind to your body the mace which controls the people
May he make you grasp the mace which multiplies the people
May he open for you the shining udder of heaven, and rain down for you
the rains of heaven.'

Compounding this paternalistic authority was the regent's control over the administration of justice. The first recorded systems of state legislation come from the Middle East; the best known, though not the earliest, is the Law Code of the Babylonian King Hammurabi (who reigned probably from 1792 to 1750 BC). In its detail this sets out a system of justice that is essentially about retaliation, but its express purpose was 'to destroy the wicked and the evil, that the strong may not oppress the weak'. Hammurabi's closing statement repeats that intention: 'My words are precious, my wisdom is unrivalled … Let any oppressed man, who has a cause, come before my image as king of righteousness!'

The sovereign embodies justice; wisdom resides in the sovereign's own palace. When the Hebrew Book of Proverbs (9.1) speaks of wisdom occupying a house of seven pillars, it evokes the palatial context of a monarchy that claims to adjudicate not only in matters of high-level state policy, but also in the most petty disputes of the lowliest subjects – redress for a pilfered lamb, and so on. A good idea of how such a palace would have been laid out and decorated comes from the site of Mari, on the middle Euphrates, which was conquered by Hammurabi in 1760 BC and thereafter ruled by his delegate, Zimri-Lim. Zimri-Lim ruled from a complex of some 300 rooms, several of which have been identified as 'audience rooms', where the king would sit in judgement. An archive containing more than 20,000 inscribed tablets provided official guidance on customs and case histories. But if supplicants were in any doubt over the king's right to dispense justice, paintings and sculptures within the reception rooms of the palace illustrated his

investiture, sanctioned by divine powers. It was a rapport between heaven and earth, maintained by the king through rites and sacrifices; and lest anyone be forgetful of that, those rites and sacrifices were also represented (*Fig. 74*).

THE ART OF MANAGING AN EMPIRE

The annals of ancient Mesopotamia and the Near East offer a grimly repetitive chronicle of collision and dispute between separate kingdoms. The Assyrian king Ashurbanipal, whose sculpted tales of victory we have already encountered (see pages 94–8), was typically lyrical in boasting how comprehensively he had destroyed Susa, the city of his enemies the Elamites. 'In a month of days I levelled the whole of Elam. I deprived its fields of the sounds of human voices, the tread of cattle and sheep, the refrain of joyous animals.' In turn, the Assyrian royal city of Nineveh was sacked in 612 BC by the Babylonians. Babylon, now an assortment of ruins by the Euphrates to the south of Baghdad, was then enjoying a renaissance, with one ruler, Nebuchadnezzar II (604–562 BC), making raids abroad and embellishing the city with great decorated gateways. (The Hanging Gardens of Babylon, esteemed as one the Seven Wonders of the World by Classical tradition, seemingly belonged to one of Nebuchadnezzar's palaces.) It was Nebuchadnezzar who sacked the temple at Jerusalem, and took Hebrew captives as forced labour for his building projects. But the cycle of royal fortunes soon moved on. A new power appeared in the region. It came in the person of Cyrus, king of Persia, hailed by the Hebrews as 'God's anointed', the liberator who saved them from their 'Babylonian captivity'. Cyrus (559–529 BC) did not destroy Babylon, nor massacre its inhabitants. He wanted the city as it was – a possession for the long term.

The Persians were essentially a nomadic people of the Iranian plateau. They were migratory, living in tents; yet as these nomads gained in power and number (inscribed tablets of the ninth century BC mention two separate groups at large, the Medes and the Persians, considered by their enemies to be the same force), they acquired for themselves a territory that stretched from the Indus to the Balkans. It would be the most extensive tract of ethnic domination so far established anywhere: effectively, the world's first empire.

The stabilization of the Persians can be dated to around 700 BC, under the leadership of Achaemenes, who gave rise to the Achaemenid dynasty. By the end of the reign of Cyrus, Achaemenid conquests encompassed an area from the Persian Gulf to

74 A fragment of a wall painting from the palace at Mari (Tell Hariri, Syria), from the 18th century BC, showing a bull in a sacrificial procession.

the Aegean Sea. The question was: how would the successors of Cyrus manage to keep control of this vast territory?

Cyrus himself left few clues. It is only from non-Persian sources – Greek, Hebrew and Babylonian – that we learn of his relative benevolence as a conqueror, ensuring, for example, the return of deported peoples from Babylon. As a matter of general policy, the Achaemenids preferred to entrust regional rule to satraps (local governors), who in turn were answerable to the Persian 'Great King'. But where was the Great King to be found? Deep in the Shiraz desert that was, as far as any place could be, the homeland of the nomadic Persians, Cyrus bequeathed some indications of the Achaemenid determination to build a monumental centre of empire. A residential palace was laid out at Pasargadae, and close by Cyrus commissioned his own imposing final place of rest. Raised in white marble, with stepped base and gabled roof, the tomb of Cyrus is now, however, all that commands attention from posterity. The monumental centre would arise elsewhere, when one of the successors of Cyrus set about constructively resolving the problem of how a huge empire might be maintained.

His name was Darius, or more authentically Darayavaush, which means 'holding firm the good'. Coming to power in 522 BC, Darius immediately encountered problems: usurpers to his throne, rebellions in the provinces, satraps seeking independence. It was an unruly situation, demanding harsh measures. But for Darius it was not enough simply to crush his opponents; all future disobedience must be deterred. It was necessary to broadcast the message that Darius was indeed holding firm the good, and that his subjects would be wise to have faith in his rule. But he ruled over millions of people across over 20 different nations. The Persian empire contained a multiplicity of ethnic groups and languages, with the potential for the sort of mutual incomprehension illustrated by the Biblical story of the Tower of Babel (Genesis 11). In a world without mass communication, how was Darius to impose his will over so many subjects?

Sensitive to the multilingual situation, Darius had his proclamations routinely inscribed in old Persian, Elamite and Babylonian. But ultimately, he could not depend upon texts – still less upon the ability of people to read them. So his answer was art: the international language of images. At strategic sites around his empire, Darius set up conspicuous statements of his authority. So on a cliff-face by Bisitun (or Behistun), dominating a route crossing from the Persian heartlands westwards, a trilingual declaration about how Darius had suppressed the early threats to his regime was

supplemented by a huge relief showing him in punitive triumph over his foes (*Fig. 75*). It was like a permanent political billboard. Its announcement was clear: cooperate with the rule of Darius or else face swift and severe retribution.

Darius, however, did not intend to style himself as a tyrant who relied upon terror and depredation. Once he had secured his own position as Great King, he turned his attention to structuring a political system that would appear to be of obvious benefit to all its various members and supporters. We do not possess any biography of Darius, but his policy is made transparent on a number of surviving inscriptions. Echoing the judicious sentiments of Hammurabi's Law Code, Darius repeatedly stresses an ideal of kingship that is not self-seeking; rather, a duty assigned to him by divine will. Like all the Achaemenid kings, he styled himself as simply the vicar or steward of cosmic order. The supreme deity was Ahuramazda, as revealed by the prophet Zoroaster (or Zarathustra). At Susa, where Darius sponsored a palace and a large *apadana* or reception hall, we find the following declaration:

'Much that was badly done, I made beautiful. Countries were in disturbance. One man was striking another. So I acted by favour of Ahuramazda, that no one strikes another, and each is in his own place. My law, of which they are afraid, is that the stronger does not strike the weak one, nor destroy him.'

Darius did not neglect the palace complex created for Cyrus at Pasargadae. But the ambition of installing himself as if at the hub rather than the apex of a great empire demanded new symbolic structures. Susa was one of these, but more grandiose, and better preserved, is the site known as Persepolis (*Fig. 76*).

Although it was much elaborated by his successors (notably Xerxes and Artaxerxes, his son and grandson respectively), Persepolis reveals to us the political vision of Darius. Laid out on an eminent terrace commanding a broad, fertile expanse, it was neither a city nor a royal residence: few signs of permanent occupation have been discovered here. Instead, Persepolis functioned as a ceremonial showpiece, where subjects of the Persian empire were occasionally united, and made to feel that they were not so much subjects as beneficiaries. Annually, at the time of the Persian New Year – which is still a major celebration in modern Iran – Darius invited ambassadors from all the nations of the empire to join him for an audience. The staircases leading to the Great Hall, where

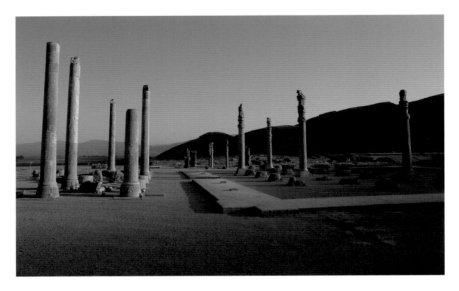

75 (top) The lofty relief of a triumphant Darius at Bisitun, c. 500 BC.

76 (above) Persepolis today – in fertile territory near Shiraz (Iran).

such imperial receptions were held, bear reliefs conveying the harmonious and dignified spirit in which Darius issued this invitation. The ambassadors, representing 23 different ethnicities, are shown clad in their national costumes – Scythians with their pointed caps, Indians wearing the *dhoti*, and so on – and they appear to be forming a happy procession, some ushered along by Persian guards or courtiers, others turning around to talk among themselves. Nowhere is there any sign of coercion, nor the slightest indication that visitors were required to approach with grovelling self-abasement before the person of the Great King. True, on the Persepolis reliefs generally there is a marked presence of Persian archers and royal guards, and all of the foreign representatives are carrying some form of tribute to their host: a dromedary from the Arabians, a kudu from the Libyans, vases, cups and bracelets from the Lydians on the Ionian coast, and diverse gifts from other peoples according to their regional identities. But what is evoked here is an act of respectful homage, not terrible taxation. The programme of images at Persepolis was designed to reassure rather than intimidate its viewers (*Fig. 77*).

Darius did not conceal the fact that his palaces were put together almost entirely by foreign expertise. On the contrary, he was evidently proud of his power to command artisans, building materials and ornaments from faraway places within his cosmopolitan empire. A tablet known as Susa's 'Foundation Charter' itemizes that cedarwood was brought from Lebanon, teak from India, gold from Bactria, silver and ebony from Egypt, ivory from Ethiopia, and so on; and that the stonecutters were Ionian (Greeks, most likely, from Persian-conquered cities and islands along the Asia Minor coastline), the goldsmiths Egyptian, and the brick-bakers Babylonian.

Of course, all these specialist craftsmen worked to Persian requirements, and at Persepolis the result can seem ordered to a fault. Hence the notorious reaction of one young Englishman, George Curzon, in the late nineteenth century:

'No one can wander over the Persepolis platform, from storied stairway to stairway to stairway, from sculptured doorway to graven pier, no one can contemplate the 1200 human figures that still move in solemn reduplication upon the stone, without being struck by a sense of monotony and fatigue. It is all the same, and the same again, and yet again.'

Curzon, like most Westerners, was educated in a Classical tradition that demonized the Persians as ruthless tyrants, the would-be invaders of Europe, whose huge armies had been so heroically opposed by the Greeks at battles such as Marathon and Thermopylae. Compared to the art of fifth-century BC Greece – in Athens the Parthenon was erected as a thank-offering to mark the end of hostilities with Persia – the decoration of Persepolis seems subservient to restrictions of perspective, stylized detail and gestural range. Precisely ten formulaic ways of defining kingship have been counted: these include the king enthroned, the king carried aloft by his subjects, the king surveying vanquished enemies, the king at an altar, the king receiving tribute, and the king shaded by servants holding a parasol. Many hundreds of archers are sculpted on the exterior walls of the *apadana* at Persepolis: their poses, hairstyles and attributes are almost identical throughout. There is no narrative of the king's deeds, no mythography of his birth or of his divine rapport with Ahuramazda. However, to complain of monotony here is to miss the cumulative visual impact intended by Persepolis. As Lord Curzon himself conceded, 'everything is directed, with unashamed repetition, to … the delineation of majesty in its most imperial guise, the pomp and panoply of him who was well styled the Great King.'

And if visitors to Persepolis found the whole place overwhelming, then Darius and his successors considerately provided a posthumous affirmation of Achaemenid majesty emblazoned large upon their tombs. Several of these were cut into sheer cliffs at the nearby site known as Naqsh-i-Rustam. They are all very similar in scheme, and the text inscribed by the tomb of Darius declares somewhat predictable royal characteristics:

'By the favour of Ahuramazda I am that sort of man who is the friend of right … It is not my desire that the weak man should have wrong done to him by the strong … I am not the friend of the deceitful man. I am not quick-tempered: those things which happen in my anger I firmly hold in control by my reason … '

The associated images, carved in deep relief for all below to see, show the king's throne being supported – again happily – by the many nations of the empire. The king himself is represented with a bow in his hand, symbolizing not just his usefulness on the battlefield, but his qualities of balance and control – qualities central to the ideal of kingship as framed by Darius.

77 A stairway frieze at Persepolis showing a procession of Median visitors carrying lotus flowers, c.500–450 BC.

And as if to deploy this symbol as a political logo, Darius had the image of himself as an archer stamped on small pieces of metal. This was a stroke of genius. For the first time ever, a leader was represented upon a coin. Small, portable and distinctive, this medium for self-promotion reached parts of his empire as no other method could.

Darius died in 486 BC. A few years later his son, Xerxes, accomplished what Darius had failed to do: a raid on the Greeks to punish them for burning down the cedar forests around the Persian province of Sardis on the Anatolian coast. Xerxes occupied the Acropolis of Athens, and by way of reprisal set fire to the precious olive groves of Attica. This was a humiliation the Greeks vowed to avenge. But the Greeks, divided into many small city-states – some democratic, others not – would have to wait over a century until a king appeared among them who was strong enough to exact vengeance. This saviour of the Greeks would not only have to match the Persians in military strength, but also learn from Darius invaluable lessons about the overwhelming power of images.

ALEXANDER THE GREAT, 'A GOD AMONG MEN'

Persepolis was put to flames in 330 BC. Whether that was a deliberate action, or mischief resulting from some drunken revel, we do not know. In either case, responsibility is laid at the feet of the Macedonian monarch traditionally saluted as Alexander the Great, who, in just 12 or 13 years of command, led his armies across the entire reach of the Persian empire and beyond.

Alexander's genius as a military strategist was honoured in antiquity, and has hardly been questioned since. And even sources hostile to him do not deny that he was an extraordinarily inspirational figure, whose own reckless presence as a commander greatly contributed to the success of his campaigns. For centuries, the story of Alexander's achievement was the romance of a dashing, heroic soldier who led from the front. This is the story that still suits Hollywood. Of late, however, historians and archaeologists have begun to revise the script. The daring young general is still there, but in two important respects the Alexander myth is now subject to modification. First, it has become clear that the aim of seizing the Asian empire created by the Achaemenids was not originally Alexander's, but came from his father, so from an early age Alexander was 'programmed' to implement an existing foreign policy. Second, while not discounting the value of Alexander's own force as a personality, we have become more aware of the

extent to which his success depended upon the fabrication and diffusion of his image. The phenomenon of Alexander 'the Great' then translates into a study not of the art of power, but rather, the power of art.

So how did he do it? The search for an answer to that question begins in his birthplace, Macedonia, where recent excavations have radically altered our view of the region's ancient history.

Now part of modern Greece, Macedonia in Alexander's time was a small, independent and aggressively expanding kingdom. Alexander's father, Philip II, belonged to a dynasty claiming descent from the deified hero Herakles. It was Philip who waged war upon the Greek city-states to the south of Macedonia, including Athens and Sparta; and Philip, too, who was proud to be listed as a victor in the all-Greek Olympic Games, and who entrusted his son's education to Aristotle, the most formidable Greek philosopher of the age.

The site identified as Aristotle's Macedonian academy, established *c.* 350 BC, is a little-visited, immediately pleasing place – the so-called Nymphaion at Isvoria, near the wine-producing centre of Naoussa. Cascades gush down through a terraced hillside, with walkways and colonnades set amid groves of shady oaks and walnut trees. The tranquillity seems timeless; it is hard to imagine that the young prince Alexander was here so fiercely drilled by his teacher, as evoked in the lines of W.B. Yeats: 'Aristotle played a taws/Upon the bottom of a king of kings'. In fact, we can only speculate what Alexander learnt from the eminent philosopher, other than going through the text of Homer's *Iliad* with him. But it seems likely that Aristotle, with one eye on precepts laid down by his own mentor, Plato, sought to impress upon Alexander the importance of demonstrating his personal superiority over the rest of mankind. Plato, in his dialogue known as *The Republic*, had advocated the 'philosopher king' as a political ideal. Aristotle, to judge from his tract entitled *The Politics*, was more realistic. He suspected that democracy would one day prevail as the least offensive system of government, but if monarchy were to succeed, it was imperative that the monarch appear to be 'a god among men'. The successful king must be transparently outstanding: he must leave his subjects in no doubt as to his own excellence.

So Alexander was primed from his youth to become 'Alexander the Great'. His ancient biographers tell us how he was trained to lead armies, and how he was instilled with dauntless courage (even if it had to be fuelled by hard drinking). We learn that of all Homer's heroes, Alexander's favourite was Achilles, the most violent and moody;

and that Alexander thought of himself as a second Herakles, whose mythological curriculum vitae bulged with proofs of monster-slaying bravado. But even a leader with Alexander's reputed stamina could not be everywhere at once, appearing as 'god among men' to all his subjects at home while fighting full time abroad. How could he create a divine presence while he himself was absent?

A marble head at Pella plausibly gives us Alexander as crown prince (*Fig. 78*). Bright-eyed, with tousled hair, he has the eager features of adolescence, yet there is no way of telling if this 'portrait' was done in Alexander's lifetime, or produced – like most others – after his death. This is a recurrent problem that confronts anyone following the trail of Alexander's images: he was such a posthumous cult figure in the ancient world that portrayals of him multiplied. However, in 1978, excavations in Macedonia finally proved that a distinctive image or 'look' had indeed been formulated for Alexander before he assumed his full commanding role.

The find occurred at Vergina, near the modern town of Veroia, to the northwest of Thessaloniki. Thanks largely to the passionate patience of one archaeologist, Manolis Andronikos, structural remains at Vergina have been identified as Aigai, the ceremonial capital of ancient Macedon. It was also the site of the royal cemetery. Andronikos and his team knew they were unlikely to find the grave of Alexander here – ancient sources suggested a hero's burial in Egypt, though its location remains elusive – but a number of *tumuli* (burial mounds) at Vergina did prove to contain within them elaborate chamber-tombs. These were built like chapels, with pillars and pediments and painted walls. Earth had been heaped over them in order to prevent desecration and robbery, but to the disappointment of the modern excavators, most had been looted long ago. Then came the discovery for which Andronikos had hoped – the undisturbed resting place of a great Macedonian king.

Andronikos himself was first to prise open the keystone of the tomb's vaulted roof. What met his eyes was an array of objects within: disintegrating timbers, patinated bronze, blackened silver – and glittering gold. Inside one golden casket, bearing on its lid the star burst emblem of Macedonian royalty, a set of charred human bones was neatly stacked. Andronikos fingered them with awe, already wondering if these might be the mortal relics of Alexander's father, Philip.

Amid the first excitement of the find, it was forgivable to overlook some small fragments of carved ivory scattered on the floor. They belonged to what had once been

78 Head of Alexander from Yannitsa, near the Macedonian city of Pella, c.300–270 BC.

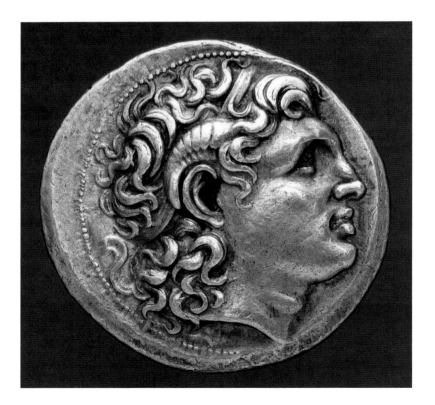

79 (top) Ivory fragments from Vergina, thought to be of the young Alexander, c.336 BC.

80 (above) A coin with the head of Alexander, c.300 BC.

a *kline* or ornate couch, normally reserved for banquets or formal drinking parties. Decorated in an exquisitely miniaturist style of relief, a number of the carved heads and bodies were perceived to be, on closer inspection, part of a lively hunting scene along one side of the couch. Small as they were, and despite a marked family likeness among them, these heads were nonetheless very individualized – and at least one of the young hunters on horseback had to be Alexander. An arched brow, an upward, 'melting' gaze, the neck distinctly tilted (*Fig. 79*): these were unmistakable characteristics of the man as described by ancient writers and captured by ancient artists.

Visitors to Vergina today will see these piecemeal ivory carvings within a museum space that dazzles with dense wreaths of finely worked gold, and perhaps underestimate the historical importance of the tiny Alexander portrait. What is most significant about the piece is its date of production. Philip was assassinated at Vergina in 336 BC, so the magnificent array of objects and regalia deposited in his tomb is of that year or earlier. Philip – bearded, hook-nosed and clearly bearing the scar of a siege incident, when an arrow had pierced his right eye – also figured in the same hunting scene on the couch. Thus described, it seems a realistic likeness. The face of young Alexander may be equally true to life. And yet it constitutes a certain look – striking an attitude, holding a pose. This was the image that would serve Alexander throughout his brief life, and forever after.

Did Aristotle have any influence over this image? It is tempting to suppose so, because the subject of physiognomics is among the many recorded scientific interests of the philosopher. For him, physical attributes, especially facial features, carried strong indications of personality. Animal resemblances were particularly telling. If a man had parts of him that resembled a lion – a thick mass of tawny hair, for example – then one could predict a bold, fierce and courageous disposition.

At any rate, the look fixed for Alexander was consistent. A dense mane of hair swept back from a broad and slightly frowning brow; intense, liqueous eyes; and the muscles of the neck always setting the royal head at an angle, as if gazing heavenwards. How far Alexander himself affected this look we can never know. By all accounts, to be in his presence was an emotive experience, even if he was only acting up to expectations. (It was rumoured that he made his mane more leonine by sprinkling it with gold dust.) Keeping the image fixed was clearly a matter of concern to him. One of his biographers, Plutarch, explicitly tells us that Alexander maintained in his entourage three image specialists, each outstanding in his medium – whether sculpture (Lysippus), painting

(Apelles), or gem-cutting (Pyrgoteles). This third artist may have been responsible for encapsulating Alexander's look numismatically(*Fig. 80*), for, like Darius before him, Alexander realized that spreading a message by coinage was highly effective – even in parts of his empire (such as Arachosia, in modern Afghanistan) where coins served no daily economic function.

The historical ambience created by Alexander is often termed 'the Hellenistic world', where the Greek language became a convenient means of communication, and Greek culture travelled in Alexander's wake (so the precepts of Aristotle reached Afghanistan). Alexander's political orientation was, however, firmly directed towards the East. If he were to establish himself as master of Asia, he would be wise to absorb the many localized and widespread traditions of divine kingship. This was exactly his practice, but it puzzled his Greek biographers: to them, it seemed like compromising with the barbarians. But even in the Greek world, Alexander's assimilation to divine status was made visible. Since he claimed descent from Herakles, it was easy enough for Alexander to present himself as wearing one of the hero's attributes, a lion's scalp. And given his flow of golden hair, Alexander could readily be imagined as Helios, the sun god.

But perhaps no ancient representation of Alexander so clearly shows the strategic importance of his image as the 'Alexander mosaic' – a Roman adaptation of a large painting that celebrated one of his several victories over the Persians (*Fig. 81*). The original painting does not survive, but the mosaic is a masterpiece in its own right. We see Alexander astride his horse, charging into the thick of battle, the only combatant shown not wearing a helmet. 'With complete disregard for his own safety', as modern citations for bravery phrase it, Alexander is thrusting his pike through an enemy body, but he has his eyes fixed upon the Persian king further away. This is Darius III, destined to be the last of the Achaemenids. A look of complete panic is written across *his* face; wheeling his chariot around, Darius clearly wants to get away with extreme haste. Whether dismayed by their leader's panic, or else likewise thrown by the sight of Alexander, all the Persians are scattering pell-mell. So we understand why Alexander is helmetless: his head, complete with furious flying hair, is terrible to behold (*Fig. 82*). If looks can kill, then this look of Alexander's, so flashing-eyed and ecstatic, is portrayed as nothing less than a weapon of mass destruction.

Alexander's death – while he was just in his early thirties – occurred at Babylon in 323 BC. The former stronghold of Hammurabi and Nebuchadnezzar was to have been

developed as his great imperial capital, eclipsing all the other many cities created in his name. It never happened. Instead, Alexander's empire was rapidly broken up and divided among his Macedonian chiefs of staff, largely according to where they found themselves at the time of their captain's premature end. Wherever they were, however, none of the so-called 'successors' of Alexander could afford to lose sight of his image. Their own claims to power depended upon the semi-divine sovereignty he embodied. His image, therefore, was their talisman, so the packaged charisma of the Alexander look lost none of its effect after he died. If anything, it gained, and ensured his place in the world's collective memory as Alexander the Great.

A MEGALOMANIAC IN RETREAT

LEGENDARILY, Alexander wished to be lord of all the world. His lieutenants, it seems, were content with less. This is what happened when the mismatch of ambitions came to a head. Ten years on from their first passage into Asia, the forces of Alexander arrived at a rain-swollen river, the Beas, in the Punjab area of India. They had marched eastwards for nearly 18,000 kilometres (11,000 miles), during a course of conquest that had so far included the Black Sea, Asia Minor, Egypt, Arabia, Mesopotamia, Persia and Bactria. Now Alexander was for crossing the torrent, and pressing onwards to the Ganges plain, but his chiefs of staff were unpersuaded, and the troops, for their part, were exhausted and homesick. The will of all ranks was firm: they refused to go on.

It was a rare episode of insubordination. As recorded in the biographies of Alexander, its immediate consequence was that the would-be ruler of the world, thwarted of his ambitions, plunged into a profound sulk lasting two full days. But eventually Alexander emerged from his tent.

Very well, he conceded: his army had reached a reasonable limit. Yet the men had a special task to perform before making the withdrawal.

Alexander's war-weary followers were divided into 12 units. Each unit was assigned to build an altar to one of the Greek Olympian deities as thanks and remembrance for divine support thus far. But these altars were not to be of the usual dimensions (about waist height); rather, like enormous towers. Then, the soldiers should set about constructing a mock camp, three times the size of the one they were actually using, and surround it with a massive ditch. They were to build great huts, too, with oversize beds inside, and huge feeding-stalls nearby; some colossal suits of armour and pieces of equipment were also to be made and strewn about. It must look as if a regiment of giants had encamped here – giants who could have negotiated this river as if it were a mere stream. Any local people coming across this abandoned outpost could thank their lucky stars that its superhuman occupants had refrained from advance.

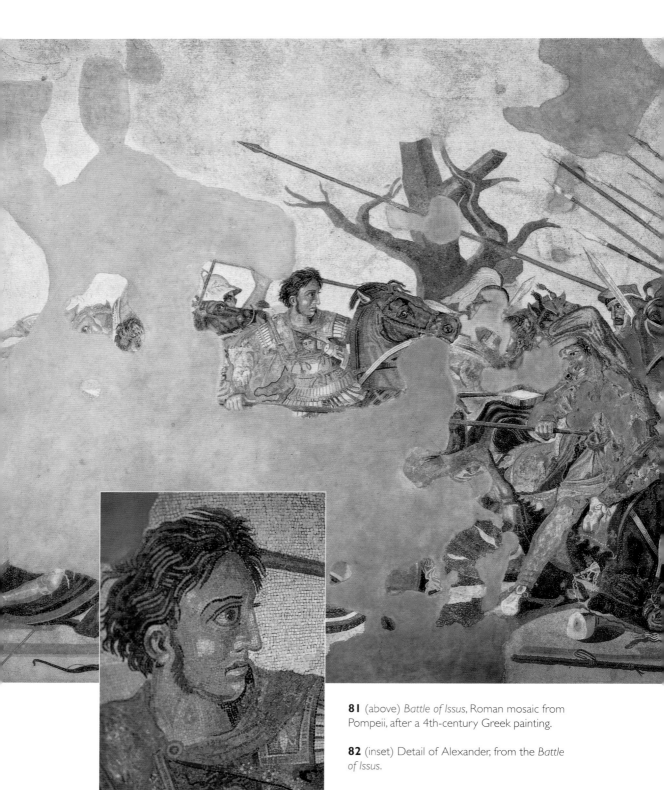

81 (above) *Battle of Issus*, Roman mosaic from Pompeii, after a 4th-century Greek painting.

82 (inset) Detail of Alexander, from the *Battle of Issus*.

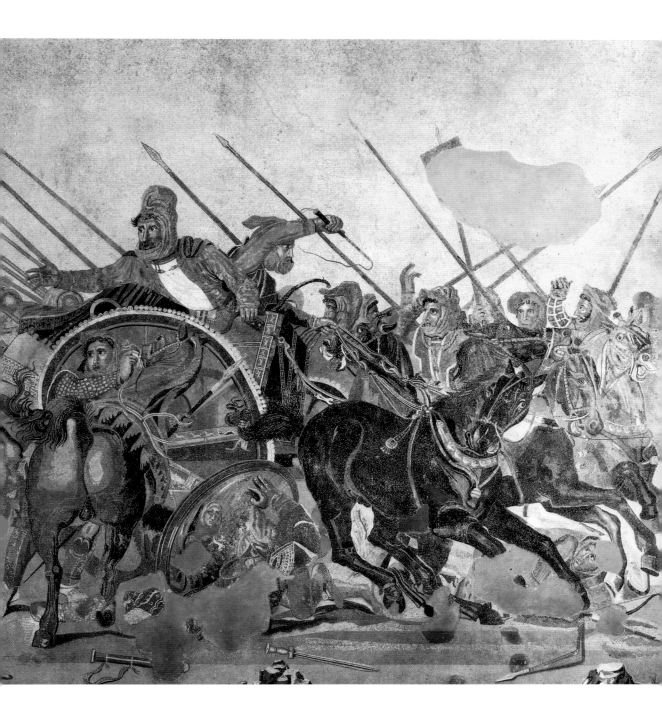

AUGUSTUS: ART AND THE ORGANIZATION OF OPINION

In Egypt, where Alexander had made himself pharaoh in 332 BC, and subsequently founded the city of Alexandria as his capital, his deputy officer was Ptolemy, who promptly proclaimed himself King Ptolemy I, eventually to be hailed as *soter* (saviour) of the country. Himself a somewhat rotund figure, Ptolemy happily traded on the more glamorous image of Alexander as the guarantee of his power. It worked well: a Ptolemaic dynasty lasted for several centuries, and saw Alexandria flourish as a centre of trade, art, scholarship and athletics. The best-known of the Ptolemies, however, was also the last – the queen who was Cleopatra VII.

Cleopatra ruled Egypt at a difficult time. Much of the eastern Mediterranean, including Macedonia, had fallen to the seemingly unstoppable military machine of Rome: once – in the ninth century BC – just a few huts on a hillside by the River Tiber, but now – by the first century BC – a city on course to build an empire greater than that of Persia or Macedonia. For a while, Cleopatra's sensual mode of conducting international relations looked as if it might succeed: one Roman general (Julius Caesar) left her with a child, then another (Mark Antony) promised her a lasting marital alliance, to the point of abandoning Rome as a capital in favour of Alexandria. But Cleopatra's charms were lost on the ambitious young politician who eventually commandeered Egypt, and made it his own special province. He was then known as Octavian, but was soon to become Augustus, the first Roman emperor.

That change of name – Augustus means 'revered' or 'awe-inspiring' – is characteristic of the calculating method by which one man projected himself as *primus inter pares* (first among equals); he not only maintained that paradoxical position for the rest of his life, but established it as a system of government lasting several hundred years. Augustus, with its overtones of piety and respect, implied that its owner's exercise of power was vocational. The deities and ancestral spirits of the Roman people supported this man and his cause.

There are echoes of Darius here and of those Hellenistic monarchs who projected themselves as saviour figures to their subjects. But Augustus was in a much more delicate position of authority. He was head of a constitution that was nominally republican, with a proud anti-monarchical history. Power was *res publica* (a public matter), not an individual right. Unlike Darius, Augustus could never flaunt himself as a king; to do so carried a

very real threat of assassination. And, unlike Alexander, he could not rely upon the charisma born of inspirational leadership in the front line, for not only did Augustus lack military flair, but he also rightly sensed that most of his fellow countrymen were exhausted by decades of strife at home and abroad. So the genius of Augustus lay in creating an illusion. He must present the absence of war as a supreme military achievement, and he must wield all the autocratic power of a monarch while seeming to restore and uphold Rome's time-honoured republican state.

We have our own word for this illusionistic process: it is 'spin' – some kind of distorting twist on reality. In certain contexts the term 'propaganda' may be used, but although this derives from the Latin verb *propagare* (to propagate in the horticultural sense), its origins lie with mission statements of the Catholic Church, and its modern application is reserved mostly for the often clumsy attempts by totalitarian governments to brainwash an entire populace. There is no ancient term for the subtle process whereby Augustus assumed monarchical power without appearing to do so. 'Organization of opinion' may be the best way of describing it. Certainly, its success derived from factors of psychological response that inform current techniques of mass advertising; and, arguably, no single ruler before or since Augustus has so cleverly understood and manipulated the power of images.

To appreciate his skill, we need to remind ourselves of the political background here.

The Roman Republic came about towards the end of the sixth century BC, when the Tarquins, an unpopular Etruscan dynasty, were expelled from the city. A basic principle of the complex constitution then installed was that power (*imperium*) should not rest with one man, but be shared (for a limited period) by two consuls, who were answerable to an assembly of senators (literally, 'senior men' of the city). From the beginning there was, however, the provision that in times of emergency a dictator might be temporarily appointed 'to carry out the business of the state'. The political tensions created by this possibility became particularly acute in the period of Rome's military expansion far beyond Italy, during the first century BC, with army generals such as Sulla and Pompey openly flouting the democratic principles of *res publica*. It was the climax of a trend when, in 44 BC, Julius Caesar – another successful general – declared himself *dictator perpetuus* (permanent dictator). He intended to be a benevolent ruler, but Caesar's benevolence only emphasized the tyrannical extent of his power. He was assassinated on 15 March 44 BC, at the hands of a group of principled aristocrats led by

Brutus and Cassius. They did not hate Caesar the man: it was his monarchical posture that offended them. His head on coins, statues of himself displayed in temples and public spaces … the peril of making such overt displays of power proved fatal. The lesson must have been clear enough to his great-nephew Octavian, who, when Caesar's will was published, found himself promoted from great-nephew to son and heir. Octavian added his adoptive father's name to his own. Eventually, 'Caesar' became fixed to the title of all Roman emperors. Meanwhile, young Octavian Caesar (later Augustus) needed to find ways of gaining Julius Caesar's power without meeting Julius Caesar's end.

And the historical circumstances in which Octavian/Augustus came to prominence are truly dramatic. Shakespeare's telling of how Julius Caesar died, and how Caesar's assailants failed to win popular support for renewing the Roman Republic, is essentially accurate. So too is the Shakespearean account of how a triumvirate, of unlikely political allies – Octavian, Lepidus and Mark Antony – first avenged Caesar's death, and then fought amongst themselves. Lepidus soon fell aside, and the final battle between Octavian and Antony took place in September of 31 BC, at Actium, off the coast of northwest Greece. As reported in Shakespeare's tragedy *Antony and Cleopatra*, this was not so much a naval success for Octavian as a gesture of defeat or indifference from Antony, who simply sailed away with his beloved Cleopatra.

Such was the reality of Actium, sad or romantic as it may seem. The illusion created by Octavian was otherwise. Actium was extolled as a momentous event, with Octavian's victory willed by the support of Apollo, for a temple to the god stood in view of the engagement. A shore settlement became the site of Nikopolis (Victory City), marked by a triumphal monument, the elaborate design of which has only recently become known to archaeologists. Back in Rome, poets hymned victory at Actium as the dawn of a new era. Civil war was over. Romans could at last begin to enjoy the fruits of peace, prosperity and world dominion.

The name change of Octavian to Augustus was made official in 27 BC, when the senators of Rome granted an unprecedented range of constitutional powers to Actium's victor – who had pursued Antony and Cleopatra to Egypt, and compelled them both to suicide. The change to Octavian's identity was made immediately visible. As he secured sole authority, so he took care not to adopt the ostentatious airs of sole authority. We witness the shift in his portrait features. A colossal head, now to be found in a courtyard of the Vatican, gives us Octavian, the youthful contender: with big hair and an upward tilt

to his features, he invites comparison with Alexander (*Fig. 83*). This was an image hardly in keeping with the name Augustus; it was, moreover, the sort of radiant saviour image likely to antagonize those traditionalists who still cherished the ideal of a Roman Republic. So Augustus commissioned a new portrait type: commanding, but not arrogant; stern, yet handsome; grave with burdens of responsibility, yet also fresh and ageless (*Fig. 84*). This was the visage that defined Augustus, and one that his artists faithfully reproduced throughout his long tenure of power at Rome – that is until his death, aged over 70, in 14 AD.

The political tactic of Augustus was not to abolish the many particular offices of power in the structure of the Roman Republic, but rather to occupy those posts himself, or else ensure his control over the appointed occupants. It was tantamount to a revolution, but of course it was never represented as such. The slogan was *res publica restituta*, 'the Republic restored', and restored for motives that were sacrosanct. It was typical of Augustus that in 12 BC he volunteered himself for the important post of *pontifex maximus* (chief priest), and equally typical that a statue of him appeared in that guise, fully draped in a toga and veil, in the posture of conducting sacrifice. Later, Augustus would set up an inscribed autobiographical record of *res gestae* (things done). Prominent among these achievements was the rehabilitation of numerous shrines and temples that had fallen into disrepair. The peace Augustus brought with him was a blessed state, guaranteed by intercession between Augustus and the gods above.

So wedded was Augustus to the ideal of a *pax Augusta* (Augustan peace) that he ordered an Altar of Augustan Peace to be set up by one of the gateways to Rome, at the end of the Via Flaminia. In the main processional relief of this altar, the person of Augustus is only slightly more conspicuous than all the other worthy Romans on whom his rule depends: as *princeps* (leader) or *imperator* (giver of orders), he appears nevertheless to be part of a team. And the Golden Age assured by his presence is gracefully symbolized on the additional carved panels on the altar, where we find a maternal figure seated amid cherubic offspring, contented livestock and the horns of plenty (*Fig. 85*). Soft breezes waft across, borne on the backs of swans. Since Augustus has settled political matters at Rome, the entire countryside regains its mythical, pristine abundance.

The range of images gathered into the Augustan project of mass persuasion is too great to catalogue here. We do not know the names of the architects, painters, sculptors and other craftsmen who contributed to the scheme, but evidently there *was* a scheme, because for all the variety of images and media, there remains a remarkable consistency

83 (top left) The colossal head of Octavian in a courtyard of the Vatican, c. 30 BC.

84 (top right) Head of Augustus, c. 25 BC, looking less radiant.

85 (above) Relief from the Altar of Augustan Peace, Rome, 13–9 BC.

of message. Those who designed the irrepressible floral patterns on the Altar of Peace, for example, were surely aware of the vogue among wall-painters for profuse vegetation, such as that seen in the frescoes of the villa belonging to Livia, wife of Augustus (see pages 135–7). Whether laying out a 'heritage trail' on the Palatine Hill, where Augustus opted to live close to the supposed hut of Rome's legendary first builder, Romulus, or creating a new Forum of Augustus in the city's heart, or decorating silver drinking cups with scenes of imperial clemency to barbarians, the Augustan image-makers worked in harmony. They were all, as we should say, 'singing from the same hymn-sheet'.

The accompanying texts survive. The literature produced under the patronage of Augustus and his wealthy friends (notably a certain Maecenas) was, like Augustan art and architecture, of high stylistic quality, and similarly consistent in its message. One poet, Ovid, incurred the emperor's displeasure, and was sent into self-pitying exile; others – Virgil, Horace and Propertius – found modes of extolling the Augustan regime that were delicate, memorable and often oblique. Just as Augustus wanted no colossal gold or silver statues of himself, so he did not invite gross flattery from his poets. Major works of history (by Livy) and geography (by Strabo) added to the general sentiment that Augustus personified a predestined 'arrival' of Rome upon the world stage. Since the rustic settlement created on the banks of the Tiber by Romulus, even since the legendary emigration from Troy by the hero Aeneas, Rome's fortunes were all leading to the glorious time when Augustus could be hailed as *Pater Patriae* (Father of the Fatherland).

Over 300 portraits of Augustus survive, from all around the Roman Empire. Of these, none demonstrates more eloquently their subject's fine judgement of political symbolism than the full-length figure known as the 'Prima Porta Augustus' (*Fig. 88*). At first glance, this looks like the straightforward image of a general raising his right hand, as if about to address his army. The marble was originally painted, making it all the more obvious that Augustus carried the purple cloak of supreme military command. But it soon becomes clear that this is not really the image of a general. For one thing, Augustus is barefoot; furthermore, the posture and musculature of his body is based upon the Classical type of a victorious athlete (following, to be precise, the 'Spear Bearer' of Polykleitos: *Fig. 31, page 74*). At his feet there is a dolphin, with a little Eros or Cupid astride. This coyly alludes to the divine origins claimed by the Julian family, ultimately descended (via Aeneas) from Venus, goddess of love. So the statue conveys authority by unconventional means. But if it is not a direct representation of Augustus as *imperator*, then what does it commemorate?

THE CAESARS' AFTERLIFE

86 (above) A statue of Charlemagne as the Holy Roman Emperor, the church of St Jean, Müstair (Switzerland), 9th century.

87 (opposite) *Charles V near Mühlberg* by Titian, 1548.

AUGUSTUS and his successors left an ideological legacy that went far beyond Classical antiquity. It was registered, for instance, in northern Eurasia, where Ivan III, the master builder of the Russian Empire from 1462 to 1505, was attracted to the concept of creating another Rome based at Moscow; and his grandson Ivan IV (Ivan the Terrible) formally insisted on the title 'Caesar' – in Russian *Czar* or *Tsar* – at his coronation in 1547.

His Latin title was *Rex Francorum*, King of the Franks, the Franks being the Germanic tribes that had overrun the former Roman province of *Gallia* (Gaul) in the sixth century, following which it became the country of France. By the time of Charlemagne (768–814), Frankish domains extended into the Balkans, and also encompassed north and central Italy. In his image, however, what Charlemagne holds is more of an ideal power than actual tenure. It is the orb of the world surmounted by a crucifix (*Fig. 86*).

In the year 800, Charlemagne had a crown placed upon his head, at the altar of St Peter's Church in Rome, by Pope Leo III. The pope himself was no stranger to regalia. *Papa est verus imperator* is how the Latin tenet goes: 'The pope is the true commander'. Here he discharged his role of directing the world's secular potentates. Charlemagne was saluted as 'most pious Augustus'; the pope kissed the ground by his feet; Charlemagne was henceforth the 'Holy Roman Emperor'. His centre of empire was maintained at Aachen, geographically closer to the heart of the unified Europe that Charlemagne sought. As it happened, his vision of European union would not be realized for over 12 centuries, but the understanding that monarchical rulers were guided by God prevailed more or less unquestioned throughout medieval Europe.

The delicacy of the rapport between monarchs and the papacy was signally demonstrated in 1527, when troops in the service of the Spanish king Charles V – a militantly devout Catholic himself – descended upon Rome and vandalized the Vatican.

The papacy came to terms with Charles V, affirming him to be Holy Roman Emperor, a title that by then encompassed control of territories in Austria, Germany, the Netherlands, Naples and Sicily, Spain and the Spanish Americas. So Charles had very considerable power. Yet he was physically a slight individual, and because of intermarriages between members of his own dynastic family, the Habsburgs, he inherited a lantern jaw so pronounced that he could not chew his food, and gaped continually.

How was he to be depicted as the imposing, heaven-sent guardian of Church and State? In a portrait commissioned after Charles had done battle with rebel German Protestants against the Catholic faith, we see how the image of Marcus Aurelius cast its archetypal shadow. In the huge canvas produced by the Venetian painter Titian (*Fig. 87*), Charles V becomes an earnest, spear-bearing knight with a mission. The legend of the battle was that the sun had delayed its going down in order to facilitate a conclusive victory for the imperial side: lustrous skies accordingly glow all around the imperator. He looks to be alone, but he would deny that it had been a solo effort: 'I came, I saw, and God conquered', was his reputed remark. Augustus would have approved.

The answer lies in the decoration of the breastplate (*Fig. 89*). Here, at the centre of the portrait, just above its subject's navel, we find, carved in relief, the image that makes the key allusion to an historical event. Two figures are meeting: one in Roman military dress, the other typified by his costume and beard as an Easterner. Something is being handed over between them. It is a set of Roman legionary standards – the 'totems' that each principal unit of the Roman army carried into battle, as emblem and rallying point. Losing such standards was tantamount to disastrous defeat: and just such a disaster had befallen Roman forces in the East, at Carrhae (Harran), several decades before Augustus took control. The bearded barbarians who had seized these standards were the Parthians, a people who by now dominated lands once ruled by Darius and Alexander. The Parthians had already resisted a campaign led by Mark Antony to retrieve the standards, a costly expedition in which many Roman lives were lost. Could *any* Roman leader redeem the shame of loss?

Only Augustus. That is what the Prima Porta statue declares. By contrast to Mark Antony, Augustus did not need to mount an invasion of Parthia. Instead, he negotiated. Historians presume that some sort of bargain was made with the Parthians, but the imagery of the statue is not concerned with such details. An emblematic Roman figure extends an arm; a generic Parthian figure surrenders the precious standards. It is presented not so much as a diplomatic triumph, more an inevitable act of destiny. Ranged around the central scene are signs of cosmic support for this transaction. The event is flanked by Apollo and his sister Diana (Artemis in Roman mythology); underneath, Mother Earth rejoices, while above there is blessing from the heavens. More threatening, perhaps, are the attendant personifications of captive peoples belonging to the Roman Empire. But this is not, overall, an aggressive or triumphalist piece. It demonstrates the power of Augustus as transcendental – a supreme authority held in alliance with divine will and the very elements of the Earth. Augustus does not need to wage war; he is above that – as close to the gods as any mortal could be.

AFTERWARDS DEIFIED

Officially, Roman emperors were accorded divine status only as a posthumous honour. It is further testament to the adroit image wisdom of Augustus that, while he allowed people to worship his spirit or 'genius' during his lifetime, he did not court disapproval

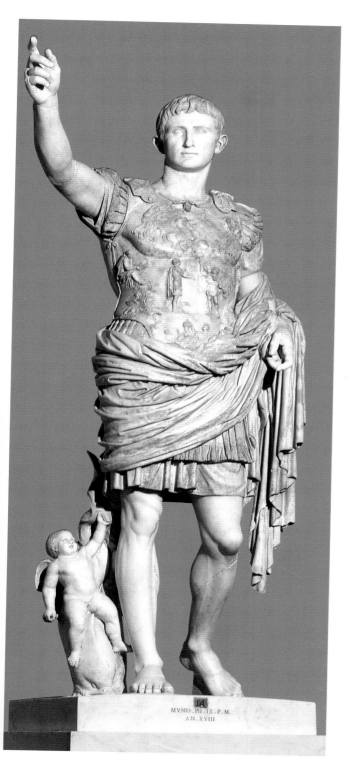

88 (left) The Prima Porta Augustus, probably a copy after a bronze original c. 20 BC.

89 (above) Detail of the breastplate of the Prima Porta Augustus.

90 Equestrian statue of Marcus Aurelius, Rome, c.176 BC.

of impious pretensions by overtly projecting himself as a god. This was a temptation that several of his successors could not resist. The infamous Nero, for example, commissioned a colossal gilded statue of himself as the sun god Helios, to shine conspicuously in Rome's skyline. His own downfall did not topple the statue, but nearby an arena for public entertainment was erected, the name of which, the Colosseum, became a lasting reminder of Nero's outsize ego. Few emperors, as it turned out, would be able to match Augustus in the exemplary handling of images: Trajan (see page 108) was one of those few.

A later successor, the second-century AD emperor Marcus Aurelius, discharged his imperial responsibilities with more sense of endurance than enthusiasm. 'Alexander, Julius Caesar, Pompey … what a load of cares were they burdened with, and to how many things were they slaves!' noted the philosopher emperor in private memoranda later published as his *Meditations*. He was philosophically contemptuous of the expectation that his image be marble, for Marcus felt this was no more than a 'callous excrescence of the earth'; gold and silver were merely dust and sediment, and the purple dye of his imperial cloak was simply organic matter squeezed from some mollusc. Yet duty called. And partly because he went to posterity as a good emperor, but mainly because later Christians in Rome mistook him for Constantine, the first emperor to accept Christianity, Marcus Aurelius has survived in one particularly influential bronze image of individual authoritarianism (*Fig. 90*). It shows him in the saddle, and wearing the military cloak of active service as *imperator*. Originally, the statue probably also figured a hapless barbarian, fallen beneath the raised right hoof of the emperor's steed, in which case the right arm of Marcus may stretch forth as much to reassure a victim as to address or direct his troops. But, especially since it was made the centrepiece of Rome's Campidoglio Square during the sixteenth century, the image has come to epitomize the vocation of paternalistic leadership: every equestrian *generalissimo* statue in the West seems descended from the piece.

TYRANNICIDES AND TOTALITARIANS

THE ORIGINAL democracy was created in Athens, c. 510 BC, with the Greek word *demokratia* meaning literally 'rule by the people' or 'popular government'. In keeping with their ideals of equality between citizens, the democratic Athenians did not like raising monuments to particular individuals. They made an exception, however, for two men deemed to have facilitated the arrival of democracy by assassinating one of the city's ruling tyrants in 514 BC. Harmodius and Aristogeiton, who died as a result of their boldness, were duly heroized as 'The Tyrannicides' (*Fig. 91*). Placed prominently in the city, this statue group became the iconic talisman of Athenian democracy. An earlier version was deliberately removed by the Persians when they occupied the city in 480 BC, and allegedly retrieved by Alexander when he took Persepolis. Meanwhile, the group appeared as a motif on Athenian coins and vases, symbolizing defiance of any regime deemed autocratic.

Fast forward to a project jointly assembled by architect Boris Iofan and sculptor Vera Mukhina for the Soviet Pavilion at the Paris International Exhibition of 1937. International exhibitions were phenomena that emerged from the nineteenth century, like the revived Olympic Games; and like the modern Olympics, their aim of promoting goodwill and cooperation among the peoples of the world was often obscured by the spirit of aggressive national rivalry. On no occasion was that spirit more evident than at Paris in 1937, when one part of Europe – Spain – was recently split by civil war, and the Fascist states (Germany and Italy) were clearly flexing themselves for military action. Iofan allowed his structure to serve as the pedestal for a bronze statue that was, at 24.5 metres (81 feet), half the height of the building itself (*Fig. 92*) The sculpture was integral to the pavilion's purpose in declaring to the world, triumphantly, 'the rapid and powerful growth of the world's first Socialist state'.

Mukhina's thickset workers, with their rigid arms and horizontally striated drapery, may now seem disturbingly robotic in aspect. We should remember, however, that they were made to be seen from a distance, from where there is no ambivalence about their symbolic effect. They hold the proletarian attributes of hammer and sickle, as on the national banner of the Soviet Union. They personify the advance, in unison, of industrial and agrarian labour. Yet this lofty group was not innovative. It was created by the same technique used for the Statue of Liberty in New York harbour – welding sheets of metal over an armature. More significantly, its composition made a clear reference to the Tyrannicides group, as if to borrow the 'feel-good factor' of their democratic associations. Again, Augustus would have approved.

91 (opposite) *The Tyrannicides* – a Roman marble copy of a Greek bronze group *c.*477 BC.

92 (left) *Industrial Worker and Collective Farm Girl* by Vera Mukhina, erected for the Paris International Exhibition of 1937.

7

SEEING
THE
INVISIBLE

It was in February 2001 that the Mullah Muhammad Omar, then head of the fundamentalist Islamic movement known as the Taliban, urged his followers to destroy 'shrines of the infidels' throughout Afghanistan. The order was most notoriously obeyed at Bamiyan, a valley in the Hindu Kush about 160 kilometres (100 miles) to the northwest of the Afghan capital, Kabul. In the sandstone bluff of this valley stood two late-sixth-century images of the Buddha. Carved from the cliff-face, one reached a height of 55 metres (180 feet), while the other, a short distance to the east along the valley, was just over 38 metres (125 feet). Local inhabitants were evacuated, but the world's press was not kept entirely distant from an artillery operation that lasted for several days. Pictures soon appeared around the globe, showing plumes of dust and smoke swelling from the enclaves where the statues had stood (*Fig. 93*). It was studious insolence; a spectacle of iconoclasm (image breaking) staged not so much to offend practising Buddhists, as to enrage UNESCO officials, guardians of World Heritage Sites.

In the heat of international reaction to the 'barbarism' of the Taliban attack upon the colossal Buddhas at Bamiyan, one historical fact was overlooked: that casual and intentional dilapidation had been sustained at Bamiyan for about a thousand years. The Taliban offensive was part of an old iconoclastic tradition. Damage was very likely first

93 The gaping hole in the rock left after the destruction of the greater Buddha at Bamiyan, 2001.

inflicted in the course of Arab raids in these parts during the ninth century. In the thirteenth century, Genghis Khan and his Mongol hordes are reported to have carried out a wholesale slaughter in the vicinity; and it is disputed whether the lower limbs of the greater Buddha were violently amputated by a seventeenth-century Mughal emperor called Aurangzeb or a twentieth-century Afghan king by the name of Nadir Shah. At one time, the cells and niches cut into the cliff around the figures provided accommodation for thousands of monks and pilgrims, but these occupants had deserted the valley since at least the incursion of Genghis Khan, so a process of gradual ruination by neglect had also taken place.

So how did the Bamiyan shrine function before all this destruction and decay? We would have little insight were it not for two Chinese writers called Fa-Hsien and Hsuan-Tsang (or Zuanzang), who during the fifth and seventh centuries respectively trekked thousands of kilometres along the line of routes collectively known as the Silk Road – a cross-continental trading artery running from western China to Mesopotamia, onwardly linking to the Levantine coast of the Mediterranean. When Hsuan-Tsang passed by Bamiyan in the year 632 or 634, he found the valley sanctuary animated by a population of some 5000 monks and devotees. Not just two, but three massive images were then to be seen – the third (now vanished) figuring a Buddha laid out horizontally in the state of final repose known as *parinirvana* (perfect passing-out). To Hsuan-Tsang, the two standing Buddhas gleamed from afar, as if fashioned from brass or bronze; evidently the wooden substructure and mud or lime-plaster stucco that formed the faces and other bodily details had some sort of metallic finish.

The huge Buddha statues at Bamiyan evidently served as some kind of caution to mortal kings and princelings. In the course of his visit, Hsuan-Tsang witnessed a public ceremony in which the local ruler of Bamiyan pledged devotion to the Buddha by offering up himself, his family, his wealth and all his trappings of state. Officiating monks at the sanctuary symbolically took the gifts, then returned them, so the prince was confirmed and blessed in his tenure of power.

Colossal images of the Buddha were not new to Hsuan-Tsang. They loomed up at various sites along the Silk Road, marking the addition of territory to the Buddhist faith. In China, for example, comparable statues were to be seen by the caves at Yungang, in the northerly Shanxi province; also at Miran, near the lake of Lop Nor. Why were these statues so large? Because the particular faith that found favour in Tibet, China, Japan and

eastern Asia was Mahayana Buddhism, which developed a concept of the Buddha as an incarnation of ultimate truth, wisdom and goodness in the world – a figure literally larger than life. Legend told of a sculptor who had been magically transported to the heavenly abode of Maitreya, 'the Buddha of the Future', and gained a glimpse of infinite power. On his return to normality, this sculptor created an image for a shrine to the north of Kashmir that envisaged Maitreya as 80 cubits tall. The cubit is an archaic unit of measurement, denoting the length of a forearm. Equating it to half a metre gives us a statue about 40 metres (132 feet) high – somewhere in between the two images at Bamiyan.

Now that those images have been reduced to dust, it seems futile to pursue the local reasons for making them in the first place, or indeed the particular motives of those who brought them down. But the wider questions remain. In what sense can an image be understood to represent the Buddha, or any other deity? How – and *why* – is visible form given to spiritual experience?

CONNECTING WITH HIGHER POWERS

The American psychologist William James (1842–1910) reduced the varieties of human religious experience to just two essential components. First we are stricken by what James referred to as 'an uneasiness'; then we attempt to resolve that uneasiness. The uneasiness is caused by the sense that 'there is something wrong about us' as we are. The solution according to James, lies in the sense that we are saved from the wrongness by making a connection with higher powers.

Worship may be defined as the attempt to make that connection with higher powers. It is the payment of respect to a force or a being conceived as supernatural. And because the supernatural is above or beyond our normal realm of perception, our attempts to describe it may be faltering or futile. 'What we cannot speak about we must pass over in silence,' declared the twentieth-century philosopher Ludwig Wittgenstein. The nineteenth-century French realist painter Gustave Courbet said that he never painted angels because he had never seen any. Much earlier, a Buddhist text from India argues for the residual indefinability of its sacred objective: 'For him who has gone to rest [the Buddha], there is nothing left to which he can be compared; words to denote him belong to him no longer. When all things have been rendered to nothing, all manner of words are also cut off.'

Yet images of the Buddha have been made with great descriptive care and conviction, and plenty of artists in the Christian tradition have not shared Courbet's objection to picturing angels. So what inhibitions arise beyond the down-to-earth reluctance to describe the indescribable, or give form and substance to what is conceived as essentially metaphysical – beyond the physical?

Christians, like Buddhists, have mixed opinions on this issue, and their debate is summarized later (see page 225). More consistent are the Judaic and Muslim attitudes towards images set up in places of worship. The Koran unequivocally condemns veneration of images as a sham, and praises the patriarch Abraham in particular for personally exerting himself to smash the objects of idolatry. Judaic dogma similarly disparages reliance upon votive and divine imagery as 'strange worship', an 'abomination'. Indeed, the law as delivered to the prophet Moses was comprehensively phrased: 'Thou shalt not make any graven image, or any likeness of anything that is in heaven above, or that is in the earth beneath … Thou shalt not bow down thyself to them, nor serve them … ' (Exodus 20:4–5) This is a strict ruling, yet it was not rooted in some primal taboo. References in the Old Testament to certain kings of Israel raising altars to the god Baal indicate that antipathy towards divine images had not always prevailed among the Semitic peoples; and the archaeology of cult practice in the Middle East demonstrates that the Phoenicians (of Biblical Canaan, or today's Lebanon) customarily placed images around and upon the altars of their deities, as did the Nabataeans, the north Arabian nomad traders who created the city of Petra (in modern Jordan). Islam saluted Abraham for taking direct action against such images, while the book of Exodus identified one divine (and petulantly monotheistic) motive for abhorring icons: 'I, the Lord your God, am a jealous god.' Either way, cult images were not a matter for indifference. If they were not venerated, then they were feared, or suspected of fostering resentment among higher powers.

We may doubt whether a culture without icons is ever possible. Judaism has its symbols, such as the menorah or seven-branched candlestick from the Temple at Jerusalem. In the Islamic world, too, the arabesques and calligraphic flourishes to be found in any mosque bid for some kind of representational status. Historically, however, it seems clear that the Islamic–Judaic prejudice against images of and for worship was essentially a mode of declaring difference. Idolatry was the hallmark of other faiths; to reject idolatrous practice was therefore a way of being distinct, a mode of self-definition.

If that is a crudely workable summary of how hostility towards images came about, we can now attempt to understand the other side. What did practitioners of idolatry think they were doing?

IDOLATRY AND DEVOTION

'Idolatry' derives from an ancient Greek word, *eidololatria*. *Eidola* were the figures of deities raised in all Greek sanctuaries and *latria* was the reverence accorded to them. When the Christian evangelist Paul visited Athens in the mid-first century he reported it to be *kateidolos*, 'images all around' (Acts of the Apostles, 17:16). This was the impression that would have struck anyone approaching the precincts of a Greek temple.

On display in the sanctuaries of Athens and of any other ancient Greek city were many images that fell within the category of 'votive offerings' – images that were gifts to the gods. Votive offerings could also take many other forms – food, money, clothes and so on – and it is not always clear whether an image is intended to represent the deity or the worshipper. At any rate, it was a busy trade.

A Phoenician inscription from another sanctuary on Cyprus, at Kition, tells us that around 800 BC a particular pilgrim to the temple of the goddess Astarte arrived there, had his head shaved, and offered his clipped locks in a vase to the goddess, along with a sheep and a lamb, plus another lamb on behalf of his family. In fact, Greek sacrificial custom allowed for those dedicating animals at an altar to join in feasting after the ritual slaughter, leaving a package of offal and bones to higher powers. But it was in the spirit of personal expenditure that one worshipper in sixth-century BC Athens not only (we presume) brought a calf up to the Acropolis sanctuary for sacrifice, but also commissioned a marble statue of himself performing the act (*Fig. 94*). In itself, the gift of a calf was substantial. The value of the votive offering was multiplied many times over, though, when memorialized in stone – if not for posterity, then certainly to solicit continued goodwill from the deity of the place.

A marble statue of such life-size dimensions as the Athenian 'Calf Bearer' would entail about a year's work for one sculptor. Although in practice the commission was doubtless subdivided among several variously skilled craftsmen, that estimate gives us a clear notion of how the votive 'investment' has been raised here, at least with respect to the mass-produced terracottas or little bronzes that were what most pilgrims in the

Greek world could afford. To comprehend what prompted an individual to spend in this way, we need to bear in mind that votive practice was, for the Greeks and many others in the ancient world, a sort of two-sided transaction. Votive offerings were made either in thanksgiving for favours received, or else in the expectation of favours to come. Where hope was concerned – say, hope for a safe journey, or a successful pregnancy, or a cure of some personal affliction – then the terms of bargaining were clear enough. One gained as one gave. The more that was offered to the gods, the more the gods reciprocated.

One of the ancient Greek words for a statue is *agalma*, which can be translated as 'something that gives pleasure to a deity'. The 'jealous god' of Moses took offence at a golden calf that was set up on an altar in the Sinai desert; by contrast, any deity of the Greeks would have been delighted. As one Greek philosopher reasoned, 'the Greek manner of honouring the gods recruits whatever is most beautiful on earth, whether in terms of raw materials, human shape or artistic precision'. Marble was deemed a finer material than clay, wood or limestone. Bronze may have been considered better than marble; but the greatest esteem was undoubtedly reserved for amber, ebony, ivory and gold. The most celebrated of cult statues in Greece were 'chryselephantine', meaning that they incorporated large quantities of gold and ivory. Votive 'credit', as it were, was assured from such an image even before it was worked on by artists.

Examples of this logic could be drawn from other cultures. In pre-Columbian America, for instance, the maize god of the Maya was often figured in jade, or with jade embellishments. The precious status of the stone in itself was supposed to assure abundance of crops, with a bead of jade symbolizing the kernel of the maize plant. But perhaps there is no parallel for the extent to which the Greeks complemented the precious status of their divine images with a muscular, sensuous, unashamed anthropomorphism – in human form. In the trenchant Greek application of this humanizing concept, deities could not only partake of the mortal frame and physical appearance, but were also prone to the usual range of human failings. In Homer's *Iliad* and *Odyssey*, even the highest of Greek higher powers – the Olympians gathered around almighty Zeus – can behave in manners lecherous, fickle, thieving and sly. They are not bound by human form, but readily make their epiphanies on Earth that way, sometimes to the bewilderment of mortal viewers. A sequence of archaic Greek poems, known as the Homeric Hymns, tells how, for example, Aphrodite the goddess of love came down

and seduced a shepherd in his hut. It was only in the bliss of post-coital relaxation that Aphrodite chose to reveal her divinity by suddenly magnifying her size and rising through the roof. Or there are the verses to Apollo, god of luminescence and music, who manifests himself to a band of sailors 'in the form of a man, quick and well built, in the full bloom of youth, his hair flowing over his shoulders', an appearance that has the sailors momentarily baffled, for they do not know if it is a god before them, or some astonishingly handsome and athletic specimen of humanity (see page 66).

According to Greek belief, a deity could be in two places at once. Yet the images of deities were widely considered to encapsulate the animated presence of those they represented; and the interior chamber of a temple where such an image was customarily installed was known as the *naos* (dwelling place) of the deity concerned. On the occasions when the doors of a temple were opened to view, worshippers were permitted to peep into these hallowed quarters: what they saw inside was a statue perceived to be, itself, endowed with powers of perception. Numerous testimonies in Classical literature tell of statues moving, sighing, sweating and weeping; several stories also recount how certain worshippers became so carried along by the sense of animate presence that they not only addressed words to an image, but made amorous advances too (see page 77).

Some Greek thinkers protested at all this. 'People might as well pray to brick walls,' was the dour comment of one sixth-century BC philosopher, Herakleitos. Another critic, called Xenophanes, asserted that 'what is good is ever to have respect unto the gods', but not by endowing the gods with mortal garb, voice and form. Or, at least, Xenophanes wanted people to recognize the partisan nature of their anthropomorphic customs. 'If horses or oxens or lions had hands,' he noted, 'or the power to paint and make the works of art that humans make, then horses would paint or carve their gods in horse-like forms, and oxen theirs in ox-like forms, and so with each, according to kind.' Similarly, Ethiopians had deities with Ethiopian characteristics, and the Thracians made theirs Thracian-looking: logically, Xenophanes implied, how could such local or 'ethnicized' divinities be conceived to wield absolute universal power?

And yet it seems that the Greeks' own mode of anthropomorphic belief contributed strongly to the Greek collective identity. In his *Histories* Herodotus noted as peculiar the religious customs of the Persians – peculiar because they erected no statues, altars or temples to their gods, instead giving sacrifices upon mountain summits, and paying homage to the heavens, and the sun, moon, earth, fire, water and winds. (Though he

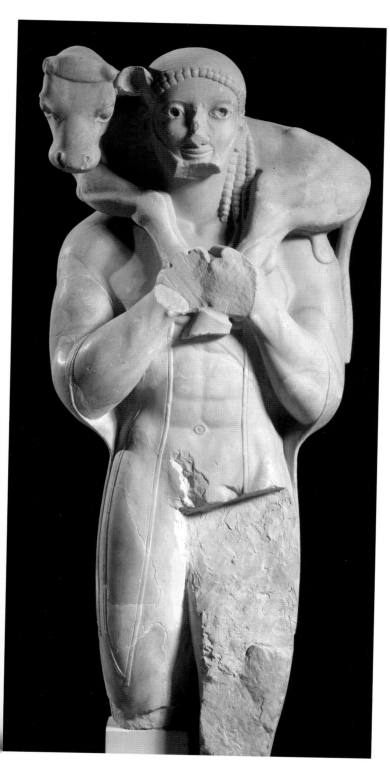

94 (left) A prayer in stone – the 'Calf Bearer', Athens, c. 570–60 BC.

95 (above) An Egyptian statuette of the hippopotamus goddess Tawaret.

does not know it as such, Herodotus is describing Zoroastrianism, whose priests, known as *magi*, indeed officiated at rites without images.) And because his audience was so thoroughly imbued with anthropomorphic practice and ideals, Herodotus felt obliged to describe in some detail another alien mode of worship, whereby images of deities drew upon the animal kingdom. This he encountered in Egypt, and we can almost hear the gasps of incredulity among his ancient Greek listeners when they learn that domestic pets such as cats and dogs enjoy sacred status there, and are more precious to the Egyptians than their own houses.

Herodotus openly acknowledged that the system of deities among the Egyptians historically predated and formally influenced the Greek pantheon. So Athena was a dark-skinned goddess for the Egyptians long before the Greeks used ivory to represent her complexion. However, the Egyptian custom of imagining these deities with animal aspects or manifestations created a powerful impression of difference or 'otherness'. Amun, the chief deity of Egyptian Thebes, might in function and divine hierarchy be twinned with the Greek Zeus, but not in image, so long as Amun appeared as a ram, or ram-headed. The original motives for associating this or that Egyptian deity with certain fauna are not always clear, though some speculations seem warranted – for example, that the god Anubis was given jackal features because he was lord over corpses and cemeteries, and jackals were known to be eagerly interested in both. In any case, explanatory myths were woven around and about all these zoomorphic images; and their cultic or superstitious relevance is rarely difficult to demonstrate.

One example may be enough: a minor deity, but memorably composite. The goddess Tawaret ('the great one') was made up mainly with the body of a pregnant hippopotamus, an animal that was, as Herodotus observed, held sacred along certain stretches of the Nile. Tawaret stood upright, however, on two leonine legs, had the spine and tail of a crocodile, and two arms mostly human, save where they turned into the paws of a lion. Her long hair was combed so that it half-covered a pair of sagging breasts; and her muzzle, which owes something to the hippopotamus, was invariably shown open, exposing enormous, peg-like teeth. Her image is consequently both unnerving and maternal (*Fig. 95*). And that is as it should be, for Tawaret served as an active protectress. She was especially protective of women during childbirth, but also of marriage and sleep; and her image, fashioned into an amulet, was customarily worn by children in order to avoid encounters with snakes and crocodiles.

THE BUDDHA'S IMAGE

The travels of Herodotus did not take him as far as the Indian subcontinent. Had he strayed there, he would surely have come across the reputation, if not the person, of a wandering teacher and holy man once known as Siddhartha Gautama, generally agreed to have lived between the mid-sixth and fifth centuries BC. Siddhartha was born a prince of the Sakya (or Shakya) clan, whose home was where the borders of India and Nepal now meet. When he took to preaching around the cities of the Ganges River basin, he became known as Sakyamuni, or 'Sage of the Sakyas'. Ultimately there was another change of name when he was hailed as Buddha, 'the Enlightened One'. Siddhartha was, therefore, the historical founder of Buddhism, a faith that, in various forms, was diffused across much of Asia by the tenth century.

We have already noted that the state of Buddhahood – an awakening, as it may also be defined – is reckoned in some early Buddhist texts to be an inexpressible attainment. Several centuries elapsed, it seems, before a figurative language was contrived to articulate not only the appearance of the Buddha in his perfected eternity, but also the key events of Siddhartha's life and mission. In the northerly region known as Gandhara (roughly approximating to modern Pakistan), some traces of Classical influence upon this Buddhist iconography have been supposed – in the folds of drapery worn by the robed Buddha and his monastic followers, or in the bodybuilder physiques sported by associated figures, carved characteristically in a grey stone called schist. Such supposition of stylistic influence is not absurd, for this was the area of India once reached (in 326 BC) by Alexander the Great and his nominally Greek army (see page 183). But the development of Buddhist imagery was more immediately shaped by the Mauryans – central Indian rulers who annulled all of Alexander's incursions – in particular the emperor Ashoka, who reigned through the mid-third century BC. Ashoka established a host of sacred sites at which relics of the Buddha were said to be preserved. These were solid mounds faced with brick, and marked off by carved stone gateways and perimeters; estimates of their number across Mauryan territory total some 84,000. The generic term for them is *stupas*: each stupa held within it a casket containing some token of the Buddha's earthly existence (a lock of hair, a tooth, ashes, or suchlike). Whatever the relic, it was never on display to pilgrims, being buried deep below the monument. It seems to have been in order to assist the focus of pilgrimage that sculptural narratives were eventually elaborated at certain stupas.

96 (top) An aerial view of the stupa at Borobudur, Java, c. 800.

97 (above) The Parinirvana Buddha at Polonnaruwa, Sri Lanka, 11th–12th century.

At Sanchi, in the centre of the Indian subcontinent, a Great Stupa created in the first century BC was elaborated with sculptural prompts and cues for followers of the Buddha's life and teaching. Centuries later, when variants of Buddhist faith had been transplanted throughout Southeast Asia, the stupa erected at Borobudur, on the island of Java, would present pilgrims with a daunting massif of stairways, corridors and terraces to ascend, densely interspersed with narrative illustrations, as it were, of the way towards the peak of enlightenment (*Fig. 96*). Elsewhere, a less complex iconography developed in which four principal episodes of the Buddha's story were singled out for special emphasis. These were his birth; his attainment of peace – the enviable personal ease reached by conquest or extinction of all cravings, a state known as 'nirvana'; his first sermon; and his death, or *parinirvana* (*Fig. 97*).

The scene of birth usually shows Siddhartha's mother, Queen Maya, holding on to the branch of a flowering tree, her legs crossed in the manner of a fertility goddess or tree spirit, and the little prince Siddhartha either emerging from her right hip, or else toddling forward to take his first steps. In some abridged versions, he is seen doing both in the same image (*Fig. 98*). According to certain Buddhist scriptures, the child walked in the four cardinal directions, declaring, 'I am born for supreme knowledge, and for the welfare of the world. This is my ultimate birth.'

Siddhartha grew up in courtly luxury. By his late twenties he seemed to have the best a man could hope for in life, including a beautiful wife and son. But that was when he renounced the comforts of wealth and family, and took to the road as a ragged wanderer. The prince made this pivotal renunciation because he was oppressed by the knowledge of the sufferings of those many mortals born less fortunate than himself: thereafter he was Sakyamuni, the jewel or wise one of his people. He practised penitential austerities, once starving himself to emaciation – a spectacular skeletal reduction sometimes envisaged by Gandharan sculptors – and meditating alone in the tradition of the *yogi* (holy man). During one prolonged meditative session beneath a bo-tree, Sakyamuni was tested by the demonic forces of Mara, lord of death and earthly desires. By dint of hard concentration, Sakyamuni resisted the assault; he came through to reach the blissful calm of transcendence that was nirvana.

Enlightenment incarnate: of all Buddhist images, this would become the most widely evoked, showing Sakyamuni - now Buddha, the enlightened one – serenely cross-legged, and often smiling. It was intrinsically, perhaps, the most difficult of events for an artist to

catch; and an alternative form of the faith, known as Mahayana Buddhism, would compound the difficulty by insisting that the Buddha's enlightenment was not fixed at any point in time, but an eternally attained state. Some artists were content simply to show the bo-tree, the heart-shaped foliage of which had served as panoply in the battle of wills between Mara and Sakyamuni. But several hand gestures were also available to indicate tranquillity attained. One of these shows the Buddha extending his hand downwards, as if to touch base: he is calling upon the Earth to witness his achievement (*Fig. 99*).

There is a sense in which every image of the Buddha is a response to that call to bear witness, and give visible and tangible honour to the intensely spiritual state of nirvana. As a Buddhist stanza has it:

'This form of yours, calm yet lovely, brilliant without dazzling
Soft but mighty – whom would it not entrance?
Whether one has seen it a hundred times, or beholds it anew,
Your form gives the same pleasure to the eye.'

Inscriptions attached to Buddhist temples and statues in Java testify to a considerable range of motives for their existence. Monuments were raised in order to protect property, or to mark boundaries, to serve as memorials to the dead, or to bring good fortune to monarchs embarking upon war. In many places where Buddhist worship was instituted, images of the Buddha were given daily baths and decked out for occasional parades. The votive offerings to a Buddha statue typically sought some benefit for self and family, perhaps expressly nirvana. Mahayana Buddhists might more generally set up a statue with the hope that it would bring happiness to all sentient beings.

In his lifetime (or more accurately, his *last* lifetime, since some variants of Buddhist doctrine stress, through the process of reincarnation, a multiplicity of lives for their founder) the Buddha had gathered followers. If not evoking the historic first sermon preached at the Deer Park in Varanasi (Benares), this attraction of disciples may be shown by scenes of the Buddha upon a lotus throne, clearly the centre of attention for all those around him (*Fig. 100*).

Enlightenment, or Buddhahood, is an ambition of all Buddhist adherents. In order to assist and encourage ordinary devotees, however, Buddhism also allows for a staff of intermediaries, known as Bodhisattvas. These are enlightened beings who have chosen

98 (left) A stone plaque showing the birth of the Buddha, from Gandhara, Pakistan, 2nd century.

99 (below left) The Buddha in earth-touching pose, Tibet, 11th century.

100 (below right) A stone relief of the Buddha preaching, from Mohammed Neri, Pakistan, c.175–200.

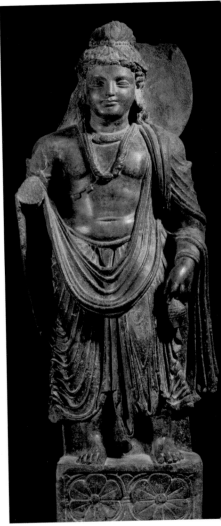

101 (above left) The Bodhisattva Padmapani, or Lotus Bearer – a detail of the wall painting in Cave I, Ajanta, 5th century.

102 (above right) A statue of the Bodhisattva Maitreya from Gandhara, Pakistan, c. 2nd century.

to delay or forsake their place in nirvana because compassion obliges them to stay and help others towards that goal. In group scenes representing the Buddha's death, the Bodhisattvas can be recognized among the bystanders as those who display no grief, since they understand that this passing away is the ultimate triumph.

The cultic importance of the Bodhisattvas is demonstrated in the layout and decoration of a number of cave sanctuaries in central India, the most famous of which is the monastic complex created at Ajanta, in cliffs above the Waghora River, northwest of Bombay. Monastic it may have been, but princely patrons endowed this site in a far from frugal style. Devotional cells and shrines were covered with paintings. Many of these paintings illustrate stories about the Buddha, including episodes from his earlier lives. Some also present richly coloured and finely detailed portraits of particular Bodhisattvas, surrounded by admirers and couched in the gorgeous environs of palaces and pavilions. While the Buddha himself was usually shown as dressed in the sparse, unstitched cloths of a monk, the Bodhisattvas exude worldly glamour in their attire and sinuous attitudes. They were celestial but, as it were, worldly-wise; and their trappings of wealth intimated their boundless resource of sympathy for humans in distress. So at Ajanta we see how the Bodhisattva Padmapani, the Lotus Bearer, tilts his gaze as if in a trance of piteous regard (*Fig. 101*). It is more than just a gaze: the lotus bloom he holds is symbolic of his power to let purity flourish above the mire of human agonies – through attained enlightenment.

All Bodhisattvas exist to facilitate that aim. Of particular importance, though, is the Bodhisattva Maitreya, deemed to be the Buddha of the Future. Maitreya is yet to be born to an earthly life. His status-in-waiting, however, did not deter artists from imagining Maitreya's appearance. A schist or black marble statue from the Gandhara region reveals Maitreya as a half-clad figure, holding a small water-pot – yet he is undeniably regal in bearing, and with a circular nimbus about his head, which is the halo of divinity (*Fig. 102*).

JAINISM AND HINDUISM

At around the same time as Siddhartha walked away from the cushioned life of court, taking nothing with him but a begging bowl, another Indian prince also espoused destitution. Subsequently hailed as Mahavira (Great Hero), he taught the effort of will required of all who would break their circular routines of birth, life, death and rebirth.

The faith that he founded is called Jainism. Mahavira himself is reckoned as one *jina* (conqueror) or *tirthankara* (ford-crosser) among 24 of such pioneers, who show how the breakthrough is to be achieved – by meditation, self-denial and deep solicitude for all forms of sentient life. In Jainism no deity grants the entrance into nirvana or enlightenment. The images that every Jain believer must look to are those of the 24 leaders of the way. Each one of these was conceived as looking very much like the others, and usually represented air clad (naked), narrow-waisted and upright, with long, matted locks – a characteristic sign of carelessness about personal well-being, or the ascetic lifestyle – either piled up or straggling over their shoulders. Sometimes a parasol is shown, alluding to the former royal status of the *jinas*; otherwise it was paramount to make clear the pose of body abandonment – feet apart, with arms alongside but not touching the torso.

The extremes of Jain commitment to non-violence, directly voiced in the Jain adage that 'harmlessness is the only religion', entail that no Jain must so much as swat a fly, let alone consume any meat; nor wield a mattock, lest it strike a worm. It may be no accident that Mahatma Gandhi, who brought about independence for modern India by a strategy of conspicuous non-violence, came from Gujarat, one of the regions where Jainism took root.

Neither Buddhism nor Jainism has survived well in India. Hinduism is the faith that presently dominates there, with upwards of 500 million followers. In fact, all three religions have their roots in the period of Indian antiquity known as Vedic, after the four Sanskrit books of knowledge called Vedas. The period occupies a millennium, from 1500 to 500 BC, with the earliest of the sacred texts, the *Rig Veda*, perhaps datable to around 1300 BC. Those who could read and use what was collected in these Vedas – hymns, invocations, ritual protocols – were known as Brahmans. They formed a literate priesthood that would eventually categorize itself as the highest of four social castes, exclusively controlling votive activity and communication with deities. Siddhartha and Mahavira were, effectively, renegades of the caste that *they* were both born to (warriors and rulers); Jainism held particular appeal for some members of the third caste (merchants), though not the others (cultivators). Buddhism, by its leader's exemplary dereliction, naturally recruited from the fourth and lowliest class, the 'unclean' menials.

Given the background of fastidious Brahman authority, it can come as a surprise to learn that Hinduism has no founding figure, nor any fixed body of dogma, though it developed out of the Vedic wisdom. There are many lively narratives about the Hindu deities, such as the epic *Mahabharata*, probably assembled between the second century BC

and the first century AD. There is also a corpus of more philosophical speculations, the Upanishads, the earliest of which may belong to around the sixth century BC. One of these, the *Vastusutra Upanishad*, discusses the rules and principles of image-making. Hinduism offers much flexibility of belief, and as a faith it can seem like the very antithesis of monotheism (one Hindu sage calculated a commodious pantheon of 330 million deities). All the same, on the basis of such texts as the *Vastusutra*, and from studies of current practice, some general features of Hindu votive behaviour can be outlined.

Hinduism allows that a work of art confers inadequate form to what is essentially elusive of form. Higher powers remain beyond any image fashioned of them, or in their honour, although they may be invoked to take up temporary residence in such an image. Nor are works of art the only media whereby divinities may be revered. Stones, fossils, trees, reptiles … the possibilities for setting up some focus of adoration are manifold. Once recognized as such, the object of cult may be bathed and anointed with water, milk and clarified butter; offered prayers, hymns and emotional recitations; also gifts of rice, flowers, saffron and perfumed oils. In short, the object is shown appeasement, for Hinduism acknowledges malevolent agents of terror within its spiritual universe, and many of its deities are likely to get angry if neglected.

The *Vastusutra* lays down some rules regarding the making of divine images: postures to be adopted, attributes conferred, and so on. A mystical geometric theory of composition also developed, in which a range of diagrammatic devices called *yantras* provided guidance for meditation. But perhaps our best strategy for assessing how Hindu art and devotion interact is to look at the image of one of the faith's primary deities, Shiva.

In fact, Shiva's worship does not invariably require an image. A sign can suffice, and often does so in the shape of a *linga* – a rounded pillar, usually designated as phallic, which in worship may be festooned with garlands and sprinkled with vermilion powder. The sensuous atmosphere of such worship is obliquely conveyed in lyrics of the fifth-century Sanskrit poet and dramatist Kalidasa. This is part of his overture to a rain cloud, coaxing it to move towards Shiva's temple at Mahakala in Ujjain:

'Girdles ringing to rhythmic steps
hands weary from waving yak-tail whisks
whose handles are inlaid with jewels,
the dancing girls there,

103 A bronze sculpture of Shiva as Lord of the Dance from the 10th–11th century.

feeling your first raindrops

like balm on the nailmarks of love

will throw you glances

as long as a line of swarming bees.'

Meghaduta, stanza 35

In Shiva, intense spiritual and sexual energy mingled: the former was bound up with his reputation as a *yogi*, the latter expressed through admirable lovemaking to his paramour, the goddess Parvati. Parvati's beauty was such that Kalidasa struggled to convey it. 'How can I describe the warmth and smoothness of her thighs, which are supple but not as rough as the elephant's trunk, nor as cold and uninviting as the banana stem?'

Hindu theology proposed no single incarnation for any of its deities. Poets and artists alike could, therefore, glory in Shiva's variance of form. Little was fixed by rule, save that, like other Hindu gods, Shiva should have a particular animal 'vehicle' to accompany or carry his representation (in Shiva's case, a bull). There is no utter insistence upon anthropomorphism in Hindu devotional art, which explains why Shiva, along with any of his divine company, may wave a multiplicity of arms and manifest himself with more than one head, as he does in a commanding monument within his rock-cut temple on Elephanta Island, near Bombay. Shiva could also appear in half-female form, for in his nature many opposites were predicted to coexist. So while his name means 'auspicious', his godliness encompassed flux and violence too. Perhaps the image that best embodies his delightful and dangerous conception is the form of Shiva Nataraja, Shiva as Lord of the Dance (*Fig. 103*). Within a ring of flames, the gyrating god lifts his left foot, and indicates the lifted foot with one of his hands. That is where the devotee may take shelter. Shiva's other foot tramples upon a stunted, writhing sprite, emblematic of all who would deny the existence of opposites inside the universe. In one of his hands the god rattles a small double-drum. The rhythm, sprightliness and levity of this motif are undeniable, whatever its scale.

Shiva's impulsive force is borne out by his characterization in Hindu literature. One story tells how Parvati, alarmed at the ease with which her husband gained access to her while she attended to her toilette, created for herself a mannikin that she animated to act as her personal bodyguard. No sooner did the guard come into being, flawlessly strong and fine-looking, than Parvati regarded him as dearly as she would a son. She

called him Ganesh, and he was sworn to let nobody near his mistress without her permission. Parvati gave Ganesh a stick to enforce this law, and he duly took up his vigil. Presently, Shiva arrived. Ganesh did not know Shiva, and obediently barred the way. There was a contest of wills; Shiva organized an attack on Ganesh, and sliced off the head of the youth. When she learnt what had happened, Parvati was distraught and furious. Shiva hastened to make amends. He promised to restore the decapitated Ganesh with the first available head that could be found. This turned out to be the head of an elephant. Returned to Parvati, with this head, Ganesh swelled into a roly-poly figure, exuding benevolence, with a rat as his vehicle, and a bowl of sweets as one of his attributes. Notwithstanding his youth, he was deemed to be patron of knowledge (he served as scribe to record the *Mahabharata* epic); because of his original role with Parvati, he was Lord of Obstacles, and as such may often be found placed by entrances and doorways; but he was also Lord of Beginnings or Undertakings, to be invoked at weddings, or at new year. His image is invariably cheering (*Fig. 104*).

Within Hinduism, the cult of Shiva may be recognized as a particular sect. The same is true of another major Hindu deity, Vishnu, the Pervader. Like other Hindu deities, Vishnu enjoys versatility of aspect, but in his conception were also formalized ten separate incarnations. In the course of a sacred text known as the *Bhagavadgita* ('Song of the Lord': itself a small part of the *Mahabharata*), this process is declared as follows (4:6-7): 'Although I am unborn, everlasting, and I am the Lord of all, I come to my realm of nature and through my wondrous power I am born. When righteousness is weak and faints and unrighteousness exults in pride, then my Spirit arises on earth.'

So, for example, Vishnu's third incarnation was in the form of a boar, Vahara, whose tusks support the world: a miniature painting encompasses the sort of colossal evil-ridding feat for which Vishnu was obliged to descend or arise on Earth. A subsequent incarnation was Rama, 'the one who charms or shines', particularly representing Vishnu's solar energy. And after Rama came Krishna, whose words in the *Bhagavadgita* are cited above.

Krishna's very name may be intoned as a chant of devotion ('Hari Krishna'). And further into the dialogues of the *Bhagavadgita* we come across an article of Hindu belief that resounds as encouragement to all votive performance, however humble, within the faith. As Krishna declares (9:25-6): 'Those who worship me come unto me … whoever offers to me with devotion only a leaf, or a flower, or a fruit, or even a little water, this I accept because with a pure heart it was offered with love.'

104 A Cambodian statue of Ganesh from the 7th–8th century.

105 A Roman statue of Artemis from Ephesus from the 2nd century BC, after older models. She is flanked by a pair of deer – she was worshipped as 'Mistress of Animals'.

CHRISTIANITY'S DILEMMA OVER IMAGES

At Ephesus, on the coast of Asia Minor, the worship of the goddess Artemis was established probably during the Bronze Age. A temple to her was erected there that became a celebrated tourist attraction, if not an acknowledged destination of pilgrimage (eventually logged as one of the so-called Seven Wonders of the Ancient World). This temple seems to have contained an olden cult image, shaped of wood and adorned with globules of amber sourced from afar (the Baltic regions, most likely). In reproductions of the image, these amber lumps can seem like so many clustered teats, or, as some have hazarded, a necklace of bulls' testicles. In either case, it made an extraordinary sight to behold (*Fig. 105*).

About halfway through the first century, at least 600 years after the magnificent temple had been built, the worship of Artemis at Ephesus was radically challenged. A stranger called Paul arrived, preaching a message incompatible with the local cult. Against Paul – whose disapproval of the 'forest of idols' at Athens has already been mentioned – arose one Demetrios, spokesman on behalf of all those whose trade lay in making silver images of the goddess Artemis. Demetrios rallied his fellow craftsmen, warning them that considerable numbers of people had heeded Paul's diatribe against idolatry – the argument that 'gods made with hands are not gods'. Demetrios pointed to the likely loss of business if this reasoning gained ground; he warned that the temple of the great goddess Artemis would be scorned, and she would be deprived of her majestic repute 'that brought all Asia and the world to worship her'. The crowd erupted, crying 'Great is Artemis of the Ephesians!', and immediately sought to lynch the evangelist Paul and his companions (see the Acts of the Apostles, 19:23-41).

Paul, whom Christians know as St Paul, and who, more than anyone else, may be considered responsible for organizing Christianity as a creed, escaped the raging mob at Ephesus. One day, though, he would be executed as a martyr (witness) of Jesus Christ. As a young man, he had been present when the proto-martyr Stephen paid for a declaration of Christian allegiance by being stoned to death outside the walls of Jerusalem. Since his own conversion to the cause, Paul was no stranger to the risk of a violent end. 'The blood of the martyrs is the seed of the church,' went the slogan of Christian campaigners in the later Roman empire. Soon enough such acts of martyrdom were not only chronicled as scripts of extravagant zeal, but also entered into a topography

of votive pilgrimage. The relics of Stephen amounted to dust, but they drew a multitude. Paul at Ephesus would appear to have issued a Christian prohibition upon images of divine intent. Yet the Christian cult of martyrs led directly to the Christian cult of relics; and the Christian cult of relics soon enough generated a class of images for which Greek terminology again supplied the word: *eikon*, meaning literally 'likeness'.

Sainthood – the process of Christian heroization, whereby a particular witness was acclaimed as holy and allocated an anniversary or feast day for special remembrance and celebration – gave rise to numerous sites of worship, even when links between saint, relics and place were tenuous. The story of a high-born martyr called Catherine, for instance, was located in the Egyptian city of Alexandria, where Catherine courted her end (at the time of the emperor Maxentius, in the early fourth century) by protesting against the Roman custom of worshipping statues. It was in Alexandria that Catherine was tried, tortured (on a spiked wheel) and eventually killed. But her relics made their way down to the Sinai peninsula, to a Christian monastery founded on the site where Moses was said to have experienced his first divine appearance. (God called out to Moses from a burning bush, as told in Exodus 3–4; the bush was not consumed, and indeed still flourishes inside the monastery.) During the sixth century, the monastery was solidly fortified in its location below Mount Sinai; and despite the respective reputations of Moses and Catherine, both of whom were opposed to divine iconography, it was also adorned with images. In the domed apse of the monastic church, a mosaic was inlaid, depicting a marvellous event: the occasion when Christ, not long before his final surrender to 'the power of men', was transfigured upon a mountain-top in the presence of some of his disciples. Gospel writers tell of how the face of Christ 'shone like the sun', and his clothes turned brilliant as light, as two prophets, Moses and Elijah, appeared to converse with him. Then a voice boomed from the heavens, affirming, 'This is my Son, my beloved.' The mosaic uses gold to transmit the sudden suffusion of brightness. The three disciples (named in Greek as John, Peter and James) fall dazzled to the ground; the two prophets make gestures as if to say, 'We told you so'; and Christ provides the almond-shaped hub from which luminous shafts radiate.

It is a brave work of art. The New Testament scriptures of Christ's birth, ministry and death were centrally concerned with the account of Jesus as a divinity in mortal form. The Transfiguration is one of the miracle signs included by those scriptures as moments when mortal limits were flaunted. Matthew's gospel refers to what happened as

a vision, but when an event was lodged into the tenets of faith as uniquely extraordinary and miraculous, how should any artist presume to render its likeness?

The commission to represent a miracle would fall often enough to artists in later Christendom. Much of the art of medieval Europe derives from precisely that sort of commission. The early Christians, however, were uncertain as to how their faith should find its graphic emphasis – not to mention the problem of their doubt over the validity of divine images at all. The primary call of Paul's ministry was for Christians to celebrate Jesus Christ not so much as he had lived and taught, but as he had been crucified. Crucifixion was known as the most abysmal form of punishment in the Roman Empire: it was a drawn-out extreme of agony and humiliation chiefly reserved for those of servile estate. Some Christian believers – the so-called Gnostics, or 'knowing ones' – adopted the attitude that Christ had only *seemed* to undergo this degrading death. But Gnostics or not, the early Christians were evidently reluctant to imagine what Paul's theology demanded – a wonderful 'lord' who had died like a criminal slave; a 'living corpse' stretched out upon the timbers of a cross. They preferred to think of Christ as a teacher with a scroll, or as the 'Good Shepherd', who would lead none of his flock astray (*Fig. 106*).

Five centuries, or thereabouts, would pass before this apparent taboo was overcome. And the first representations of Christ on the cross were done with a palpable effort to avoid the horror and pathos of the scene. On one early attempt, carved into a church door-panel in Rome, the artist still seems bashful about showing the *arbor infelix* (unhappy tree) that was the Roman euphemism for the cross as a mode of death (*Fig. 107*). Christ is there, and the two thieves who were condemned to die alongside him; but a viewer could be forgiven for thinking that all three are holding out their arms in benign appeal, not racked across beams.

For several hundred years on, 'Christ in Glory' was a concept sustained despite the theological importance of Christ's desolate death on a cross. Prior to about the end of the first millennium marked by Christians as *Anno Domini* (AD) – 'by the year of [the birth of] the Lord' – Christ was depicted as shiningly triumphant, even when crucified. But the Christian clergy were periodically beset by worries over whether such depictions were valid at all. It was the Roman emperor Constantine who, in the early fourth century, officially accepted Christianity as an institutional faith, and who established a new and predominantly Christian capital city at the edge of Asia Minor, on the site of Byzantium. Named after its founder, Constantinople, was the centre of an empire known as Byzantine,

and is now the Turkish city of Istanbul. But from the outset, Christian bishops attached to Constantine's court fretted about the quantity of old Classical or pagan statuary that the emperor insisted on importing to adorn his city, a 'second Rome'. These antique images of Zeus, Athena, Aphrodite – or Jupiter, Minerva and Venus, as they were to the Romans – what were they supposed to mean when displayed in a notionally Christian society?

In fact, the deities of the Greeks and Romans were not yet formally abandoned. It was a subsequent Byzantine emperor, Theodosius, who terminated cult practice at such long-honoured Classical sanctuaries as Olympia and Delphi (in the last decade of the fourth century), and we can presume that vast numbers of Classical votive and divine images were burnt, melted down, dismantled or pulverized around this time. But local and regional traditions of sanctity were not easily obliterated. In Asia Minor, for example, the custom of staging a religious festival for some solar divinity at around the time of the winter solstice was so entrenched that Christian clerics were obliged to fix the calendar date of Christ's nativity in that period, and allow due celebration of 'the Sun of Righteousness'. And in terms of church location, it happened that many Christian basilicas were built within or upon old Classical temples – therefore with a longitudinal axis pointing east, towards the rising sun (which is what 'orientation' literally implies). Naturally the question arose: should worship in a Christian context proceed as it had done in a Classical temple – with the conspicuous mediation of images?

The debate over this issue was complicated by much doctrinal wrangling about Christ's paradoxical designation as a *theanthropos* (god-man): those who would confine him to 'one nature' were eventually reckoned to be heretics. A heretic is, in its original sense, 'one who chooses' – chooses wrongly, in the eyes of ecclesiastical authority – and perhaps it was the proliferation of errors or heresies in early Christianity that ultimately favoured the use of images in the Christian Church. Images could deliver the messages of orthodoxy, or 'unswerving belief', more directly than the bulky transcripts of scholarly dispute. Where fuzziness prevailed, images could bring instant resolution.

That didactic justification of church art was invoked during an episode in Byzantine history known as the Iconoclastic Controversy. In the year 726 the emperor Leo III outlawed all images of Christ and his mother, the Virgin Mary. This purge amounted to iconoclasm (literally 'breaking images'). Those who protested could consider themselves iconophiles, or 'image lovers'. The iconophiles were not, however, enamoured of image-making merely for the sake of doctrinal clarity. They also argued that the worship of God

106 (top) Wall painting showing Christ as the Good Shepherd, Rome, 3rd century.

107 (above) Door-panel from the church of Santa Sabina, Rome, 5th century.

was distinct from the 'relative honour' paid to divine images. An image might be carried in processions and serve as the focus of burning incense or lighted candles, but it remained in itself merely an aid to contemplation; like a ladder enabling the devout spirit to ascend to levels of higher power. In any case, as the iconophiles argued, Christians conceived of a creative God, a God whose handiwork was manifest all around. He must surely approve of art for divine purpose, so the embellishment of places set aside for the worship of this God was righteous and appropriate.

The matter was settled in the year 843. Then it was the empress Theodora who prescribed the following lines to be chanted in an annual feast of orthodoxy.

> 'We paint icons, we venerate them with our mouths, our hearts, and our will –
> images of Christ and the saints. The honour and veneration directed toward
> the likeness guide us to its original. That is the doctrine of the Fathers inspired
> by God.'

And this doctrine was duly built into the structure of the Eastern and professedly orthodox branch of the Christian Church – strong in Constantinople until 1453 (when Muslim Turks overran the city and effectively ended the Byzantine Empire), penetrating to parts of the Middle East, and extending through Greece and the Balkans into Russia. Orthodox churches were fitted with a screen to separate the altar from the nave: whether this screen was a low barrier or a high wall, it served as a hanging space for icons, and was known as an *iconostasis* (icon stop). In its developed state, the iconostasis would be a wooden partition with three doors, and display a preordained layout of devotional images. Over the middle doorway there should be an icon of Christ enthroned, perhaps in the office of *pantocrator* (ruler of all); this central Christ should then be flanked by icons of saints who offer prayers of intercession.

There were other subjects of icon-painting, notably the Virgin Mary, or *Theotokos* (the one who gave birth to God); and there were other opportunities for positioning icons within an Orthodox church, such as free-standing 'veneration poles'. In general, the premises of worship were available for beautification 'like a bride', so it can be a heady experience to step into an Orthodox church layered with such adornment over centuries. And for the makers of icons, an overtly embellished effect is in keeping with their intentions. It must seem as if form, colour and execution all came irresistibly, compelled

by a surge of divine impetus. Indeed, certain icons – for instance, one at Edessa, in northern Syria – were notorious for being 'not made by human hands', especially if they represented the visage of Christ. Because of lingering suspicions about pagan idolatry, artists employed by the Orthodox clergy remained nervous of doing anything in three dimensions. But they were not, evidently, discouraged from adopting ostentatious strategies for stressing the spiritual purpose of their work. These included some clear departures from naturalistic models. In Orthodox icon-painting, heads often appear elongated in relation to bodies, eyes magnified within heads, and fingers drawn to tapering finesse – all distortions signifying holiness. Colours and metallic gleam were also emblematic. Icons were (and still are) painted on wooden panels primed with chalk, in tempera – pigments mixed with egg yolk. The bright effect of this paintwork is heightened by an 'assist' or hatching of gold, the lustre of which reveals divine energy and radiance, while its value testifies to the devout motivation of the icon-maker.

When art declaredly flows from religious devotion it may be perverse to celebrate particular painters and periods of painting. But it is generally agreed that icon-painting was never so delicately practised as in Russia during the early fifteenth century. Particular centres of excellence included Moscow, Pskov and Novgorod, and various artists have been identified. Principal among them is Andrei Rublyov. Little is known about him, but we do know that he thought of himself as writing rather than painting an icon, therefore, in his way, contributing to scripture. And when we gaze at one of his 'writings', a typically centre-of-screen Christ in Glory (*Fig. 108*), we understand how it is that gold, for the icon-painter, is not simply a shiny colour. In Slavonic manuals of icon-painting, the word for 'gold' is *svet*, which means 'light'. Gold is a gloom-dispelling force. It is accurate to describe the art of the Orthodox icon as 'writing in gold'; equally felicitous to think of these icons set up as panels to catch and reflect divine light.

Eastern Christendom was not isolated in its quandary over religious imagery. Around the year 600, the bishop of Marseilles in the south of France had conducted a purge of images throughout his episcopal territory. No doubt he thought he was acting well, but he received a letter of rebuke from Pope Gregory the Great.

'It is one thing to worship a painting, and quite another to learn from a scene represented in a painting what ought to be worshipped. For what writing provides for people who can read, paintings provide to the illiterate who

108 *Christ in Glory* by Andrei Rublyov, c.1410–15.

behold them … Paintings are books for the uneducated … [who] from looking at things achieved [*res gestae*] come to feel ardent compunction.'

So the Roman church of the West also gave imagery an edifying role, and, in Gregory's final quoted phrase, a purpose of distinctly emotional stimulation. Here 'compunction' is a key word of physiological sensibility. It means a pricking of the flesh, a mingled feeling of discomfort, pathos and remorse. To call it 'ardent' may imply the burning painfulness of this sensation, yet it is highly desirable. It is the Christian conscience.

Gregory's dictum is often cited as a commendation of religious images as 'the Bible for illiterates'; but the signal it gives about deliberately affective art is historically more important than that. Western Christians, it is true, would subsequently debate the limits of artistic expression in divine and votive imagery, and there were local and periodic outbreaks of iconoclasm or censure. But there was essentially no stopping the development of a truly pathetic Christian iconography as sanctioned by Gregory's words. It is the iconography that must show, for the sake of arousing compunction in its viewers, Christ not glorying on the cross, but hurting there. It is the iconography of martyrs gaining sainthood by bloodshed. It is more about trial than triumph. It wants beholders to feel bad – sinful – before they feel good.

Examples of this art survive in huge quantity – if not so often within the places of worship for which it was originally designed, then put on show in the world's galleries and museums for secular aesthetic reverence. The very richness of production says something in itself. Like the Buddhists before them, some Christians opted for the reclusive piety of monastic living, following the lead of St Anthony (in fourth-century Egypt), St Benedict (in sixth-century Italy) and others. But while frugality of lifestyle was a cornerstone of such conventual communities, that did not prevent them from being industrious and growing wealthy. The papacy, too, became a major landholding power. (Gregory was one among a number of popes who were shrewd managers of worldly affairs.) In short, the Church established itself as a well-resourced patron of art.

One entrepreneurial twelfth-century monk in central France, Abbot Suger, president over the abbey and church of Saint-Denis, left a generous testament of why he sought to make his domain a treasury of objets d'art and natural valuables – golden vessels, precious stones and rare minerals. Between 1137 and 1148 he supervised the abbey's reconstruction and refurbishment as an imposing Gothic monument, its towers, vaults

and pointed arches designed to make a vertical statement of divine glory. All expense on the building could be justified in the same way as investment in costly art and jewels: as an act of praise in honour of a bountiful God. Suger paid no heed to contemporary dissidents, notably St Bernard of Clairvaux (1090–1153), who complained that lavish structures and intricate decoration distracted the mind from prayer with 'elegant deformity and formless elegance'. St Bernard's order of monks (known as Cistercian because it was based in Cîteaux) inhabited studiously austere surrounds. At Suger's Saint-Denis, by contrast, everything was made of the finest materials by the best craftsmen. Even the simple career of St Benedict was celebrated in expensive stained glass (*Fig. 109*).

From a distance, the garnering-up of earthly riches by Abbot Suger can look like sheer greed. But his justification of it reveals a mind dominated by the same understanding as prevailed among the ancient Greeks: that visual access to deities came about through the shaping of rare natural substance by rare human artifice. Sometimes the rare natural substance might suffice as it was. As the Italian scholar and novelist Umberto Eco has concluded, medieval Europeans 'inhabited a world filled with references, reminders and overtones of divinity, manifestations of God in things. Nature spoke to them heraldically: lions or nut-trees were more than they seemed; griffins were just as real as lions because, like them, they were signs of higher truth.'

So no vows of poverty prevented art. Not long after Suger's church at Saint-Denis was raised, one of Catholicism's best-loved heroes, St Francis of Assisi, abandoned a life of bourgeois ease in the central Italian region of Umbria to go about as a mendicant, like Siddhartha, with little more than a pouch for alms or the fruits of wayside charity. By his kindness and good works St Francis earned the reputation of being 'another Christ'. But what St Francis stressed was a particular identification with Christ in his suffering. Chronologically, as charted by the gospel writers, Christ's Passion was a relatively brief period, from his arrest on a Thursday evening to his burial in a tomb by Friday night – a matter of hours. Yet for St Francis and his followers, the drama and intensity of this Passion could sustain a lifetime's dedication to the Christian ideal.

St Francis himself so empathized with the figure of Christ suffering on a cross that he became, during an intense session of prayer in the mountains, stigmatized – that is, impressed with the five stigmata marks of the crucified Christ. Associates of St Francis – his so-styled 'brothers', or friars – verified the scars, and relayed that they had been transmitted from a Christ-like apparition in the sky. In due course an artist imagined

109 (top) Scene from a stained glass window originally at Saint-Denis, Ile de France, c.1140–4.

110 (above) *The Stigmatization of St Francis*, attributed to Giotto, Assisi, 1295–1300.

the event, with connecting filaments threading to the points where nails had pierced feet and hands, and where a Roman soldier had jabbed his lance into Christ's torso to test for death on the cross (*Fig. 110*).

Franciscan monks, dressed in dun-coloured robes like their founder, propagated this Passion-focused mode of Christian worship far beyond the green hills of Umbria. Across Europe, from the early thirteenth century onwards, the conscious imitation of Christ became a spiritual task widely preached and practised. And it gained ground thanks not only to a proliferation of religious images, but also a marked increase in their vivacity. In terms of devotional practice, the prickly compunction urged by Pope Gregory became something altogether more drastic, as rites of fasting, flagellation and other forms of self-chastisement were cultivated. Places of pilgrimage and church buildings alike would feature formal sequences of statuary or paintings to conduct worshippers along the Stations of the Cross, rehearsing the miserable route of Christ from his condemnation by the Roman governor Pontius Pilate to the hill of Calvary, the place outside Jerusalem specified for his crucifixion. The earnest desire to participate as closely as possible in Christ's suffering gave extra impulse for Christians in Europe to journey towards Jerusalem. In 1095 the phenomenon known as the Crusades had been launched by a pope calling for the Holy Land to be wrested from Muslim control by a holy war. Over the next two centuries, many European nobles volunteered for the cause combining it with anti-Semitic hostility towards those blamed for Christ's death.

In terms of papal doctrine, crusading was proposed as a mode of doing penance. To embark upon a crusade was expensive and dangerous; the reward was remission of sins. That logic, minus the element of danger, may also be applied to the patronage of art.

There was a generally accepted requirement for churches to provide images with scriptural or, more importantly, liturgical significance – 'liturgical' meaning the prescribed conduct of public worship, especially the rite whereby Christians honour and imitate the Last Supper shared by Christ with his disciples. Holy Communion, or the Eucharist as it is also called, was instituted as a regular and rather joyous observance by the early Christians. Its formal Catholic conduct, however, developed into a more plangent meditation upon the meaning of the Passion, for which many images were appropriate – not only evocations of the original Last Supper, and the events of the Passion, but also related episodes from the gospels, such as Christ's premonition of death in a garden called Gethsemane, and his betrayal by the disciple called Judas.

The clergy of each church could regard it as part of their vocation to commission frescoes, sculptures, painted panels and so on, to create the ambience of worship. Chalices, basins, pulpits, lecterns and vestments were among the other items of equipment necessary for worship, and also offering occasions for artistic patronage.

So there was, to put it simply, a normal or ordinary level at which any Christian church or chapel might be decorated. But that did not preclude further embellishments, and the building of other places of worship, financed from outside. These were votive opportunities, on small scale and large, individual and collective.

The Italian city of Venice contains many examples of such endowments from church members who were not actually in Holy Orders – the laity. Venice, a port of departure for crusaders, was capital of a Christian mercantile empire by the fourteenth century, thanks to connections made with the East by spice traders and outbound travellers such as Marco Polo (whose journeys through Asia were made between 1271 and 1295). It was a republic with plenty of wealth in private hands. It also subdivided socially into a number of artisans' guilds. These were not unusual as such: clubs of cobblers or cabinet-makers could be found in most medieval European cities. But the Venetian guilds were especially zealous in defining themselves as devotional fraternities. They built meeting-places for which they commissioned not only altars for worship, but also programmes of imagery that would heighten the sense of Christian togetherness.

Barbers, belt-makers, boatmen and butchers are among the known commissioning bodies of religious art in Venice. Even the association of dealers in second-hand rags raised funds for an altar in their clubhouse. Collectively they were able to make the same bid for divine audience as an aristocrat – not to mention some magnate who had cornered the market in pepper or peacock feathers.

Archival correspondence regarding these commissions, whether collective or individual, makes it quite clear what votive intentions were lodged with them. In 1475, for example, we find one Marco Zorzi, a minor nobleman, writing to the prior of San Michele, an island church in the Venetian lagoon, for permission to build a chapel annexe there. Zorzi sought to establish a family tomb in this chapel; he was prepared also to fund the daily recital of a mass for the souls of himself, his ancestors and his descendants ('mass' being the Catholic sacrament of the Eucharist, conducted by a priest, with little or no lay participation). So Zorzi's proposal entailed not only the costs of building work and the chapel furnishings – including an altarpiece painting, and the accoutrements of

111 *The Resurrection*, altarpiece by Bellini for the Zorzi chapel in the church of San Michele, Venice, *c.*1476–9.

the Eucharist: chalices, altarcloths, candlesticks, a crucifix – but also a capital fund to supply or supplement the income of a priest to perform the daily mass.

Zorzi at first suggested the dedication of his chapel to the Virgin Mary, but he seems to have been persuaded that a more suitable theme was the Resurrection – that miracle, celebrated by Christians on Easter Sunday, whereby Christ vacated his tomb and 'rose from the dead'. Giovanni Bellini, the painter who undertook to provide the visual focus of Zorzi's chapel, came from a family of specialists in such work. His picture of the event, complete with dumbfounded soldiery and rabbits frisking in delight, was fresh and inventive (*Fig. 111*). Those worshipping here may have experienced from the officiating priest a ceremony muttered in Latin and mostly out of earshot; but in a mortuary chamber, even by candlelight, Bellini's painting cheered its viewers with the bright expectancy of life after death.

Zorzi's first choice of votive title for his chapel was not eccentric. The cult of the Blessed Virgin Mary, or the Madonna (My Lady) as the Italians called her, was as extensively respected in the West as it was in the Byzantine world. And although her role in the gospels made Mary an obvious successor to the childbirth and fertility goddesses of pagan antiquity, Mary's shrines were open to a wide range of reverential attentions. She could be thanked for deliverance from every imaginable disaster; she was beseeched for cures to all sorts of illness and disease; prayers and gifts to her might vouchsafe anything from a good crop of grapes to a criminal pardon. Looking at one German votive image of the Virgin, which shows tiny devotees peeping and imploring from the shelter of her mantle (*Fig. 112*), it is hard to resist summarizing that Mary served as a sort of universal ideal mother. At the same time, it is worth noting that inscriptions attached to votive offerings at popular Marian sanctuaries often reveal an overt faith in such-and-such an image. A man who had, say, escaped unhurt from brigands did not simply thank the Blessed Virgin in the usual formula – *per gratia ricevuta* (for kindness received). Thanksgiving would be due to the Madonna of So-and-So – a particular picture or sculpture located at a place where homage could be made with the blessing of tradition.

Mary was adored as the Queen of Heaven and the Mother of God; depictions of the Madonna with child probably dominate the iconographic record in most Catholic countries. But Mary was also the *Mater Dolorosa* (Sorrowing Mother), to whom the corpse of her son was immediately entrusted when brought down from the cross.

Franciscan writers scripted the tender process of preparation for burial with a degree of realistic detail not to be found in the gospels: it was all part of a religious culture that fostered and approved outbursts of weeping in worship.

Whether nursing or grieving, Mary will often be painted in robes of finest blue (*Fig. 113*). The colour was allusive, evoking Mary's celestial status as Queen of Heaven. It was also symbolic of votive generosity, since ultramarine – derived from the precious mineral lapis lazuli – was one of the most costly pigments available to painters (and their patrons).

Christian altarpieces at the time, whether sculpted or painted, were, by convention, not documentary scenes. They tended to offer ideal, timeless images, typical of which is the stationary gathering of clerical worthies, saints and angels in a holy conversation around an enthroned Madonna and child. Sometimes a likeness of the patron or donor was added to this group. But the cultic function of an altarpiece might also require that artists be bold in seeking an effect upon those who came there to offer prayers. The images of certain martyrs regarded as having therapeutic powers – for example, St Sebastian – might be produced in such a way as to make the endured misfortunes of that martyr nauseatingly explicit. Or, indeed, the suffering of Christ crucified could be depicted in such a way as to relate his agony to the worst of mortal afflictions. A remarkable example of this is attributed to a German painter called Matthias Grünewald, who in the early sixteenth century designed a complex folding altarpiece for the chapel of a monastic hospital at Isenheim, in the Alsace region (*Fig. 114*). When swung open on their hinges, the altar panels would display a tableau of Christ's birth and resurrection. That opening happened only on special days in the religious calendar, however. Normally, what confronted those coming to worship here – many of whom, we presume, were hobbling along with leprosy and other such infirmities – was the double image of Christ in the festering extremes of bodily disintegration. The main panel is flanked by images of St Sebastian and St Anthony; Christ dangles abjectly amid figures who swoon or fall to their knees on one side (his mother faints in the arms of the disciple John, Mary Magdalene prays), while the prophetic person of St John the Baptist – in the gospels, Christ's forerunner or herald – indicates and pronounces the greatness of this putrefying man. Below, in the altar's base or *predella*, women tend to the corpse before its entombment – aghast and caring all at once.

In the Christian rite of Holy Communion, performed at an altar such as this, a chalice of wine is held up by the priest with the words, 'This is my blood, shed for you.'

112 (above left) *Virgin of Mercy* by Michel Erhart, c.1480–90.

113 (above right) Mary's celestial blue robes in Ambrogio Lorenzetti's *Maestà*, c.1335–40.

114 The Isenheim Altarpiece, Colmar (Alsace), attributed to Matthias Grünewald, *c.*1513–15.

Bread is then broken, with the words, 'This is my body, take and eat … ' However, during the period in which Grünewald painted the altarpiece at Isenheim, Christians in Europe were arguing fiercely among themselves about a number of doctrinal issues, including the question of what was meant by those four words, 'This is my body'. The full reasons for the subsequent rift in Christian credence between Catholics and Protestants, and the complexities of theological dispute at this time of Reformation, need not concern us here. But we may register that this was also the period when the printing press began to impact upon the lives of many people. The Bible, which for centuries could be read only in manuscript form by those who knew Greek, Latin, Hebrew or Aramaic, was not only translated into the many vernacular languages of Europe, but expressly into the sort of idiom that could be understood by ploughboys and weavers and published, along with other tracts of devotional literature, at a price affordable to everyone. Pope Gregory's sanction of church images as scripture for the illiterate became less pertinent now.

Yet there was little slacking in the production of divine and votive images. On the contrary, senior Catholic bishops, convened between 1545 and 1563 for a series of meetings known as the Council of Trent, reaffirmed the necessity of images to clarify articles of faith, encourage imitation of the saints, and above all to stimulate viewers 'to adore and love God'. Images, they said, should be charged with energy and conviction, with the aim of instilling the same energy and conviction in whoever beheld them. If good Christians were to adore and love their God, then let the images of worship deploy the full figurative expression of love and adoration.

In 1562 a Spanish nun called Teresa, celebrated for her piety and well-organized kindness, issued her spiritual autobiography, in which her mystic achievement of closeness to God was described in terms not remote from the sensual jargon of an intense love affair. Not long after her death in 1582, Teresa was officially canonized as a saint, and when a certain Cardinal Cornaro came in 1647 to establish a memorial chapel for himself and his family in a Roman church, this St Teresa was his preferred subject for an altarpiece sculpture. The artist commissioned for the work, Gianlorenzo Bernini (1598–1680), chose to show the saint at the moment of her most ecstatic encounter with God, which she herself had described as follows:

'Beside me … appeared an angel in bodily form … In his hands I saw a great golden spear, and at the steely tip there appeared to be a point of fire. This

he plunged into my heart several times so that it penetrated to my entrails. When he pulled it out, I felt that he took them with it, and left me utterly consumed by the great love of God. The pain was so severe that it made me gasp some moans out loud. But the sweetness brought on by this intense pain is such that one cannot possibly want it to cease; and one's soul is then content with nothing save God.'

Bernini's rendering of this final 'transverberation' causes nudges and winks from viewers alien to its devotional context (*Fig. 115*). For the sculptor and his contemporaries, however, the statue was a proper aid and inducement to prayer. Far from being suggestive of orgasmic bliss, it was a signal that to find divine love was pure pleasure – in Teresa's words, 'no sense of anything but enjoyment, without any knowledge of what is being enjoyed'.

THE FUSIONS OF STYLE AND BELIEF

The renewal of Catholic evangelism in the mid-sixteenth century, historically known as the Counter-Reformation, not only gave fresh impetus to the making of inspirational votive and divine images in those European countries loyal to the papacy; it fostered militant missions abroad, too. These included such formidably drilled and dauntless campaigners as those gathered under the banner of the Society of Jesus, established in 1542. The Jesuits, as they were known, often took care to master the dialects of the people they wished to convert, but they also understood well the power of images. Squadrons of Spanish Jesuits penetrating into the forest heartlands of South America had with them not only picture-books of the Christian faith, but also trained sculptors. Among the semi-nomadic Guaraní inhabitants of the area that now corresponds to Paraguay a model Jesuit state was created, and one of the factors that held this curious mixture together was the fusion of indigenous and imported styles of religious art. The Guaraní had their own tradition of investing surface patterns and geometric designs with spiritual significance. The Jesuits brought the figurative naturalism of the West. A hybrid ensued. Guaraní sculptors took up the Western way of making figures on a life-sized scale, or grander; but into the coiffures and draperies of these figures they carved the pattern devices of their own repertoire, including those of body painting. The Jesuits

115 *The Ecstasy of St Theresa* by Bernini, Rome, 1644–7.

116 (above left) *St Dominic with a crucifix* by El Greco, c.1606.

117 (above right) A wooden figure of a Buddhist worshipper, from Angkor Wat, c.16th century.

Bread is then broken, with the words, 'This is my body, take and eat … ' However, during the period in which Grünewald painted the altarpiece at Isenheim, Christians in Europe were arguing fiercely among themselves about a number of doctrinal issues, including the question of what was meant by those four words, 'This is my body'. The full reasons for the subsequent rift in Christian credence between Catholics and Protestants, and the complexities of theological dispute at this time of Reformation, need not concern us here. But we may register that this was also the period when the printing press began to impact upon the lives of many people. The Bible, which for centuries could be read only in manuscript form by those who knew Greek, Latin, Hebrew or Aramaic, was not only translated into the many vernacular languages of Europe, but expressly into the sort of idiom that could be understood by ploughboys and weavers and published, along with other tracts of devotional literature, at a price affordable to everyone. Pope Gregory's sanction of church images as scripture for the illiterate became less pertinent now.

Yet there was little slacking in the production of divine and votive images. On the contrary, senior Catholic bishops, convened between 1545 and 1563 for a series of meetings known as the Council of Trent, reaffirmed the necessity of images to clarify articles of faith, encourage imitation of the saints, and above all to stimulate viewers 'to adore and love God'. Images, they said, should be charged with energy and conviction, with the aim of instilling the same energy and conviction in whoever beheld them. If good Christians were to adore and love their God, then let the images of worship deploy the full figurative expression of love and adoration.

In 1562 a Spanish nun called Teresa, celebrated for her piety and well-organized kindness, issued her spiritual autobiography, in which her mystic achievement of closeness to God was described in terms not remote from the sensual jargon of an intense love affair. Not long after her death in 1582, Teresa was officially canonized as a saint, and when a certain Cardinal Cornaro came in 1647 to establish a memorial chapel for himself and his family in a Roman church, this St Teresa was his preferred subject for an altarpiece sculpture. The artist commissioned for the work, Gianlorenzo Bernini (1598–1680), chose to show the saint at the moment of her most ecstatic encounter with God, which she herself had described as follows:

'Beside me … appeared an angel in bodily form … In his hands I saw a great golden spear, and at the steely tip there appeared to be a point of fire. This

he plunged into my heart several times so that it penetrated to my entrails. When he pulled it out, I felt that he took them with it, and left me utterly consumed by the great love of God. The pain was so severe that it made me gasp some moans out loud. But the sweetness brought on by this intense pain is such that one cannot possibly want it to cease; and one's soul is then content with nothing save God.'

Bernini's rendering of this final 'transverberation' causes nudges and winks from viewers alien to its devotional context (*Fig. 115*). For the sculptor and his contemporaries, however, the statue was a proper aid and inducement to prayer. Far from being suggestive of orgasmic bliss, it was a signal that to find divine love was pure pleasure – in Teresa's words, 'no sense of anything but enjoyment, without any knowledge of what is being enjoyed'.

THE FUSIONS OF STYLE AND BELIEF

The renewal of Catholic evangelism in the mid-sixteenth century, historically known as the Counter-Reformation, not only gave fresh impetus to the making of inspirational votive and divine images in those European countries loyal to the papacy; it fostered militant missions abroad, too. These included such formidably drilled and dauntless campaigners as those gathered under the banner of the Society of Jesus, established in 1542. The Jesuits, as they were known, often took care to master the dialects of the people they wished to convert, but they also understood well the power of images. Squadrons of Spanish Jesuits penetrating into the forest heartlands of South America had with them not only picture-books of the Christian faith, but also trained sculptors. Among the semi-nomadic Guaraní inhabitants of the area that now corresponds to Paraguay a model Jesuit state was created, and one of the factors that held this curious mixture together was the fusion of indigenous and imported styles of religious art. The Guaraní had their own tradition of investing surface patterns and geometric designs with spiritual significance. The Jesuits brought the figurative naturalism of the West. A hybrid ensued. Guaraní sculptors took up the Western way of making figures on a life-sized scale, or grander; but into the coiffures and draperies of these figures they carved the pattern devices of their own repertoire, including those of body painting. The Jesuits

have a reputation for strict dogmatic teaching, but here it seems there was not so much imposed doctrine as a process of uniting two belief systems. Guaraní who converted to Christianity were able to retain many of their own religious traditions.

A Guaraní-made Christ displays certain ethnic features that are clearly Guaraní – high cheekbones, wide nostrils and so on. This was as the ancient Greek philosopher Xenophanes would have predicted: humans making divine images according to their own characteristics of physiognomy. Xenophanes specifically mentioned the example of Ethiopians, and we duly find that Ethiopian Christians depicted Christ and his apostles with familiar local features. But no amount of customizing religious imagery can mask the similarity in human religious behaviour.

The gestural language seems universal. On his knees, hand to heart, there is an Italian monastic founder, St Dominic, as painted for the decoration of a Spanish cathedral by an artist of Greek origin (*Fig. 116*). On his knees, with hands together, there is an unknown Buddhist disciple, as sculpted for the Khmer temple of Angkor Wat (in modern Cambodia) by an unknown but probably local artist (*Fig. 117*). We could, if we wished, compile a list of those elements of comparative belief shared between Counter-Reformation Catholicism and Theravada Buddhism, but that is hardly necessary. The doctrines and theories of religious practice may differ very much. However, as William James concluded, the *feelings* and *conduct* of religious practice are essentially similar the world over; so similar as to make religious behaviour a component of both human psychology and human biology.

So it is that we could imagine no great sense of cultural displacement, no fear of essential alienation, if the dedicants of votive statuary at a shrine in ancient Greece were magically transported through several thousand years and halfway across the world to a Buddhist cave-temple in modern Laos (*Fig. 118*). Votive statues and statuettes gathered in another place at another time display another form of the divine, yet in function and intent are quite the same. This is no trick of coincidence. Those religions that have a use for images are not, in terms of conduct, very distinct. The images themselves may look very different, but *how* those images are displayed at sacred sites, deployed in ceremonies and addressed by devotees is not a matter of much variation.

FROM AWE TO ABSTRACTION

It has become a commonplace to liken today's museums and art galleries to places of worship. The comparison is readily made, given that so many public museums seem to be architecturally modelled upon sacred buildings of the past. Between their hieratic rules of reverential behaviour ('Do Not Touch'; 'Quiet, Please') and our anticipation of spiritual uplift museums seem constitutionally poised to supply pseudo-religious or ritualistic experiences. So although most of us see sacred art detached from its original context – with no whiffs of incense, no dance of torchlight, no ecstatic shrieks or whispered prayers – we may yet feel that it has been redisplayed in some equally precious and exalting way. Curators know how to conjure an aura of excitement and revelation. Vistors are marshalled like pilgrims. Creeping into the carefully installed presence of awesome, valuable, untouchable objects, we hush our voices and widen our eyes. This, if not idolatry, is not far short of it.

That glib likening of museums and temples is nonetheless true for being repeated. It should not, of course, obscure the fact that the making of religious imagery as such continues, even if certain major faiths – notably Buddhism and Christianity – have ceased to generate images in the quantity they once did. Our panorama has passed over whole centuries of religious art, and allowed no glances at those parts of the world where its output is currently sustained. We have made a very partial survey, and our account has been biased not only towards those religions with a need or fetish for images, but also towards those people who commissioned the images, and those who used them for worship. The spiritual motivation of individual artists has scarcely occupied us at all.

The anonymity of most of the works of art featuring here is one reason for that neglect. And often enough the knowledge of a certain name, career path and even personality is no warrant for insight into the workings of that artist's soul. But in cases where an artist commits faith to words as well as images, or where a writer resorts to images, we may find some demonstrable evidence of religious impulse. The English Romantic William Blake (1757–1827), offers such a case (*Fig. 119*), as does the Lebanese Kahlil Gibran (1883–1931), who, like Blake, was poet, prophet, draughtsman and painter. One figure, however, is of especial importance in any general and historical consideration of how art engages – or tries to engage – with the human intimations of divinity. This is the Russian-born painter Wassily Kandinsky (1866–1944), who,

118 An ensemble of Buddhist votives in one of the sacred caves of Bac Ou, Laos.

119 The frontispiece from *Europe – A Prophecy* by William Blake, 1794.

according to the annals of conventional classification, produced the world's first conscious or theorized example of 'abstract art'.

That was in 1910. In the same year, Kandinsky began to compose a written statement explaining his purposes as an artist. It was eventually published from Munich in 1912: a brief, dense book, its title rendered in English as *Concerning the Spiritual in Art*. Not all of its message is easy to relate to Kandinsky's painting at the time, or to his subsequent output. If a gist can be extracted from the essay, though, it might be presented as follows.

Musicians are to be envied. They have at their disposal a means of expressing spiritual states; a means of expression that is independent of nature, that is its own construct. Some musicians may take inspiration from a songthrush piping in the woods, or a drumming of thunder. But music does not *need* those models. Its sounds can have a life all their own. Art, by contrast – well, art seems to be reliant upon not only nature, but a whole universe of objects. Art seems to be forever reminding its viewers of something to be seen in the real world. An apple, a waterfall, a naked woman, a deity incarnate – whatever it might be, something *objective*. Could art never, then, operate like music: take the human soul soaring into the bliss of transcendence, above and away from the things of the world?

For Kandinsky, the content of painting should be nothing other than painting. Once, as he records, he had a vision of pure art – art that was as attuned and direct and arresting as music. This was, he then realized, one of his own pictures turned upside-down so that its subject was unclear; its effect came from the harmonies of colour and form. Colour working as colour, without associations of object; and form working as form, unattached to the delineation of things, stories or scenes.

Whether Kandinsky could ever hope to reach and keep hold of his ambition 'to consider art and nature as absolutely separate domains' remains arguable. A sequence of his abstract works would carry studiously non-referential labels – *Composition I*, *Composition II*, and so on. Later he tried to convey 'the pure inner workings of colour' in his titles – *Green Sound, Tension in Red*, and suchlike. Yet he was very much aware that the colours on his palette, for all that they were capable of causing 'spiritual vibrations', were nevertheless loaded with particular cultural and object-related associations. Red, for example, had its own meaning within the Slavonic terminology of icon painting (where the word *krasnyi* doubles for both 'red' and 'beautiful') – not to mention the

idiomatic usage, among Russian peasants, of calling that part of the house where icons were displayed as 'the red corner'. Kandinsky also conceded that forms within his compositions could take the semblance of objects in the world. So when we gaze on a Kandinsky abstract painting, such as one entitled *Red Oval* (*Fig. 120*), it may be hard to refrain from finding not only an egg in the eponymous central red oval shape, but also a boat, and an oar, and so on – and commentators have duly speculated biographical reasons for why such objects might be there.

Still, the aim of Kandinsky's striving was clear. He believed that his art was preparation for an 'Epoch of Great Spirituality', and that the figurative, naturalistic traditions of imagery were impediments to that epochal achievement. His was an essentially religious motivation. He was deeply sympathetic to a movement launched in the late nineteenth century, known as Theosophy, which sought to unite all the religions of the world around a common 'wisdom about God' (as *theosophia* translates). A Russian clairvoyant, Helena Blavatsky, was prominent among the founders of Theosophy; it was also to have influence upon the messages of the Austrian educational guru Rudolf Steiner. 'Guru' is appropriate here, for many esoteric features of Theosophist teaching came from India; and in Kandinsky's yearning for an art unimpeded by objects we may sense the disdain of an Indian holy man for material things. Moreover, Kandinsky had academic training in the study of ethnography, and was well informed about the shamanic practices of tribal communities in northern Russia. Altogether this was a potent cocktail of comparative beliefs.

Not all practitioners of abstract art are required to accept that their work is brought about by a quest for the transcendent. But that is the genesis of the abstract as a mode of artistic expression. It is lodged in the history of the struggle to envisage the invisible.

20 *Red Oval* by Wassily Kandinsky, 1920.

8

IN THE
FACE OF
DEATH

THE WRITER LAY DYING. Prone to tuberculosis, his lungs at last were failing beyond recovery. Doctors had advised the south of France, so he was consigned to a sanatorium at Vence, in the hills above the Côte d'Azur, as autumn settled and fruit began to drop from the trees.

> … it is time to go, to bid farewell
> to one's own self, and find an exit
> from the fallen self.

He reached for a metaphor – some symbolic means of visualizing his imminent voyage towards the cold, the dark and the sheer unknown. It came from a museum – an object once seen in a cabinet of Egyptian antiquities.

> A little ship, with oars and food
> and little dishes, and all accoutrements
> fitting and ready for the departing soul.

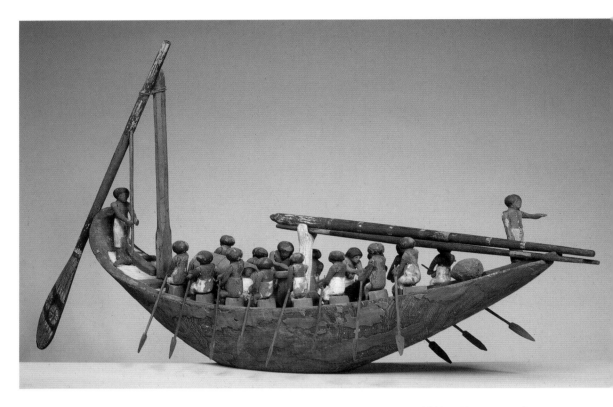

121 Wooden ship with shabti figures, from the tomb of Mentuhotep, Deir-el-Bahari, c. 2000 BC. Twenty-one figures are aboard the boat, heading downstream: a lookout stands in the bow, pointing the way.

D.H. Lawrence (1885–1929) was not an adherent of any established religious faith. His childhood attendance of a Nonconformist chapel in Britain's industrial Midlands left him with fond memories of hymns that boomed a fierce expectation of life eternal – *'Jerusalem, my happy home, when shall I come to thee?'* – but he had rejected all modes of conventional Christian belief, along with the orthodox morality he challenged most notoriously in his last novel, *Lady Chatterley's Lover*. Bedridden and fading, he was naturally fearful at the prospect of 'the dark flight down oblivion'. Yet he was not without hope. In his poem entitled 'The Ship of Death', Lawrence voiced the need to prepare for the end; to set sail for the soul's 'longest journey' towards a place for which there were no directions.

It must be dark, for sight and sense will be lost. So the ship of death sets off – into nothingness.

> Everything is gone, the body is gone
> completely under, gone, entirely gone.

So it seems – a terminus, an unimaginable finality; full stop.

Yet not so. Dawn emerges from night; and from the pitch black of death, the little ship drifts across the flood. Frail and faltering it may be, but still the soul arrives –

> … into the house again
> filling the heart with peace.

> Swings the heart renewed with peace
> even of oblivion.

> Oh build your ship of death. Oh build it!
> for you will need it.
> For the voyage of oblivion awaits you.

'The Ship of Death' is a poetic metaphor, not an exposition of ancient Egyptian beliefs about the afterlife. It is an apt metaphor nonetheless. We know that miniature wooden boats became a customary part of the 'furniture' in Egyptian tombs during the Middle

Kingdom (2040–1783 BC). Examples of such boats may be seen in many museums around the world (*Fig. 121*). Some appear to be carrying a small, corpse-like effigy on board; some carry models of foodstuffs and various utensils; most are staffed by an ensemble of wooden or wax manikins known as *shabtis* or *shawabtis*. These were not so much the crew of the boat as a company of servants ready to assist with chores in the next world. Some of these *shabti* figures are inscribed with their willingness to help ('*Here I am*'). We may see them busily grinding meal, making bread and beer, or else prepared for heavier agricultural labours, such as the digging of irrigation channels. All aboard the ship of death, a workforce for the afterlife. The *shabtis* present a team of retainers who will ensure that eternity is both a comfortable state and, most reassuringly, not a well of loneliness.

Whether serving the modern writer on his deathbed, or the funerary honours of an ancient Egyptian noble, the image of the ship of death seems equally easy to explain. It is a comforting symbol. Death may be a journey to the unknown, a mystery tour beyond us, but we should embark upon that journey with good cheer, trusting to a means of transport we know and recognize. The symbolism of a voyage across water occurs in both pagan and Christian traditions. Classical poets such as Homer sang of faraway 'Isles of the Blessed' to be reached by fortunate souls; chapel preachers visualize a '*land of pure delight, where saints immortal reign*', beckoning across '*a narrow sea*'. For D.H. Lawrence, it was enough to accept that if death were like night, then new life must come as predictably as break of day. In any case, imagery serves to provide consolation.

We share the need for such consolation. Whether out of sight, in peripheral vision, or staring us straight in the face, death is – after all – the one event we cannot miss. Biologically, like other creatures, we humans are programmed to postpone that event for as long as possible. But, quite unlike other creatures, we make an occasion of death. It is a feature peculiar to our species to conduct formal burials: and though some archaeological evidence has been claimed to demonstrate that Neanderthals and humans of earlier periods mourned their dead with flowers and suchlike, more elaborate formalities of burial are generally considered part of the 'cultural explosion' happening among *Homo sapiens* of the Upper Palaeolithic period (see page 20). The placing of bodies in specially demarcated areas, accompanied by 'grave goods', such as tools, weapons, items of personal adornment and joints of meat, is a feature of human presence in various parts of the world *c.* 30,000 years ago. That is when death became a ritual; and if people

were being laid to rest with axes, clothes and food, we suppose that such ritual indicates some primal concept of an afterlife – an existence beyond the grave.

Archaeologists, of course, capitalize upon this aspect of human behaviour. Few qualms are ever voiced about opening graves of the past. If robbing tombs were an absolute crime, we should have little to look at in our museums. The ancient Egyptians were not the only people of the past to bury their dead accompanied by treasured personal possessions – objects that we dig up with predatory greed, then parade as our *cultural heritage*. But apart from an instinct for treasure-hunting, the driving logic here is that the contents and style of given burials – or an entire cemetery – will hold key information about the deceased persons, or about the society to which they belonged when alive. An individual who ranks highly in the society of the living will be given special honours among the community of the dead; it should be possible, by the same reasoning, to detect from their funerary record persons who were once impoverished or marginalized when alive. So the rite of passage involved in transferring someone from the society of the living to the community of the dead is assumed to be a reflective process, valuable for reconstructing the past.

Our encounters with old burials and funerary monuments, therefore, tell us a great deal about how our ancestors lived. Yet we also become aware of how they *died* – how they prepared for the inevitable event of death. This is where we may feel most disquiet because we belong to an age unparalleled in its alienation from death. We survive infancy better, and live, on average, longer lives than at any other period of human history, but never before have we tried so hard to pretend that death does not happen. In Western countries cosmetic surgery flourishes; senior citizens are often segregated from the rest of society, and when they die it is rarely conceded as a natural end (heart attack, or some disease or mishap, will be cited as the cause of death); and funerals are usually subdued and brisk occasions, costing little in time or money. Many of us go for years, even decades, without so much as setting eyes upon a dead person. In short, we have tried to make death not so much inevitable as invisible. The reality of death has never been more distanced from our daily lives.

So why then do we fill our vision with *images* of death? Violent computer games, 'slasher' films, stage tragedies and corpse-strewn news bulletins? If we truly wish death to be a remote prospect, why do we insist upon imagining it so vividly and so frequently? This is a paradox that could perhaps be explained by any armchair psychologist, but it raises the more complex historical question of how humans created and developed an

122 Remodelled skull with shell eyes from Jericho, *c.* 7000 BC.

iconography of death. If we can trace the process by which death became a subject of *art* – an event mediated by symbols, pictures and metaphors – then we may begin to comprehend the uniquely peculiar effect of death as a fact of life. Death is a terror, but a terror we have learnt to manage. This chapter explores the importance of art in these strategies of terror management. Examples come from various parts of the world, not necessarily in chronological order: the process is universal.

THE JERICHO SKULLS

It was the Hebrew prophet Ezekiel who described how God had set him down in a valley of dry bones and let him witness the marvel of skeletons raised from their graves and restored as living beings (Book of Ezekiel 37). 'Can these bones live?' was the challenge of faith to Ezekiel; and some similar sentiment may have been at work among the ancient inhabitants of Jericho, a walled settlement to the northeast of Jerusalem, dating from as early as *c.* 7000 BC. For in 1953, excavations led by Kathleen Kenyon uncovered precocious evidence of the human desire to preserve or even renew the skeletal remains of the dead. No one was expecting this find: the area under archaeological scrutiny was one of domestic occupation, not a graveyard. It was scheduled to be the last day of the season's work, a time for tidying up and closing down, when someone tugged at an object embedded in one of the Neolithic walls, and out came a skull.

This skull was clearly a human remain, but not like any ordinary skull. Its nose cartilage had been reconstructed in plaster, and the eye-sockets were occupied by a pair of inset cowrie shells. Anyone gazing upon such an object could only conclude that here was an attempt to give bones a semblance of life (*Fig. 122*).

It was out of the question to pack up and leave such an archaeological sensation. Surviving on corned beef sandwiches, Kenyon's team stayed on in Jericho to investigate more thoroughly, and found a further seven skulls similarly 'reconstructed'. Each appeared to have been carefully detached from the rest of the body, and bore layers of clay once used to remodel facial features. Shells – sourced to the Red Sea – were again used for eyes, and traces of hair were also found, as if belonging to wigs that once crowned the cranium. Most significantly, all the skulls had been shaped to a smooth finish on the underside, suggesting that they were once intended to stand for display, perhaps on some shelf in an alcove; certainly above floor level.

At Jericho, therefore, it seems that certain dead persons had been 'saved' to abide with the living, their decorated skulls serving somewhat like old family photographs upon a mantelpiece. The supposition is that these reminders of the dead were created to serve as a focus for some form of ancestral veneration. The early agricultural settlers of Jericho, farming around a fertile oasis in the Jordan valley, occupied a *tell* (mound) in which one mudbrick house was built literally on top of another. Already, in this settled situation, the links between ancestors and claims upon property were being forged. The living therefore had a motive for cherishing the memory of the dead, and the dead were given special status beyond the grave. This practice of reverence for the dead from their descendants marks a crucial stage in the development of death's representation: it means that to die is not to be deceased, but rather transformed – into an ancestor.

HONOURING THE ANCESTORS: THE CASE OF EASTER ISLAND

The geographic isolation of Easter Island within the Pacific Ocean, over 3700 kilometres (some 2220 miles) from the nearest major land mass (Chile), along with its relatively small extent – 166 square kilometres (64 square miles): one could walk across the island in a morning – makes it unusual as an example of any autonomous human society. On this volcanic outcrop, as it happened, the practice of ancestor worship had disastrous consequences. Easter Island offers, nonetheless, a classic case of how the ancestral dead can literally loom large in the visions of the living.

Probably first settled by Polynesian mariners in the fifth and sixth centuries, and known in Polynesian as Rapa Nui, the island did not feature on European maps before 1722, when a Dutch navigator called Jacob Roggeveen came across it on Easter Day and named it accordingly. What greeted Roggeveen was the sight for which Easter Island is now a tourist attraction – the slopes of a grassy coastline dominated by almost 400 huge and baleful heads of stone, tall as the houses in Roggeveen's native Amsterdam (*Fig. 123*). The Dutchman witnessed islanders kindling fires before the effigies, and offering prayers at the platforms on which they stood.

The total number of these stone heads has since been counted at around 1000. Each platform (*ahu* in Polynesian) was constructed with a view to the sea, and extended up to 150 metres (495 feet) long; but the effigies (known as *moai*) were all originally positioned to face inland. From the many figures left unfinished in a central quarry – an

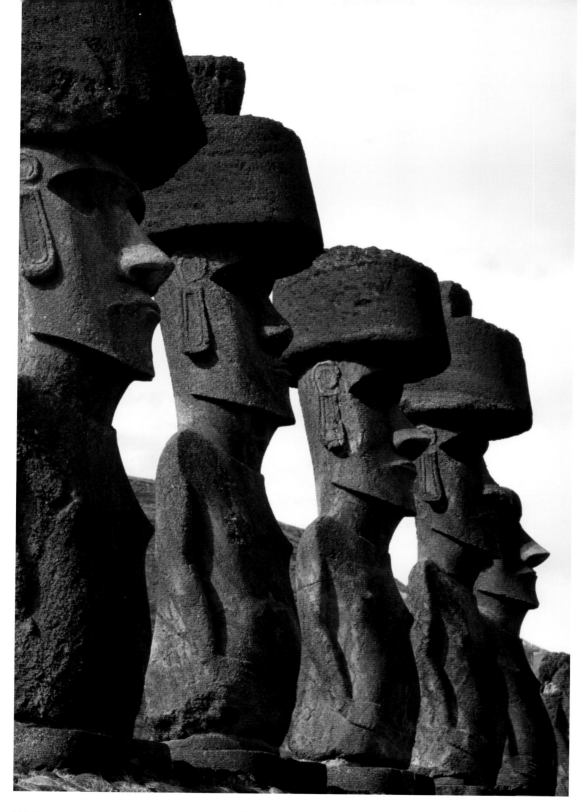

123 The colossal stone heads on Easter Island, *c.*1000–1500.

old volcanic crater – it is clear that no metal tools, only basalt picks, were used to achieve a columnar torso-base and the features of a head. The largest of the statues, left unshifted in the quarry, is estimated to weigh around 270 tonnes. Once installed upon their platforms, some of the images were evidently given inlaid eyes fashioned from white coral and red scoria stone. A separate piece of red scoria, carved like a drum or pillbox, might be added to the head as a sort of topknot. Over time, as far as a chronology can be established, the statues appear to have 'competed' in terms of size and elaboration. Ultimately, they proved too large to move.

In fact, what brought about the end of this custom was not a shortage of stone, but a lack of timber on the island to supply the logistics of transport. Some modern commentators cite Easter Island as a tragic parable of human environmental mismanagement, a case of 'paradise lost', since the relentless cutting down of trees for scaffolding, rollers and rope eventually left the island population (an estimated 10,000 at its peak) with not only a barren, eroded terrain, but also no means of making houses for shelter and boats or dugout canoes for fishing.

So what motivated such a huge and finally calamitous expenditure of resources and effort? The excavation of certain *ahu* sites has yielded no evidence of burials below or near the platforms. The consensus is, however, that the *moai* served as headstones of a sort. None is quite like another: patterns on the torsos may reflect individualized tattoo marks or body-paintings, while the grouping of the figures might indicate some family or clan association. Wider Polynesian tradition tells that a chieftain's umbilical cord was retained from his birth, and deposited at shrines such as these. If the Easter Island figures were intended as images of heroized or venerable ancestors, then their coastal situation may have had something to do with proprietorial access to marine resources along one particular stretch of shore; and their inland-facing aspect was aligned, perhaps, to a system of allocating land by strips to various family units. What is unquestionable about these statues is their visibility – their dominance of this small community's insular parameters. The Pacific horizons beyond stayed clear, for all we know, over many centuries. On the island itself a population divided into some 17 clan-groups may have had no other form of claim upon workable land, except to erect prominent images of their forefathers upon the bases of cult worship and overt respect.

Already by the seventeenth century, the degradation of their environment was causing impoverishment, infighting and cannibalism among the Easter Islanders. Most

of the *moai* were pushed over, it was said, for failing to provide the protection and bounty their presence guaranteed. Yet this fate does not detract from the original function of the statues: markers of the aggrandized dead, conspicuously on view to reassure onlookers from the community of the living.

Ancestral worship, as we have noted, is an essentially reassuring practice: it diminishes the terror of death by allowing the dead to live on through images. But what happens when the imagery of death and dying is used to the opposite effect – that is, to heighten and perpetuate the terror of mortality? To travel east from Easter Island to the pre-Hispanic cultures of South and Central America is to discover a stark answer to that question.

THE AZTECS: AN EMPIRE BUILT ON TERROR

The story of the Spanish conquest of lands to the north and south of Panama and its 'peak of Darien' is well known, but worth partial summary here.

In February 1519 a Spanish adventurer, Hernando Cortés, landed on the shores of the Gulf of Mexico. He had come from Cuba, one of the Caribbean islands lately claimed on behalf of the court of Spain, following the expeditions of Christopher Columbus in 1492. Cortés arrived with around 500 men and 16 horses. He had come not merely to travel in these parts, but to stay – an intention signalled when he burnt his boats. The evangelical aspect of his mission was also made clear when he set about building a settlement on the coast and named it Veracruz, city of the 'True Cross'. A priest was part of his retinue, as it had been assumed that the region's indigenous populace would be godless heathens.

It was also assumed that this would be a land bereft of anything resembling civilization. So, as they made their way up on to the central Mexican plateau, Cortés and his compatriots were astonished to find not only the overgrown ruins of huge, stone-built structures, but eventually came across the busy urban centre of a great empire – a city called Tenochtitlan, set up in the middle of a lake. This was the capital of the people known as the Mexica, or Aztecs, ruled by one whose name was transcribed by the Spaniards as 'Montezuma'. The city itself caused even more amazement. One of the men with Cortés, Bernal Diaz, later recalled how at first they wondered if they had not stepped into some enchanting dreamworld, with so many finely built towers

appearing to rise out of the water. Then, as they entered Montezuma's city, they were overawed by how opulent and well-ordered it all seemed to be. The very palaces of Spain diminished by comparison.

But juxtaposed with this precise magnificence was something that caused these hardened soldiers profound disgust. The Aztecs were not godless: on the contrary, they had many deities, whose pyramid temples pricked the skyline. What shocked the visitors were the ceremonies performed at these temples, particularly the culminating act of human sacrifice. Lines of victims were led up to an altar at the summit, to be lain over a block and have their hearts hacked out by priests wielding long serrated knives. Warm hearts were offered triumphantly to the gods, while the bodies were tossed aside. The steps of the temples cascaded with human blood; the priests were blackened with it; the sacred precincts were filled with blood, and screams, and the stench of death. Just as the wonders of Tenochtitlan the city could scarcely be conveyed by words, the actualities of Aztec sacrifice were almost indescribably horrific.

Modern historians, perusing these gruesome eyewitness accounts by Bernal Diaz and others, have tended to suspect a measure of exaggeration. In the era of post-colonial regret, it has become academically fashionable to discredit Cortés as a predatory, double-dealing *conquistador* bent on robbing Montezuma first of his gold and then of his empire. Of course, Cortés would want to represent himself as a saviour, bringing light to the savage darkness of the jungle: he had to justify to both his contemporaries and posterity the destruction of a splendid city. One influential commentator (Stephen Greenblatt) draws attention to the 'absolute cultural blockage' whereby the Spanish deplored idolatry, violence and cannibalism among the Aztecs, while violently imposing a religion centred upon the image of a crucified figure who had instructed followers to drink of his blood and eat of his body.

Quoting Aztec oral sources, the Spanish alleged that at the dedication ceremony of the Templo Mayor (Great Temple), the apex of which can today be glimpsed in the historic centre of the conurbation that has succeeded Tenochtitlan – Mexico City – four squads of executioners had dispatched four processions of captive victims who stood in queues 3 kilometres (2 miles) long. Estimates of the death toll from this sacrificial spree, conducted in 1487, vary from 14,000 to over 80,000. But is *any* estimate credible? Why should we believe the Spanish – so prone to give a moral gloss to their extermination of Aztec culture?

There are some good reasons for suppressing doubt. In the first place, it is widely agreed that human sacrifice was an essential part not only of Aztec religion, but of other peoples in Central America and the Andes. A succession of ethnic groupings – including Olmec, Zapotec, Maya and Toltec in ancient Mexico, and Moche and Inca in Peru – are known or suspected to have practised human sacrifice. Direct evidence of the custom has come to light at Teotihuacan, the most monumental city of the entire region *c*. 500 AD; while at one Moche site – Huaca de la Luna, near Trujillo on the Peruvian coast – archaeologists have uncovered not only numerous skeletons of victims interred at the base of a pyramid, but even the club once used to shatter their skulls – a club still sticky with blood. The macabre elaborations of Moche pottery are not quite, it seems, a potter's fantasy (*Fig. 124*).

While the Aztecs were not inventors of this custom, they may well have taken it to a new extreme: for Aztec society was avowedly militaristic in its organization. Young warriors were obliged to prove their worth, not so much by killing enemies on the battlefield, as bringing them back alive – to be held prisoner until the religious calendar demanded a spectacle of death. Surviving illustrated manuscripts or 'codices' compiled by the Aztecs themselves explicitly show priests ripping out the hearts of such captives. It was evidently a matter of pride, not shame; mass murder conducted not in some swift and efficient way (like the guillotine of the French Revolution), or turned into an industrial process (like the Nazi death-camps), but staged as an exultant feat of human butchery.

In the end, we can never know the total numbers of those put to sacrifice by Aztec priests. But to survey what remains of Tenochtitlan is enough to comprehend what horrified Cortés and his men, and fired them with a righteous zeal to see the city fall. Whatever the realities of human sacrifice in Aztec religion, the embellishment of Tenochtitlan's ceremonial centre is unnervingly direct in its allusion to the cult. Enclosure walls of altars around the Templo Mayor were decorated with façades of multiple skulls, carved from stone with a stucco finish (*Fig. 125*). Priests and deities alike were represented with sacrificial knives between their teeth; those knives, fashioned from obsidian, the glassy black volcanic stone, feature prominently in dedicatory offerings. The stone-carved reclining figure generically known as a *chacmool* holds a dish of suitable dimensions to receive a human head or heart.

The imagery of death and dismemberment is everywhere, albeit relying upon symbolic devices for its effect: for example, the jets of blood spurting from a decapitated body are represented by eager snakes. And a curious object frequently reappears, sometimes in the clutches of a god, or else as a stylized motif, looking somewhat like

124 (below) Decapitation scene on Moche pottery.

125 (bottom) A façade of skulls on the Templo Mayor, Tenochtitlan, 15th century.

126 (left) Stone statue of Coatlicue from Tenochtitlan, c.1450–1500.

a piece of tropical fruit. The distinctive shape appears on a statue of Coatlicue, the snake-skirted earth goddess who gave birth to Huitzilopochtli, the Aztec god of war: along with severed hands, it makes a heavy necklace that ends in a death's-head pendant (*Fig. 126*). The same shape may be seen in the clenched grip of the death's-head figure at the centre of the so-called 'Stone of the Sun', once intended as a sacrificial altar in the sacred precincts of Tenochtitlan. It is not a fruit at all; it is the human heart.

These images glorify the rite of sacrifice and attest its religious function. According to Aztec cosmology, the gods had created the world by sacrificing their own blood. Quetzalcoatl, 'the plumed serpent', carried out the sacrifice, spilling his blood too. This meant that mortals owed their existence to the gods, an obligation that could only be settled in kind. If repayment were not forthcoming, the gods would forsake the Earth. The sun would wane, the crops would fail, and all life would perish.

The concept of human blood providing cosmic nourishment was deeply rooted in ancient Mexican beliefs. Players of the enigmatic ball-game, instituted in Olmec culture many centuries before the Aztec empire, seem to have re-enacted the sun's daily journey across the heavens. A movement of the ball that went contrary to solar motions was penalized – and this was a game in which the penalties could be drastic. The carved walls of the grandiose ball-game court at the Mayan site of Chichen Itza certainly suggest as much. There we see, for example, one player, still wearing his knee-pads, proudly flourishing the head of a decapitated opponent.

To die for the gods was deemed an honour, but it was not an honour for which the Aztec ruling nobility cared to volunteer. Victims could be slaves or social outcasts, but predominantly they were prisoners of war, seized from the numerous subject peoples of the expansive Aztec regime. The splendour of Tenochtitlan derived from exacting economic tribute from these peoples. Tribute was forthcoming only because failure to provide it entailed war – and the herding of captives for sacrifice. So the Aztec empire was built on terror, and the images of skulls, knives and ripped-out hearts were necessary to maintain a vivid, ubiquitous fear of death.

When Hernando Cortés saw this empire collapse with the city of Tenochtitlan in 1521, he could bless his possession of crossbows, cannons and horses – all new to the Aztecs – and also his fortuitous import of smallpox, a disease that spread rapid damage among the besieged inhabitants of Tenochtitlan. But his greatest advantage came from within the empire. The Aztecs were feared and hated by vast numbers of the people

they ruled, so Cortés lost no time in recruiting a large army of the disaffected. When Tenochtitlan yielded, these were the troops who rampaged through the city, dealing with the Aztecs in the supreme local currency – human blood.

THE TERRACOTTA ARMY: A SUBSTITUTE FOR SACRIFICE?

Ruling by terror is part of the historical reputation of the warlord sometimes saluted as 'the first emperor of China': Qin Shihuang, or Shi-Huang-ti, whose achievement between 221–210 BC was aggressively to extend the small state of Qin (or Ch'in) into a large domain, cordoned to the north by the only piece of human handiwork visible from outer space – the Great Wall of China. But archaeologists, working constantly since the 1970s, have discovered that Qin Shihuang was in fact a master of terror management – a pioneer of using art to reduce, not increase, the palpable fear of death.

In the words of one of his scribes, Qin Shihuang commanded 'a million armed soldiers, a thousand chariots and ten thousand horses, to conquer and gloat over the world'. Yet this potentate was haunted by his mortal destiny. Scientists at his court were sent to scour the land for magical plants that might create the elixir of eternal life. Failing such a find, Qin Shihuang prepared to meet his end. He might be compelled to retire below, but must he go there alone?

Historians believe that a number of ancient peoples – for instance, the Scythians of the Russian steppes – indulged in ritual slaughter when a king died. Retainers in the royal household were put to death in order to accompany their master in the next life; also interred with the king were his favourite horses and his chariot. Qin Shihuang was not so demanding. In the vicinity of his intended mausoleum at Lintong, near Xi'an in Shanxi province, he commissioned a number of underground pits or chambers to accommodate his companions in death. Previous feudal overlords and nobility in the region had gone to their graves with perhaps several figurines of bronze or clay. Qin Shihuang went with a following of thousands – all done on life-size scale (*Fig. 127*).

Infantry soldiers, neatly lined up according to the prevalent rules of regimental formation; cavalry, with their ponies, chariots and stablehands; possibly, too, the elite force of the emperor's own bodyguard: all were shaped in clay, baked, painted and issued with fully functional bronze weapons and accoutrements. Moulds were used for certain sections of the figures, but none is exactly like any other: care was taken to individualize each member

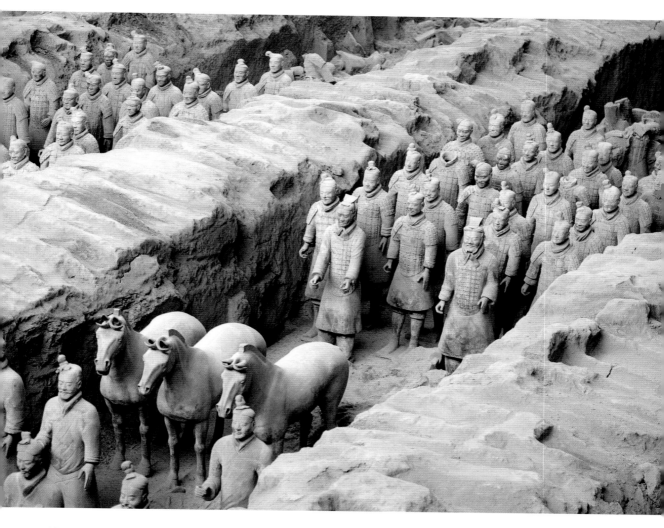

127 The Terracotta Army, China – a view of some of the figures excavated so far.

128 Boys diving from multi-coloured cliffs – detail of paintings in the Tomb of Hunting and Fishing at Tarquinia, c. 500 BC.

of this mighty royal garrison. If the emperor's own tomb mound constituted his private palace or 'forbidden city', then these chambers served as satellite army camps or barracks.

To muster this force of earthenware warriors was a logistical, as well as an artistic, triumph, involving an estimated half a million craftsmen and labourers. We today are amazed to see the result. But what is more amazing is the fact that not one of these figures was created for public view. Lifelike they certainly were, and all for the sake of reassuring one man who was profoundly afraid of death.

THE ETRUSCANS AND THE MAKING OF THE UNDERWORLD

The sheer extravagance with which Qin Shihuang budgeted for his departure from the world is foreign to us, as are many past testimonies of burial involving precious goods or sacrifice. As the English poet W.H. Auden mordantly observed (in 1962):

> Nobody I know would like to be buried
> with a silver cocktail shaker,
> a transistor radio and a strangled
> daily help …

We have abandoned such observances. Archaeologists of the future will find it very difficult to deduce from *our* tombs what social rank we occupied when alive. Furthermore, it is said (by social scientists) that nowadays only a very small proportion of people maintain any traditional beliefs about the afterlife. The Christian notions of heaven and hell, for example, are reckoned largely to have disappeared from collective consciousness. So what use is there in pursuing a final case study of the ancient imagining of death from a famously enigmatic people, the Etruscans? The answer is that although these long-buried inhabitants of pre-Roman Italy knew a world very different from our own, a study of their view of death directly illuminates our own ambivalent attitude. Why do we persist in the paradox of wanting to sanitize death out of existence, while bombarding ourselves with images of its proximity? Because we are locked into juggling the balance between fear and reassurance. This is a psychological necessity that the Etruscans discovered over 2000 years ago.

In 1837 arguably the world's first virtual reality experience of the ancient world was installed in a house in London's Pall Mall. A dozen rooms at one genteel address

were temporarily transformed into Etruscan tombs. Some were painted chambers, minutely reproduced from tombs at Tarquinia, a major Etruscan city to the north of Rome; others contained authentic sarcophagi and various funerary relics – armour, mirrors, utensils, jewels and skeletal remains – excavated from various Etruscan sites. The lighting, designed to simulate that used for entering some subterranean site, was provided by blazing torches. Visitors were encouraged to believe that they were descending into a netherworld of Etruscan ghosts.

But this show was not set up as a gloomy or forbidding experience. One of the first exhibits was a mocked-up tomb, the painted walls of which showed Etruscans happily at ease on banqueting couches, making music and dancing ecstatically in open countryside. As the accompanying catalogue commented, much of the decoration of Etruscan tombs seemed intended 'to remove from death every idea of horror'. Death, to the Etruscans, seemed 'to be nothing less than the approach and passage to a new life in the Elysian fields; where, in union with their deceased kinsmen and friends, they were to live in perpetual enjoyment and pleasure, feasting and dancing'.

The Pall Mall exhibition was a marked success, adding to the romantic dream of Italy as an age-old sanctuary of warmth and light. Almost a century later, the tuberculosis-ridden D.H. Lawrence made a pilgrimage to Etruscan tombs *in situ*, seeking among these places of death the vitality he deemed lost by industrialized society. Clambering down into the various painted tombs concealed in hillsides above the town of Tarquinia, Lawrence was not disappointed. Surrounded by images of merriment and simple, even puerile, delights, such as those to be seen in the Tomb of Hunting and Fishing (*Fig. 128*), the ailing writer was enraptured by the manifest 'throes of wonder and vivid feeling throbbing over death'; the 'quick ripple of life' that animated these ancient Etruscans who, Lawrence supposed, 'must have lived with real fullness'.

Since virtually nothing survives of Etruscan literature, it is easy to speculate about their systems of belief: there are no Etruscan voices to contradict us. But from the archaeological record it becomes clear that the Etruscan concept of death was much more complex than its rosy representation first to a Victorian public and then to the ardent D.H. Lawrence.

Etruscan tomb design was inspired by the notion that the dead should be given accommodation that was familiar – that is, resembling the houses of the living. Early Etruscan 'hut urns', made of clay or bronze to contain an individual's cremated remains, attest to this ideal. It is also evident at a number of Etruscan cemeteries, where the

129 (top) The interior of the Tomb of the Reliefs, Cerveteri, *c.* 350 BC.

130 (above) A view of the Banditaccia 'necropolis', Cerveteri.

131 A hook-nosed demon on a painted wall in the Tomb of the Blue Demons at Tarquinia, c. 420 BC.

presence of soft volcanic stone facilitated the carving of commodious chambers from solid rock. When creating such tombs, Etruscan masons might replicate in stone not only timber architectural features, such as windows, doorways, roofing, pillars and joists – all to no structural purpose underground – but also domestic furniture, such as chairs and couches, plus sundry household fixtures and fittings, and armour or ornaments (*Fig. 129*).

Even humble burials were equipped with grave goods drawn from the domestic sphere – fire tongs, loomweights, and so on; not to mention plates, cups and victuals for taking sustenance below. So the Etruscan dead formed communities of ancestors, and each elaborate burial ground – rather more than a cemetery – was known as a *necropolis*, or 'city of the dead'. The most substantial expression of this is to be found at Cerveteri, between Rome and Tarquinia, where an entire plateau still retains the air of a pseudo-urban centre. Its tombs, set out on streets and thoroughfares, even in terraced rows, are like so many desirable residences for eternity (*Fig. 130*). 'So easy and friendly,' commented Lawrence when he paid Cerveteri a springtime visit in 1927, finding again a 'free-breasted naturalness and spontaneity … that at once reassures the spirit'. In such tranquil and cosy surroundings death could seem a positively enticing prospect.

Yet there was a dark side to this Etruscan construction of the afterlife: a vision of death that brought with it hideous demons and ghastly torments. It was an aspect of Etruscan imagery that was given little prominence in the Pall Mall exhibition, and dismissed by D.H. Lawrence as a regrettable corrosion of the free Etruscan spirit by Roman influence. However, it now appears that this dark aspect was independently created by the Etruscans themselves – as if to counter any complacent assumption that death might be simply the merry continuance of life.

In 1985 engineers plotting the path of a new water pipeline to supply modern Tarquinia were forced to stop and summon archaeologists when they sounded hollow space below. The archaeologists drilled down and peered into the hollow space with an inverted periscope. Sure enough, it was an Etruscan tomb, and a painted tomb at that: not surprising, since other painted tombs were located in the area. But as the periscope swivelled to survey the painted walls of the tomb, images were glimpsed that were truly alarming.

One side of the tomb was decorated with conventional scenes of delight – music, dancing, quaffing wine. The other side, by contrast, featured pale figures beset by a gaggle of hook-nosed, groping demons (*Fig. 131*). To call this the 'Tomb of the Blue Demons' does not quite convey the quality of the blue pigment used here: it is the

queasy, electric blue of flies that cluster over putrefying flesh. These images were not intended to reassure: quite the opposite.

Are these the oldest surviving images of hell? Possibly. They are certainly the first sign of a major shift in Etruscan iconography, as their tombs become ever more dominated by pictures and statues of hideous demons, the staff of the underworld. Led by Charun, the beaky, livid green ferryman of the dead, who in Etruscan art carries a large mallet with which to hurry his charges, these demons are often shown as unwelcome winged messengers, sent to claim yet another soul from the sunlight and enforce the final farewell. So what was it that brought about such a shift in the Etruscan world view regarding the afterlife – from happy to hellish?

Lawrence was half-right about the Roman factor. By the time the Tomb of the Blue Demons was painted, in the late fifth century BC, Etruscan political fortunes were spiralling into decline. A century earlier the Etruscan king, known to the Romans as Tarquinius Superbus (Tarquin the Proud) had monumentalized what was little more than a shanty town spread over several hills by the banks of the River Tiber, building palaces, paving the forum (market) area, and laying down massive drainage channels. Then, *c.* 510 BC, the Etruscan kings were expelled from Rome, and the citizen farmers who established the Roman Republic formed a military-based state, whose experiments in aggressive expansion took them directly into the fertile heartlands of Etruria. The Etruscan cities, though confederated, did not combine effectively to resist the Roman advance. By 396 BC, one of the major Etruscan centres, the city of Veii, had fallen to the Romans. Others, including Cerveteri and Tarquinia, followed one by one. By the late first century BC – the time of the emperor Augustus and his pre-eminent poet, Virgil – Etruscan culture, along with the Etruscan language, was no more than an antiquarian curiosity.

Etruscan soothsayers, priests of a deeply fatalistic religion, predicted an 'end of time' as a destiny for their own people. This may be one reason why the Etruscan cities failed to mount an effective resistance to the process of Roman conquest. On an individual level, however, it is apparent that measures were taken to adapt the imagery of death. Banquets still await the fortunate in the next world, but these are now the stuff of hope, not expectation. The demons will allocate doom to those who deserve it.

Etruscan civilization disappeared, but the Etruscan dead stayed on, discreetly, in their underground tombs. We do not know just how much Virgil drew upon Etruscan

132 *The Damned* by Luca Signorelli, Orvieto, 1499–1502.

notions of the afterlife when, in Book VI of his *Aeneid*, he gave the first detailed description of the underworld in Western literature. Nor can we be sure how far Dante, Virgil's self-confessed medieval successor, incorporated folk knowledge of Etruscan tomb imagery into his poetic picture of the *Inferno*, a patent amalgamation of the Hebrew–Christian hell and the pagan Hades.

Did images of the Etruscan underworld filter into the Christian repertoire? If not, there are some surprising coincidences. In the late fourteenth century, an Italian painter was commissioned to decorate church walls with 'Scenes from the End of Time' – the Last Judgement, the day of reckoning, when the evil would be consigned to torment amid sulphurous flames, and the righteous escorted to heaven's golden bliss. Apocalyptic passages from the New Testament Book of Revelation gave limited graphic guidance for the frescoes produced by Luca Signorelli in the San Brizio chapel of Orvieto Cathedral. Orvieto was once a significant Etruscan city; orderly rows of Etruscan tombs may still be seen at the foot of the hill where Orvieto rises, and the cathedral itself probably lies on top of an Etruscan temple. Was it direct access to an Etruscan tomb, or some distant local memory, that caused Signorelli to show 'The Punishment of the Damned' supervised by teams of greyish-blue demons (*Fig. 132*)?

'IN THE END … '

The paintings in Orvieto Cathedral offered worshippers a cautionary choice with regard to the afterlife: to be saved or damned; to spend eternity in bliss or torment. On one side, heartening reassurance for the event of death; on the other, sheer terror.

As noted earlier, church attendance is not what it was, and fears of hell have faded. But even in secular Western society, the tendency persists to visualize the end. It may be in a gallery or on the stage; on celluloid or video screen; or, perhaps most tellingly, as an essential element in the colour supplement of weekend newspapers. Lifestyle features dominate the pages of such magazines: food, wine, health, beauty, fashion, travel. But, almost *de rigueur*, there will be an essay concerned with death, probably a photo-journalistic spread showing humans in some part of the world beset by war, famine, disease or other agony (*Fig. 133*).

It will not put us off our lunch. But this, now, is how we manage the terror of death. Extended as our lives may be, we mortals are still mortal. Images help us sometimes to remember that.

133 *A dead North Vietnamese soldier and his plundered belongings, Hue, 1968*
by Don McCullin.

SELECTED FURTHER READING

1 THE HUMAN ARTIST

A number of books germane to the general enterprise of this project may be tallied here, beginning with two studies of the human instinct for art as a means of 'making special' by the anthropologist Ellen Dissanyake: *What Is Art For?* (Washington 1988), and *Homo Aestheticus: Where Art Comes From and Why* (Washington 1995). M. Greenhalgh and V. Megaw, *Art in Society* (London 1978) contains various case-studies mixing 'art and anthropology'; theory and practice are nicely combined in R. Layton, *The Anthropology of Art* (2nd ed., Cambridge 1991). W. Noble and I. Davison, *Human Evolution, Language and Mind* (Cambridge 1996), gives an overview of the evidence for the early development of symbolic capacity in the human species; as for historical instances of how humans respond to art, D. Freedberg's *The Power of Images* (Chicago 1989) remains essential reading. On how children make art, see N.H. Freeman and M.V. Cox, *Visual Order: The Nature and Development of Pictorial Representation* (Cambridge 1985). The mistake of equating the term 'primitive' with 'simple' was definitively exposed by Franz Boas in his 1927 study, *Primitive Art*; but reconciling ancient and non-Western art with the traditional 'story of art' has proved a challenge, as shown by S. Price, *Primitive Art in Civilized Places* (Chicago 1989).

2 THE BIRTH OF THE IMAGINATION

No apologies for using, like others before me, the story of the Spanish nobleman and his daughter at Altamira as an historical epitome: it is still a telling story. For details I have relied upon B. Madariaga de la Campa, *Sanz de Sautuola and the Discovery of the Caves of Altamira* (Santander 2001). For the momentous 'recantation' essay of Emile Cartailhac, '*Mea culpa* d'un sceptique', see *L'Anthropologie* 13 (1902), 348–54. There are good surveys of the ensuing debate in P.J. Ucko and A. Rosenfeld, *Palaeolithic Cave Art* (London 1967); P.G. Bahn, *Prehistoric Art* (Cambridge 1998), and M. Lorblanchet, *La Naissance de l'Art* (Paris 1999). The 'art for art's sake' case is made by J. Halverson in *Current Anthropology* 28 (1987), 63–89. No hopes of visiting Chauvet, but for good pictures see J-M. Chauvet et al., *Chauvet Cave: The Discovery of the World's Oldest Paintings* (London 1996). For the latest on Lascaux: N. Aujoulet, *The Glory of Lascaux* (London 2005). For more on the 'cultural explosion', diet and other factors of Stone Age archaeology, C. Gamble, *The Palaeolithic Societies of Europe* (Cambridge 1999). The 'shamanistic' interpretation of cave-paintings, no longer eccentric, is argued with patience and elegance by David

Lewis-Williams, *The Mind in the Cave* (London 2002). My citation of a Bushman shaman becoming a lion is drawn from B. Keeney ed., *Ropes to God: Experiencing the Bushman Spiritual Universe* (Philadelphia 2003), 53. Interim results of excavation at Göbekli Tepe are published in *Paléorient* 26 (2001), 45–54; see also J. Peters and K. Schmidt, 'Animals in the Symbolic World of Pre-Pottery Neolithic Göbekli Tepe', in *Anthropozoologica* 39 (2004), 179–218. A wider archaeological context of Göbekli is given by J. Cauvin, *The Birth of the Gods and the Origins of Agriculture* (Cambridge 2000), and S. Mithen, *After the Ice* (London 2003).

3 MORE HUMAN THAN HUMAN

Still to be treasured for its elegant range across the Western tradition of bodily representation is Kenneth Clark's *The Nude* (London 1956). G.L. Hersey, *The Evolution of Allure* (Cambridge, Mass. 1996) adds further insights. On the story of the Venus of Willendorf: W. Angeli, *Die Venus von Willendorf* (Vienna 1998). V.S. Ramachandran's application of 'peak shift' theory to figurative art is expounded in an article co-authored by W. Hirstein, 'The Science of Art', in *Journal of Consciousness Studies* 6 (1999), 15–41 (with comment and debate in subsequent numbers of the same journal); also in Ch. 4 of his 2003 Reith lectures, *The Emerging Mind* (London 2004). A book entitled *The Artful Brain* is promised for late 2005. For gull-chick research: N. Tinbergen, *The Herring Gull's World* (London 1953). On the Egyptian canonical tradition, see E. Iversen, *Canon and Proportions in Egyptian Art* (2nd ed., Warminster 1975), and G. Robins, *Proportion and Style in Ancient Egyptian Art* (London 1994). I have explored the notion of 'the Greek Revolution' elsewhere: N.J. Spivey, *Understanding Greek Sculpture* (London 1996); on how the Greeks shaped up in sculpture, see also A.F. Stewart, *Art, Desire and the Body in Ancient Greece* (Cambridge 1997), and W.G. Moon ed., *Polykleitos, the Doryphoros and Tradition* (Wisconsin 1995).

4 ONCE UPON A TIME

A genial history of Hollywood storytelling is given by T. Shone, *Blockbuster* (London 2004). The more forbidding academic study of stories is represented by M. Bal, *Narratology: Introduction to the Theory of the Narrative* (Toronto 1985); and in the realms of psychology, by J. Bruner, *Making Stories* (Harvard 2002). My citation from Roland Barthes is translated from his 'Introduction à l'analyse structurale des récits' – the theoretical manifesto for a collection of influential 'semiological'

essays entitled *L'analyse structurale du récit* ('Communications', 8: Paris [1966] 1981). On storytelling in ancient art: P.J. Holliday ed., *Narrative and Event in Ancient Art* (Cambridge 1993) does not render obsolete a symposium on 'Narration in Ancient Art', published in Vol. 61 of the *American Journal of Archaeology* (1957). A. George, *The Epic of Gilgamesh: A New Translation* (London 1999) is an accessible version of the same author's work towards a 'definitive' text; J. Maier, *Gilgamesh: A Reader* (Wauconda 1997) collects a useful range of essays, articles and literary echoes relating to the Gilgamesh epic. For more on Mesopotamian literacy, J. Bottéro, *Mesopotamia: Writing, Reasoning and the Gods* (Chicago 1991). My account of the finding of the lion-hunt reliefs at Nineveh is drawn from H. Rassam, *Asshur and the Land of Nimrod* (New York 1897), 24ff. Expository accounts of the friezes displayed in the British Museum may be found in J. Reade, *Assyrian Sculpture* (London 1983), and D. Collon, *Ancient Near Eastern Art* (London 1995). The 'east of Helicon' phrase derives from M.L. West's iconoclastic *The East Face of Helicon* (Oxford 1997). Egyptian narrative art: see G.A. Gaballa, *Narrative in Egyptian Art* (Mainz 1976); for a sample of texts, W.K. Simpson ed., *The Literature of Ancient Egypt: An Anthology of Stories, Instructions and Poetry* (Yale 1973). The rapport between myth, text and picture in ancient Greece has fascinated scholars for over a century, beginning with Carl Robert's *Bild und Lied* (Berlin 1881); more recently A. Shapiro, *Myth into Art* (London 1994). The universality of the Cyclops story is argued in D.L. Page, *The Homeric Odyssey* (Oxford 1955); see also J.G. Frazer's Loeb edition of Apollodorus, *Bibliotheca* Vol. 2, 404ff. For Baya Horo in Papua New Guinea, see L.R. Goldman, *Child's Play: Myth, Mimesis and Make-Believe* (Oxford/New York 1998). Trajan's Column is 'unwrapped' in S. Settis et al., *La Colonna Traiana* (Turin 1988); on its 'filmic' qualities, see A. Malissard, 'Une nouvelle approche de la Colonne Trajane', in *Aufstieg und Niedergang der römischen Welt* II. 12.1 (Berlin/New York 1982), 579–604. On 'Songlines' and Aboriginal storytelling, T.G.H. Strehlow's *Songs of Central Australia* (Sydney 1971) is necessarily complemented by a biography of the author – so B. Hill, *Broken Song* (Milsons Point 2002). An anthology of Aboriginal tales is collected by R. and C. Berndt, *The Speaking Land* (Ringwood 1989). For a case study of one myth's antiquity, see P. Taçon et al., 'Birth of the Rainbow Serpent in Arnhem Land Rock Art and Oral History', in *Archaeology in Oceania* 31 (1996), 103–24. G. Chaloupka, *Journey in Time* (Chatswood, NSW, 1993), gives a well-illustrated survey of Arnhem Land rock art; D.A. Roberts and A. Parker, *Ancient Ochres: The Aboriginal Rock Paintings of Mount Borradaile* (Marleston 2003), publishes some of the images from this part of the territory.

5 SECOND NATURE

Citations from Alfred Haddon come from A.C. Haddon, *Evolution in Art* (London 1895). On the rapport between prehistoric sites, rock art and topography – ancient and modern – see C. Chippindale and G. Nash eds., *Pictures in Place: The Figured Landscapes of Rock Art* (Cambridge 2004), B. Bender ed., *Landscape: Politics and Perspectives* (Oxford 1993), and C. Tilley, *A Phenomenology of Landscape: Places, Paths and Monuments* (Oxford 1994). Simon Schama's *Landscape and Memory* (London 1995) contains insights on the Western tradition of viewing 'Nature', so too K. Clark, *Landscape into Art* (2nd ed. London 1976). On the Roman wall-paintings: R. Ling, 'Studius and the Beginning of Roman Landscape Painting', in *Journal of Roman Studies* 67 (1977), 1–16; for Renaissance theories, E.H. Gombrich, *Norm and Form* (Oxford 1966), 107–21. Chinese painters' observations: S. Bush and H. Shih, *Early Chinese Texts on Painting* (Harvard 1985), 141–90, see also M. Sullivan, *Symbols of Eternity: The Art of Landscape Painting in China* (Oxford 1979). American manifestations of 'the Picturesque': A. Wilton and T. Barringer, *American Sublime: Landscape Painting in the United States* (London 2002). 'Land art': a survey of the genre is given in S. Boettger, *Earthworks: Art and Landscape of the Sixties* (California 2003).

6 ART AND POWER

An early account of the Benin trophies taken by the 'British Punitive Expedition' can be found in H. Read and O. Dalton, *Antiquities from the City of Benin … in the British Museum* (London 1899); a more systematic study is by W. Fagg, *Nigerian Images* (London 1963). On courtly pomp in Europe, see P. Burke, *The Fabrication of Louis XIV* (Yale 1992); for the 'theatre state' concept, C. Geertz, *Negara* (Princeton 1980). The archaeological background to the 'King of Stonehenge' find of 2002 is given in D.V. Clarke, T.G. Cowie and A. Foxon, *Symbols of Power at the Time of Stonehenge* (Edinburgh 1985). For results of Italian excavations at Arslantepe see M. Frangipane ed., *Alle origini del potere* (Milan 2004). The study of Mesopotamian royal imagery was pioneered by Henri and H.A.G. Frankfort, whose work remains necessary reading, e.g. H. Frankfort, *Cylinder Seals* (London 1939); see also J.N. Postgate, *Early Mesopotamia: Society and Economy at the Dawn of History* (London 1992). On the Persian empire: C. Nylander, 'Achaemenid Imperial Art', in M.T. Larsen ed., *Power and Propaganda: A Symposium on Ancient Empires* (Copenhagen 1979), 345–59; plus J. Boardman, *Persia and the West* (London 2000). Of the vast literature created by Alexander, I recommend D.M. Lewis et al. eds., *Cambridge Ancient History (Second Edition)*, VI: *The Fourth Century B.C.* (Cambridge 1994), esp. 876–81, J. Carlsen et al. eds., *Alexander the Great: Reality and Myth* (Rome 1993), M.J. Price, *The Coinage in the Name of Alexander the Great* (Zürich 1991), and A.F. Stewart,

Faces of Power (California 1993). M. Andronikos, *Vergina: The Royal Tombs* (Athens 1994) evokes the excitement of the Vergian discoveries. The power-politics of Augustus were shrewdly analyzed, with one eye on the rise of the Fascist dictators, by Ronald Syme in *The Roman Revolution* (Oxford 1939); the visual aspects of this process scrutinized by P. Zanker, *The Power of Images in the Age of Augustus* (Ann Arbor 1988). On totalitarian imagery see D. Ades et al. eds., *Art and Power* (London 1955).

7 SEEING THE INVISIBLE
Bamiyan and beyond: a survey was made at Bamiyan before the Taliban attack — see T. Higuchi ed., *Bamiyan: Art and Archaeological Researches on the Buddhist Cave Temples in Afghanistan* (4 vols, Dohosha 1983–4). For a prejudiced account: R. Byron, *The Road to Oxiana* (London 1981) [1937], 262–4; for Byron's photographs, *Apollo* magazine July 2002, 28–34. Interpretation using Hsuan-Tsang: D. Klimburg-Salter, *The Kingdom of Bamiyan: Buddhist Art and Culture of the Hindu Kush* (Naples 1989). The colossal image at Davel: H.A. Giles, *The Travels of Fa-hsien (399–414 AD), or Record of the Buddhistic Pilgrims* (Cambridge 1923), 9. On other Buddhist images along the Silk Road, the accounts of Aurel Stein remain valuable, such as *On Central Asian Tracks* (London 1933), 193–202; see also S. Whitfield ed., *The Silk Road: Trade, Travel, War and Faith* (London 2004). For more on Buddhist iconography: A.K. Coomaraswamy, 'The Origin of the Buddha Image', in *Art Bulletin* 9 (1927), 287–328, B. Rowland, *The Evolution of the Buddha Image* (New York 1968), J. Miksic, *Borobudur* (Hong Kong 1990). For Hindu iconography: D.L. Eck, *Darsan: Seeing the Divine Image in India* (Chambersburg 1981), and R.H. Davis, *Lives of Indian Images* (Princeton 1997). E. Kitzinger, *Byzantine Art in the Making* (Cambridge, Mass. 1977) and A. Grabar, *Christian Iconography: A Study of its Origins* (New York 1968) are among many interpretative studies of early Christian art; see also N.J. Spivey, *Enduring Creation* (London 2001), 39ff. The Iconoclasm dispute is thoroughly discussed in A. Besançon, *The Forbidden Image* (Chicago 2000). On icon-painting: L. Ouspensky and V. Lossky, *The Meaning of Icons* (Boston 1955). On Guaraní Christian images: G.A. Bailey, *Art on the*

Jesuit Missions in Asia and Latin America, 1542–1773 (Toronto 1999). Ethiopian Christian images: M.J. Ramos and I. Boavida eds., *The Indigenous and the Foreign in Christian Ethiopian Art* (London 2004). On Kandinsky — and echoing the chapter heading — M. Henry, *Voir l'invisible: Sur Kandinsky* (Paris 1988).

8 IN THE FACE OF DEATH
D.H. Lawrence, quoted in the overture to this chapter, reappears at the end, and might also have been mentioned with regard to the Aztecs, whose fascination for him is evident in his 1926 novel, *The Plumed Serpent*. A fully annotated text of Lawrence's *Sketches of Etruscan Places*, edited by S. de Filippis, is available in the Cambridge Edition of the Works of D.H. Lawrence (Cambridge 1992). A historical overview of Western attitudes to death is given by P. Ariès, *The Hour of Our Death* (New York 1981); for anthropological approaches, R. Huntington and P. Metcalf, *Celebrations of Death* (Cambridge 1979); for archaeological approaches, M. Parker Pearson, *The Archaeology of Death and Burial* (Texas 1999). See also J. Bremmer, *The Rise and Fall of the Afterlife* (London 2002). Jericho skulls: a readable account is given by Kathleen Kenyon in her *Digging up Jericho* (London 1957). Easter Island: archaeological revelations in J. Flenley and P. Bahn, *The Enigmas of Easter Island* (Oxford 2003); for the most up-to-date account of Easter's 'turbulent history', see S.R. Fischer, *Island at the End of the World* (London 2005). Aztec sacrifice: for general remarks about Spanish accounts of the Americas see S. Greenblatt, *Marvelous Possessions* (Oxford 1991); for a more detailed analysis see Inga Clendinnen's *Aztecs: An Interpretation* (Cambridge 1991) — see also her essay in *Representations* 33 (1991), 65–100. On the Etruscan rapport with the dead see B. d'Agostino, 'Image and Society in Archaic Etruria', in *Journal of Roman Studies* 89 (1989), 1–10; N.J. Spivey, *Etruscan Art* (London 1997); and (for a full compendium of tomb paintings), S. Steingräber et al., *Etruscan Painting* (New York 1986). Don McCullin has given an account of his career in *Unreasonable Behaviour* (London 1990); an album of his work, introduced by former editor Harold Evans, is simply entitled *Don McCullin* (London 2001).

ACKNOWLEDGEMENTS
This book is single-minded; however, being allied with a television series to which many others contributed, its boundaries of intellectual property are elastic. I owe thanks to the several researchers and consultants involved by the BBC, in particular David Barrowclough; to the series producer, Mark Hedgecoe, and other producer-directors of individual episodes — Ben McPherson, Nick Murphy, Francis Whateley and Martin Wilson — and our executive producer, Kim Thomas; and to various sources of assistance and expertise around the globe, notably the following: Sven Hauer, Angeliki Kottaridou, David Lewis-Williams; Sally May, Howard Morphy, Anthony Murphy and all at Injalak Arts Centre; Klaus Schmidt; and Shahrokh Razmjon. A fellowship at the Centre for Cross-Cultural Research at the Australian National University, Canberra, furnished time and facilities for preparatory reading and fieldwork; and I am grateful, as ever, for the abiding support and indulgence of the Faculty of Classics, Cambridge University, and Emmanuel College.

PICTURE CREDITS

Page 10t Alinari/Bridgeman Art Library/Biblioteca Ambrosiana Milan; 10b AKG/Erich Lessing Mauritshuis, Amsterdam; 17 Thomas Stephan © Ulmer Museum; 18 Giraudon/Bridgeman Art Library; 23t Pierre Vauthey/Corbis Sygma; 23b Jean Clotte/Centre d'information et de documentation, Grotte Chauvet – Pont-d'Arc; 26 Bridgeman Art Library; 28/29 Charles Jean Marc/Corbis Sygma; 35b D. Lewis-Williams; 42 Archivo Iconografico, S.A./Corbis; 45 Thomas Stephan © Ulmer Museum; 51 AKG/Vatican Museums; 53t Erich Lessing/AKG; 53b © 2001 Scala, Florence/Castello Sforzesco, Milan; 54 © 2005 Digital Image, MoMA/Scala, Florence – Museum of Modern Art, New York/acquired through the Lille P. Bliss bequest 333.1939 © Succession Picasso/DACS 2005; 56 Erich Lessing/AKG; 69l Erich Lessing/AKG; 69r Erich Lessing/AKG; 70l AKG; 70r Gianni Dagli Orti/Corbis; 74 AKG/Nimatallah/Archaeological Museum, Naples; 76 AKG/Vatican Museums; 77 Rabatti-Domingie/AKG/Uffizi Gallery, Florence; 80 Jean-Louis Nou/AKG; 82 Electa/AKG; 83l © 1990 Scala, Florence/Museo Civico de Arte Antica, Turin; 83r Werner Forman/Corbis; 85 Erich Lessing/AKG/Musée de la Tapisserie; 88 Lucasfilm Ltd/Paramount; 93t Nik Wheeler/Corbis; 93b R Sheridan/Ancient Art & Architecture Collection Ltd; 96t The Trustees of the British Museum; 96b The Trustees of the British Museum; 103 Erich Lessing/AKG/Cabinet des Medailles, Bibliothèque Nationale, Paris; 106 Erich Lessing/AKG; 112 Erich Lessing/AKG/Musée de la Tapisserie; 123 Kimbell Art Museum/Corbis; 126 John Van Hasselt/Corbis Sygma; 130 Bridgeman Art Library/V&A Museum; 133 Archivo Iconografico, S.A./Corbis; 136 Erich Lessing/AKG/Museo Nazionale Romano delle Terme; 139 Corbis/Christie's Images; 142 AKG/Musée Conde, Chantilly; 143 AKG/V&A Museum; 145 Erich Lessing/AKG/Graphische Sammlung Albertina, Vienna; 146t AKG/Stedelsches Kunstinstitut, Frankfurt-am-Main; 146b Kimbell Art Museum/Corbis; 149 Gift of Thomas Fortune Ryan, 1912.1 Collection, University of Virginia Art Museum; 150 Corbis; 153 Gianfranco Gorgoni/Collection: DIA Center for the Arts, New York/courtesy of James Cohan Gallery, New York/© Estate of Robert Smithson/licensed by VAGA, New York, NY/DACS 2005; 155 Gregor M. Schmid/Corbis; 157 Werner Forman/Corbis; 158 The Royal Collection © 2005, Her Majesty Queen Elizabeth II; 161l from Revd John Williams, Missionary Enterprises; 161r Dagli Orti/The Art Archive/Bibliothèque des Arts Décoratifs, Paris; 164/165 Jason Hawkes/Corbis; 166t The Trustees of the British Museum; 166b The Art Archive/The British Museum; 169 Gianni Dagli Orti/Corbis; 172t Roger Wood/Corbis; 175 Corbis; 179 Dagli Orti/The Art Archive/Pella Museum, Greece; 180b Dagli Orti/The Art Archive/Fitzwilliam Museum Cambridge; 184/185 AKG/Archaeological Museum, Naples; 190b Pirozzi/AKG; 192 © 1990 Scala, Florence/San Giovanni Battista, MüStair, Switzerland; 193 Rabatti-Dominigie/AKG; 196 Alinari Archives/Corbis; 198 Gianni Dagli Orti/Corbis; 199 Gregor M. Schmid/Corbis; 201 AKG/Collection of the Ronge Family; 202 Corbis/Reuters; 209l Nimatallah/AKG/Akropolis Museum, Athens; 209r AKG/British Museum; 212t Charles & Josette Lenars/Corbis; 212b Jean-Louis Nou/AKG; 215t V&A Picture Library; 215bl AKG/Collection of the Ronge Family; 215br Paul Almasy/Corbis; 216l Lindsay Hebberd/Corbis; 216r Angelo Hornak/Corbis; 220 Jean-Louis Nou/AKG; 223 Erich Lessing/AKG; 224 Erich Lessing/AKG; 229t Erich Lessing/AKG; 229b © 1990 Scala, Florence/Church of Santa Sabina, Rome/courtesy of the Ministero Beni e Att. Culturali; 232 © 1990 Scala, Florence/Tretyakov State Gallery, Moscow; 235t Karen Tweedy-Holmes/Corbis; 235b Stefan Diller/AKG; 238 Jörg P. Anders/bpk/Staatliche Museen zu Berlin, Preussischer Kulturbesitz, Gemäldegalerie; 241l Jörg P. Anders/bpk/Staatliche Museen zu Berlin, Preussischer Kulturbesitz, Skulpturensammlung und Museum für Byzantinische Kunst; 241r © 1990 Scala, Florence/Palazzo Comunale, Massa Marittima; 242 Erich Lessing/AKG/Unterlinden Museum, Colmar; 245 Pirozzi/AKG; 246l Joseph Martin/AKG; 246r Luca I. Tettoni/Corbis; 249 Chris Lisle/Corbis; 250 Bridgeman Art Library/Yale Center for British Art, Paul Mellon Collection; 253 Solomon R. Guggenheim Museum, New York © ADAGP, Paris and DACS, London 2005; 255 Archivo Iconografico, S.A./Corbis; 256 bpk/Staatliche Museen zu Berlin, Preussischer Kulturbesitz, Ägyptisches Museum; 260 Archivo Iconografico, S.A./Corbis; 263 Wolfgang Kaehler/Corbis; 268tr Nathan Benn/Corbis; 268b Ian Mursell/Mexicolore/Bridgeman Art Library; 271 Viktor Korotayev/Reuters/Corbis; 272 Archivo Iconografico, S.A./Corbis; 275t Archivo Iconografico, S.A./Corbis; 279 AKG/Nimatallah; 281 Don McCullin/NB Pictures.

The following images are © BBC: Tim Cragg 172b, 180t, 195l and 195r; Matthew Hill 9, 115, 116t, 116b, 275b and 276; Andrea Illescas 104t; Ben McPherson 268tl; Nick Murphy 62, 65l, 65r; 73; Nick Murphy/Henry Moore Foundation 55; Nick Murphy/Archaeological Museum Reggio Calabria 2 and 79; Christian Mushenko 121; Carolyn Vermalle 35t, 38, 46t and 46b. The images on the following pages were kindly supplied by the author: 7, 15, 104 below, 109, 184 inset, 190 top left and 190 top right.

INDEX